Samuel Prout (1783–1852)

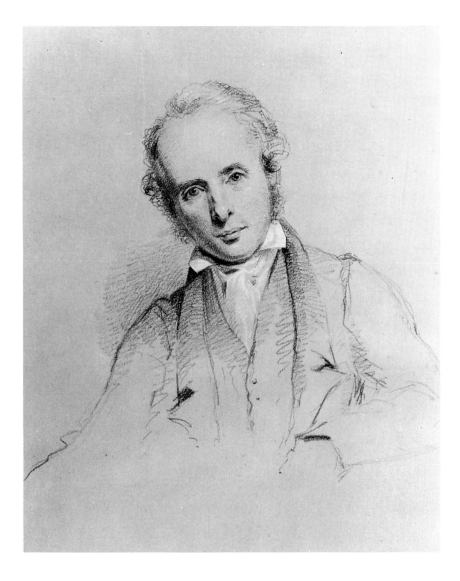

RICHARD LOCKETT

Samuel Prout

1783–1852

B. T. BATSFORD LTD · LONDON
IN ASSOCIATION WITH THE
VICTORIA & ALBERT MUSEUM

ISBN O 7134 3490 2 (cased)
ISBN O 7134 3491 O (limp)

Typeset and printed in Great Britain by
Butler & Tanner Ltd
Frome and London
for the publishers
B. T. Batsford Ltd
4 Fitzhardinge Street
London W1H 0AH

TO GILLIE

Frontispiece
William Brockedon, *Portrait of Samuel Prout*, 1826
National Portrait Gallery (NPG 2525/12)

Series general editor:
John Murdoch, Deputy Keeper
of the Department of Paintings
Victoria & Albert Museum

Contents

List of illustrations

V LAST YEARS: 1840–52

FIG. 35 *Hotel de Ville, St-Quentin, France*
Whitworth Art Gallery, University of Manchester

NOTE: With the exception of the frontispiece, and where specified, all the illustrations are drawings or watercolours by Prout. This list does not include illustrations given in the catalogue of works in the collection of the Victoria & Albert Museum (p. 95 ff.). **Bold** numerals given in the text are references to illustrations in the **catalogue**; references such as 'fig. 9' indicate illustrations in the general chapters.

COLOUR PLATES *between pages 120 and 121*

PLATE I *Maen Rock, Cornwall*
N. Devon Athenaeum, Barnstaple

PLATE II *Cors-y-Gendel, near Barmouth, Merioneth*
Wiltshire Archaeological Society, Devizes

PLATE III *Interior of Malmesbury Abbey, Wiltshire*
Wiltshire Archaeological Society, Devizes

PLATE IV *Broadwater, near Worthing, Sussex*
Fitzwilliam Museum, Cambridge

PLATE V *Teignmouth and the Hamoaze, Devon*, soft-ground etching pub. by T. Palser in *Picturesque Delineations*, 1812
Plymouth City Museum and Art Gallery

PLATE VI *Cottages near Saltash, Cornwall*, soft-ground etching coloured by hand, pub. by T. Palser in *Prout's Village Scenery*, 1812
Victoria & Albert Museum, London

PLATE VII *Interior of Old Fincham Church, Sussex*
N. Devon Athenaeum, Barnstaple

PLATE VIII *Studies*
Birmingham City Museum and Art Gallery

CATALOGUE 5 *Estuary scene*

CATALOGUE 46 *The Forum of Nerva, Rome*

CATALOGUE 48 *West porch of Ulm Cathedral, Württemberg*

CATALOGUE 65 *The Arch of Constantine, Rome*

NOTE: unless otherwise stated, the plates are taken from watercolours and drawings.

Foreword

This attempt to catalogue works by Samuel Prout in the national collection at the Victoria & Albert Museum has depended on the help of Michael Kauffmann and the Print Room staff. The associated research into the artist's work and career was activated by John Murdoch, the series editor. Staff at other museums have been most helpful, in particular David Alston, David Blayney Brown, William Bradford, James Dearden, Jane Farrington, Andrew Greg, Vivien Knight, Patrick Noon, Michael Pidgley, Harley Preston, Duncan Robinson, David Scrase, Michael Spender, Vivien Tubbs, Stephen Wildman and Michael Wilson.

The burden of my inquiries has fallen on the museums of Barnstaple, Devizes, Exeter, Hastings, Plymouth and the V&A itself, and I owe an especial debt to Jane Baker, Anne Buddle, Pamela Colman, John Rowe and Victoria Williams.

Unpublished sources are quoted by kind permission of: the Trustees of the National Library of Scotland, Edinburgh; the British Library Board; the Trustees of the Royal Society of Painters in Water-Colours, Bankside Gallery; the Society of Antiquaries; Canon John King; C.R. Cooke. Transcriptions of unpublished material have been generously shared by Jane Baker, Helen Guiterman, John Munday, Marcia Pointon, Richard Prout, Alexander Robertson, Eric Smith and Anthony Spink. Illustrations are reproduced by kind permission of: private collectors; City Museum & Art Gallery, Birmingham; the Wiltshire Archaeological Society, Devizes; the Usher Art Gallery, Lincoln; Thomas Agnew & Sons; the Trustees of the British Museum; Christie's; the Courtauld Institute of Art; the Trustees of the National Maritime Museum; the Trustees of the National Portrait Gallery; Spink & Son; the Trustees of the Tate Gallery; the City Art Galleries, Manchester; the Whitworth Art Gallery, University of Manchester; His Grace the Duke of Norfolk; the Tyne and Wear County Council. Permission both to quote unpublished sources and to reproduce illustrations has been kindly given by: the Trustees of the North Devon Athenaeum, Barnstaple; the Syndics of the Fitzwilliam Museum, Cambridge; the Royal Albert Memorial Museum, Exeter; the City Art Gallery, Leeds; the City Museum & Art Gallery, Plymouth; the Yale Center for British Art, New Haven. The Witt Library, Courtauld Institute, and the photographic library of the Mellon Centre for Studies in British Art, London, brought several Prout works to my attention.

My interest in Samuel Prout dates back to the gift of a drawing of San Marco, Venice from my father. Thirty years later the completion of a book on the artist has depended on the amicable interest over recent months of Charles and Rosalind Gray, James and Elaine Lindsay-German, Bruce and Jenny Taylor, and the tolerant support of my wife and family.

Chronology

1783 Sept. 17. Born at Plymouth to Samuel Prout and Mary Cater

c. **1788** Suffers a severe attack of sunstroke, an accident to which some of his later ailments were attributed

1790s Receives informal drawing lessons from the Revd Dr John Bidlake, the Headmaster of Plymouth Grammar School.
Copies drawings by T.H. Williams

1796 Jan. 26. With B.R. Haydon, a schoolfellow, sketches the wrecked East Indiaman the *Dutton*

1801 Winter visit of John Britton to Plymouth who takes Prout on a tour in Cornwall

1802 Moves to London at Britton's invitation.
Making drawings for the *Beauties of England and Wales*.
Tour in Cornwall and Devon

1803 Introduced to Northcote and by him to Benjamin West who gives Prout a lesson in the principles of light and shade.
Copies sketches for Britton after Hearne, Alexander, Turner, Cotman and Mackenzie.
Exhibits *Bennet's cottage on the Tamar, near Plymouth* at the RA – address 10 Water Street, Bridewell Precinct.
Summer tour in Essex and Cambridgeshire

1804 Lodging with Britton at 21 Wilderness Row, Goswell Street, Clerkenwell.
David Cox said to have been a friend at this time.
July. Tour of Essex for Britton.
Sept.–Oct. Tour of Wiltshire for Britton

1805 Engravings after Prout's drawings appearing in the *Beauties*, Britton's *Architectural Antiquities* and Storer's *Antiquarian and Topographical Cabinet*.
Health breaks down, returns to Plymouth

1806 Tour in Cornwall, Devon and Wiltshire

1808 Returns to London. Address at 35 Poland Street

1809 Teaching at Dr Glennie's School, Dulwich Grove

1810 Exhibiting at the British Institution and the Associated Artists in Water-Colour.
Unsuccessful application for post of drawing master to the Tower Cadets.
Dec. 27. Marriage to Elizabeth Gillespie

1811 Well-established as a supplier of cheap monochrome and watercolour drawings to Palser and Ackermann.
Supplies most of the illustrations for Clarke's *Relics of Antiquity*...
Until 1816 address given as 4 or 7 Brixton Place.
J.D. Harding said to have been a pupil at this time.
Prout has developed an extensive teaching practice in addition to his post at the Dulwich school

1812 *Picturesque Delineations in the Counties of Devon and Cornwall*

1813 *Rudiments of Landscape in Progressive Studies*.
Tour in Wales

1814 Summer tour from Leeds to Edinburgh

1815 First exhibits at the Old Water-Colour Society.
First documented visit to Hastings.
Picturesque Studies of Rustic Scenery

1816 *Studies of Boats and Coastal Scenery* and *Studies of Cottages and Rural Scenery for the use of Young Students*

1817 July. 'I am ordered off immediately to seek the benefit of my native air.'
First published lithograph

1818 (?) Tour to Yorkshire and Scotland

1819 Elected a member of the OWCS.
First continental tour to Paris via Le Havre and Rouen

1820 Exhibits his first Normandy views in the OWCS.
Probable second Normandy tour – to Honfleur and Mont-St-Michel.
A Series of Views of Rural Cottages in the West of England

1821 Tour of the Rhine.
Picturesque Buildings in Normandy
(lithographs)

1822 All 20 exhibits at the OWCS sell on
the first day, including a *Strasbourg* at
35 guineas.
(?) Sketches alongside Bonington at
St-Omer.
Publishes the first *Illustrations of the
Rhine*

1823 Tour to the Rhine, Saxony and
Bavaria

1824 Sells 28 watercolours at the OWCS
for £350, including a *Munich* at 50
guineas.
Exhibits through Arrowsmith at the
Paris Salon alongside Bonington, etc.
Tour to Switzerland and Italy

1825 *Ponte di Rialto, Venice*, his 50-guinea
exhibit at the OWCS

1826 (?) Tour to Normandy and Touraine

1827 *Ponte Rialto* the premium picture, at
60 guineas, at the OWCS.
Possible tour to Venice (if not in
1825) in connection with an
unrealized project for a book

1829 'Painter in Water-Colours in
Ordinary to His Majesty', George
IV.
Tour to Brunswick, Dresden and
Prague.
Commissioned to illustrate the first
Landscape Annual

1830 Elected a Fellow of the Society of
Antiquaries.
Retained to illustrate the second
volume of the *Landscape Annual*

1832 Organizing subscription for his
*Facsimiles of Sketches made in Flanders
and Germany*

1833 *Facsimiles . . .* published.
May. Severe bout of illness.
Nov. At Calais after a visit to Paris
where he sees Boys and Callow

1834 Tour to the Loire but falls ill
between Angers and Paris.
Interiors and Exteriors, 26 lithographic
plates.
Ruskin Senr buys a *Lisieux* at
OWCS

1835 F.G. Moon buys *On the Grand Canal,
Venice* for 50 guineas at the OWCS
and publishes it as a steel engraving.
Moves from 4 Brixton Place, his
address since 1811, to 2 Bedford
Terrace, Clapham Rise

1836 *Hints on Light and Shadow, Composition
etc.*, commissioned by Ackermann for
£250 (published 1838).
Severe illness in the autumn causes
his move from London to Hastings –
6 Caroline Place

1837 'Painter in Ordinary in Water-
Colours' to Queen Victoria.
'Artist to the Dowager Queen
Adelaide' (then residing at St
Leonards).
Moves to 57 Great George Street,
Hastings

1839 *Sketches in France, Switzerland and Italy*.
Long summer tour (? where)

1840 'Painter in Ordinary in Water-
Colours' to Prince Albert.
Henry Gastineau tries to find him a
home in London
Has a *pied-à-terre* at this time at 39
Torrington Place

1841 *Prout's Microcosm*

1844 Move from Hastings back to London
to his final address at 5 De Crespigny
Terrace, Denmark Hill, Camberwell.
Sketches at Home and Abroad published
by A.M. Nattali – a rearranged
reprint of *Interiors*

1845 Visit to Antwerp, Bruges and Brussels
where, with David Roberts and Louis
Haghe, he is presented and dined

1846 Last continental tour, to Brittany
and Normandy.
Praise for Prout in *Modern Painters*,
Vol. 1 (3rd ed.)

1847 Tour in the West Midlands

1849 Ruskin's appreciation of Prout
published in *The Art Journal*

1851 Last exhibits at the OWCS

1852 Feb. 10. Dies a few hours after
attending a Ruskin birthday party.
Buried in West Norwood cemetery

Introduction

PROUT AND THE CRITICS

Samuel Prout's reputation as a watercolour painter, whether judged in critical or financial terms, grew rapidly after his death in 1852, having receded from a previous high point in the mid-1820s.[1] Prices for his water-colours rose from £73 at a sale of 1853 to a staggering £1002 in a sale of 1868.[2] John Ruskin's 'verbose worship' of Prout (rarely, in fact, applied to his watercolours as distinct from his drawings) was first publicized in the third edition of the first volume of *Modern Painters* in 1846.[3] Ruskin illustrated his admiration for the artist most fully in a loan exhibition arranged by him at the Fine Art Society in London in 1879, an exhibition that focused on Prout's pencil sketches made on site, many of them lent to the exhibition by the artist's only son, Samuel Gillespie Prout. On this occasion, a delayed retrospective, the artist shared the room with William Henry Hunt, another of Ruskin's favourites. This exhibition, and the sale in 1880 of most of the best drawings that had been retained in the family, brought Prout's drawings and sketches before the public for the first time since the studio contents sale of 1852.[4] However, neither the sale nor Ruskin's Fine Art Society exhibition changed the prevailing view of Prout. It was as one of the outstanding exponents of the British school of watercolour painting that he accordingly appeared at the Manchester Jubilee Exhibition of 1887, when his exhibits outnumbered all but David Cox, Copley Fielding, William Henry Hunt, Edwin Landseer, G.F. Watts, J.M.W. Turner and J.E. Millais.

According to Frederick Wedmore, however, reviewing Ruskin's Prout/Hunt exhibition, Ruskin's elevated view of Prout's abilities was already out of step with the prevailing tide of critical opinion;[5] the Manchester selectors were perhaps reflecting a more popular taste. Certainly Prout's reputation fell rapidly after the turn of the century; A.J. Finberg wrote disparagingly in 1919, 'Compared with Cotman, Prout is mortal, and bound rather heavily with the shackles of time and circumstance. His work was always in the mode of his day, and as fashions change his work appears old-fashioned.'[6] Cyril Bunt omitted Prout from among his *Little Masters of English Landscape* (1949) and Iolo Williams treats him as 'a footnote'.[7] The proper critical balance is re-established within the strong historical context of T.S.R. Boase's *English Art 1800–1870*: 'Ruskin admired him immensely and he has suffered from his overpraise, but he was a great popularizer; his vision of romantic Europe strongly affected the English mental image of the Continent and few have rendered so effectively the texture of elaborate stonework.'[8] Similarly, within the larger canvas of Martin Hardie's three volumes on watercolour painting (1967/8), Prout's presence is again

marked.[9] More recently (1977), Andrew Wilton has given Prout considera-
tion, particularly in relation to Bonington.[10]

There are a number of good reasons why Samuel Prout should have
declined in critical esteem and why he is not among the 'rediscovered' such
as Bonington, Cotman, Shotter Boys, or Linnell. The literature on the
British school is still essentially about watercolour painting; drawing, which
is undoubtedly Prout's strong point, is treated incidentally except within
the monograph or exhibition. Critics irritated by Ruskin's prejudices have
not always re-examined the raw material that provoked his enthusiasm.
So, Ruskin's effort as an exhibition organizer was not repeated for Prout
until 1951, at Plymouth, when he received his only one-man show. Here
it was possible to consider Prout in the round and to see something of his
earliest work which still remains virtually unknown. Unfortunately the
catalogue of that exhibition, which is unillustrated, is unduly modest.

BIOGRAPHICAL SOURCES

The organizers of the Plymouth exhibition gathered together some impor-
tant unpublished material, but this, being only faintly reflected in the
catalogue, has proved ephemeral. The paucity of biographical information
about Samuel Prout is another reason why critics of British art have grown
bored with him; so much of the literature merely repeats the information
to be gleaned from Ruskin in the *Art Journal* of 1849[11] or from John Britton
in *The Builder* of 1852.[12] Ruskin was primarily interested in Prout's coinci-
dental achievement, recording vanishing corners of European cities,[13] while
Britton's interest clearly wanes after the early years when Prout was in his
employ. The edition of Ruskin's *Notes on Samuel Prout and William Hunt*
containing autotype facsimiles of Prout drawings of the sort of which Rus-
kin never tired, does not seem to have been, or to be, generally known.[14]

Ruskin's exhibition may have stimulated J. Hine to publish new infor-
mation gathered from the artist's daughter Isabella Anne Prout and from
correspondence between the artist and three Plymouth families, the East-
lakes, the Opies and the Johnses. Prout's widow was in fact still alive but
no one seems to have asked her to reminisce. J.J. Jenkins of the Old
Water-Colour Society had already failed to squeeze much information out
of Samuel Gillespie: 'I am afraid I can offer you no information respecting
the life and professional practice of my dear father, which could be of
service to you, in compiling your projected work upon Water Colour Paint-
ing.'[15] He did in fact have many relevant family papers. J.L. Roget, who
in 1891 published the book planned by Jenkins, had to rely on the records
of the OWCS itself. From these he provided the essential account of Prout

as an annual contributor to the Society's exhibitions from 1815 to 1851. Apart from C.E. Hughes' valuable attempt to reconstruct Prout's continental tours from the same information (the catalogues of the Society's exhibitions), there has been no significant addition to Prout's biography as inherited from the nineteenth century.[16] The cataloguing of individual collections of British watercolours, however, has stimulated research into particular Prout watercolours and drawings.[17]

Other sources that can be used to enlarge the artist's biography are collections of letters at the British Museum, Barnstaple and Cambridge. A major source is the collection of family papers which has passed from Samuel Gillespie Prout to the North Devon Athenaeum, Barnstaple. These papers include account books documenting the artist's clientele (private patron, picture dealer, print publisher), and his financial circumstances over significant stretches of his career. The earliest account book does not start until 1809 and for the period before this some information can be gleaned from drawings made for Britton and now in the Library of the Wiltshire Archaeological Society at Devizes.[18] These can be added to drawings of a similar period now at Plymouth and Exeter. Unfortunately the account books covering the crucial years 1816–24 are missing. These were the years when Prout rose to the top of his profession and was momentarily of considerable significance within the context of British art and of 'the discovery of Europe'. To judge from those that survive, the missing account books would have told us about Prout's most accomplished publication, *Illustrations of the Rhine* (1822–6). They would also provide a full picture of his sales to private clients outside the confines of the OWCS exhibitions. They might not, however, have filled in the gaps in our knowledge of Prout's tours; the surviving account books for 1809–16 and 1824–50 are mysteriously uninformative on this subject.

This was a point on which S.G. Prout relented in his correspondence with Jenkins; editorial additions to the Jenkins Papers will suggest the relative value of his information, and the Chronology includes what can be confirmed from other sources.

My father's first visit to the Continent was in 1819 when he went into Normandy. In 1821 he visited Germany and the Rhine. In 1822 Switzerland [very unlikely]. In 1823 Belgium and the Rhine. In 1824 Italy where he made a lengthened stay. In 1826 Normandy, Touraine and that part of France [possible]. In 1827 again into France [possible]. In 1829. Into Germany (Brunswick and Hanover) [the latter projected only]. 1834. Into Saxony and Bohemia & Brunswick and home thro Holland [all very unlikely]. In 1835 to Paris [possible]. In 1836 My father went to Hastings where he resided until the year 1844 – when he returned to Town. In the following year he visited Belgium and in

1846 – Normandy which was my dear Father's last tour.

Some biographical information can be extracted from the drawings them-
selves, particularly from the earliest years. However, it was not Prout's
practice at any stage in his career to help art historians by dating his
sketches or finished works. He only puts the briefest topographical descrip-
tions on his sketches made on site. Marrying up particular watercolours
with entries in the account books is therefore hazardous.

Much more can be made of Prout's numerous contributions to the con-
temporary book trade. There is a regular stream of published sketchbooks
and drawing manuals from 1812–26. Since these employ soft-ground etch-
ing (with or without aquatint and hand-colouring) and then lithograph,
Prout's official or public drawing style and, to a lesser extent, painting
style, can be followed. The argument here, however, will be that in his
working sketches he developed a more sensitive drawing style than can be
deduced from these etchings and lithographs. From the latter it would not
be evident that Prout had developed his characteristic graphic style, asso-
ciated with the continental views, before his first tour abroad in 1819.

MAJOR PUBLIC COLLECTIONS

It is not easy to study Prout as a book illustrator or printmaker since no
single library contains all his published books or engravings. The West
Country Studies Library at Exeter has a large collection of the early views
engraved after Prout for the *Beauties of England and Wales* and the *Antiquarian
and Topographical Cabinet*. The British Museum has a collection of proof
engravings, put together by John Pye, of illustrations in the *Repository of
Arts*. The Plymouth Museum and the Victoria & Albert Museum Print
Room contain many of the soft-ground etchings, and the Print Room
together with the National Art Library contain most of the books of soft-
ground etchings and lithographs. Publication history is complicated, since
engravings were evidently issued separately, often being dated earlier than
the book with which they became associated, and might be used in more
than one publication and even by more than one publisher. The same is
true for Prout's original prints, which came out singly, and were issued in
parts before being published with title page. They could be issued more
than once in book form, i.e. the same plates under different book titles.
The list of publications here is certainly incomplete and invites revision
(Appendix 2). For the topographical books, J.R. Abbey's four volumes
remain the most helpful descriptive literature.[19]

Many British museums and art galleries came into existence at the very
moment that Prout's reputation reached its height and therefore it is not

surprising that his works are to be found in several collections. Sketchbooks apart, the major collections are, in approximate order of size: the National Maritime Museum, Greenwich (150); the North Devon Athenaeum, Barnstaple (125); the Royal Albert Memorial Museum, Exeter (77); the Victoria & Albert Museum, London (75); the Birmingham City Museum and Art Gallery (73); the Fitzwilliam Museum, Cambridge (58); the Plymouth City Museum and Art Gallery (47); the Wiltshire Archaeological Museum, Devizes (46); the Hastings Museum (32); the Ashmolean Museum, Oxford (30); the British Museum, London (26); the Center for British Art, Yale (21); the Manchester City Art Galley (20); the Whitworth Art Gallery, Manchester (19).

The Barnstaple collection represents studio material that survived the 1852 and 1880 sales and other disbursements from the family such as those to Plymouth and Hastings. The Barnstaple collection contains five sketchbooks, one album and one portfolio of drawings. The Victoria & Albert Museum collection is the most representative, having over 70 drawings and watercolours, besides six sketchbooks. Exeter is strong in West Country views because of the John Lane bequest. Lane may have acquired some of these drawings from the Prout family; he certainly consulted Samuel Gillespie Prout about attributions.[20]

The Birmingham collection is representative but owes its importance to J.R. Holliday, who also benefited Newcastle, Cambridge and the Victoria & Albert Museum. It is not known when or where Holliday acquired his hoard of Prout drawings but it is likely to have been after 1905; he died in 1927. Some fine drawings in the Yale collection are (according to Martin Hardie) from a large parcel of Prouts that came to light in 1914, which was the year that both the Victoria & Albert Museum and the Plymouth Museum acquired some fine drawings from G.T. Phillips.

Some of the best drawings, as opposed to watercolours, are those in the Cambridge, British Museum, Courtauld Institute and Yale collections. The two Manchester collections together best represent Prout as a watercolour painter and a few of the City Art Gallery watercolours were purchased by 'guarantors' of the Manchester Jubilee exhibition of 1887.

During his lifetime, as Ruskin impressed on his readers, Prout retained his original sketches. Sketchbooks, as distinct from loose drawings, were not offered in the 1852 sale or in 1880. The latter sale did contain two albums 'containing upwards of three hundred sketches and slight drawings' and 'eighty studies for pictures and drawings'.[21] At least two such albums were put together by the artist's youngest daughter Isabella Anne, and partially survive at Barnstaple and Greenwich. S.G. Prout sold an early

sketchbook to the Victoria & Albert Museum in 1902 (**6**). An important album of 24 copies of tour sketches came to light recently in a private collection. These can be identified as 'copies of sketches' commissioned from the artist by Lord Lansdowne in 1825 at a mere 2 guineas each. They are graphite on white wove and are all of approximately 17 × 11½ in. This is the scale of many drawings in the Prout sales and of those referred to here in the catalogue, although the majority are on tinted paper. The copy sketches are not obviously different from many drawings assumed to have been made on site, a description that may have been used too freely.

Character of the Artist

Since a description of the artist's career may not reveal his personality, some attempt will be made here to define it. Prout's character was dominated by two factors: his religiosity and his almost continuous ill health. The first may be related to his family background, which was that of non-conformist shopkeepers attached to the Old Tabernacle in Plymouth, where Samuel, a fourth child, was baptized.[22] A younger son, Ebenezer, became a Congregational minister; he was the father of the once-celebrated musical professor and composer of the same name. Samuel's elder brother John, the father of John Skinner Prout, went into the music business. Samuel, according to his daughter Isabella, was a self-taught organist and flautist. At an early age he would slip away to play the organ in the parish church of St Andrew's at Plymouth, and this may have been the start of his migration to the Established Church, of which he became a stalwart member. He was married as an Anglican, and his children were brought up likewise.[23]

> 'There never', say his children, 'was a brighter or happier Christian.' When at Hastings his parish church was St Mary's (where, by-the-by, in the Sacrarium Prout's arrangement of colour is still kept up). He regularly went to that church, and the vicar (the Rev. Mr Vores) used to say, 'I always wait for Prout to come in *to light up my church*.' He loved simple and sincere piety wherever he saw it, and he witnessed very many expressions of it. In the picturesque streets on the Continent, at the sound of the Angelus, at the passing of the Host, at the statue of the Madonna, his emotion was touched (and to some extent his sympathy) by the unaffected homage of the poor peasants and children; but abroad or at home, in his hotel or in his studio, his constant companions were his English Bible and Prayer Book; and with them *he* was *satisfied*.[24]

Two details might be added to this retrospective view. Prout wrote to his friend David Roberts in 1844:

> I am pleased that you did not travel *round about* yesterday to Brixton. The heat was Egyptian, and the sandy-road shadeless. Besides – it is a church going day,

and though always thankful and happy to see old friends, yet, when a brother artist calls I am unhappy unless I can talk – *the shop* which is always shut on Sunday.[25]

Other letters illustrate his 'emotion' and 'sympathy' towards Roman Catholicism. Writing from Calais to Dominic Colnaghi in Paris in November 1833 he says: 'I meant to have purchased Granet's Interiors (I believe Lithography) also to have bought up all the Priests, processions & all creatures & things belonging to the R. Catholic faith. If you should meet with any odds & ends of this description, which I can stick onto my churches...'[26] Writing home to his daughter from Rome in December 1824: 'I am in such a hurly burly all day in seeing sights & paying visits that when I return to my room my ideas are rooks asleep before I put on my night-cap.'[27] A disapproving description of contemporary Roman funeral customs then leads into a small sermon: 'Oh, my dear detter, sometimes think of death.' He attributes Roman belief in legends to the fact that the people were not allowed Bibles. Writing home from Bamberg in August 1829, Prout is much more enthusiastic: 'Here everybody goes to church ... I love strange things, & I thought it *delightful: – religious electricity.* They are R. Catholics but the Germans have fewer ceremonies, fewer priests; are regular in their attendance, clean in their persons, with every appearance of sincere devotion. Oh that they were better taught!' Then follows another sermon.[28] To judge from the handful of books from Prout's library that survive at Barnstaple, this supporter of the Religious Tract Society had a liking for seventeenth-century divines.

Prout's health, or rather lack of it, is a *leitmotiv* that runs throughout his life. Whatever the cause, he was driven back to Plymouth from London in 1805 and was away three years. Early in his life his principal malaise was 'bad head ache, very bad indeed' and 'violent rheumatic headache', to quote his sufferings on a summer tour to the north-east in 1814. Today we should perhaps say that he suffered from migraine. By 1817 his other and lasting malady had developed: 'a confirmed diseased expectoration from my lungs'. When Prout met up with Thomas Uwins in Rome in 1824, the latter observed to his medical brother, 'He seems to have been the round of doctors without much benefit.'[29] Ten years later Prout wrote to the Secretary of the Athenaeum, who was helping to promote his recently published *Facsimiles of Sketches made in Flanders and Germany*:

Thank God I am at home and in a sad crippled state. Between Paris and Angers I lost all the little stock of health I had gained at Hastings, & it was with much difficulty and the utmost efforts I retraced my steps to the french capital, where I laid up, in repair, for three weeks. Since my return I have seen an M D: who

has frankly acknowledged that appearances and symptoms too evidently point out the malady. Today I have submitted to give a good drink of blood to a set of black wretches yclept Leeches. I passed the Athenaeum this morning, but I had not breath enough to speak, and my guardian daughter would not let me get out of the fly.[30]

Just over a year later, in August 1835, the watercolour painter Edward Webb called on him and found him 'very poorly, spitting blood'.[31] It was a year later still, 'having lately had another alarming attack of hemorrhage', that Prout removed from Brixton to Hastings.[32] Someone less familiar with medical talk might have used the term consumption, i.e. tuberculosis.

The removal from London to Hastings had social as well as professional implications. Certainly in the 1820s Prout was on terms of some familiarity with several members of the aristocracy who were then buying his watercolours, supporting his publications and eager to employ him to teach their children. Although there is no indication in the correspondence that Mrs Prout was equally entertained, Prout himself was invited to dine and even to stay. The Newcastles, Staffords, Northwicks and Bedfords were particularly friendly. Prout was also on easy terms with a few significant patrons of lower social rank such as Broderip and Allnutt. His relationship with some members of the publishing world was also close, for example with the Ackermanns. He went to parties given by Thomas Boys and George Cooke. It was probably in the 1820s that Chantrey, who at that time was undoubtedly a close friend, attempted to boost Prout's career:

I did not forget to send your sketches. Turner was not in town & Jones was ill and Thomson was ill and therefore I could not make the party I intended. I am anxious that the good men of the R A should be better acquainted with your talent and I know of no better way than quietly to lay your sketches before them unexpected and when they are themselves in good humour.[33]

This was to be a private party but Prout also, no doubt, attended Ackermann's soirées, conversaziones, and the Graphic – regular social gatherings of artists and amateurs. He certainly attended the Artists' Conversazione from 1828 to 1833 but only made two isolated attendances thereafter.[34]

The removal to Hastings must have reduced Prout's opportunities to mix with patrons and artists and there is no doubt that he was anxious to return to London. He says pathetically to J.H. Maw, 'Your residence at Hastings greatly quieted my restlessness to remove, as I had found in you what no other person in the town could give.'[35] Maw offered Prout and his family society, a collection of works by contemporary artists, and discussions on artistic principles and techniques. Nevertheless Prout evidently

hoped to return to London in 1840. This is made clear by a letter from Henry Gastineau dated April 17: 'I write for the purpose of telling you that a friend of mine is just going to leave his house situated at the top of Denmark Hill; he is at present uncertain how soon he can vacate it, but at the very latest he must do so at Christmas. It would afford, I think, just the accommodation you require ...'[36] In 1844 W. Collingwood, who was friendly with Prout in Hastings, wrote to say how pleased he was to hear that Prout was moving back to London to 'scenes and society so much more congenial'. Even in 1851, when Prout must surely have realized that he was at the end of his career, the prospect of returning to Hastings was alarming:

> My medical advisers urge the importance of my *residing* at the sea-side, and eventually I expect this will take place, and I am sorry to say, it will be necessary for the sake of *economy*, as continued ill health has reduced my income. I have hesitated, fearing the distance from London might interfere with professional advantages.[37]

The surviving correspondence is dominated by commiserations about his ill health as well as his own explanations of why he is unable to fulfil commissions in the agreed time. There is no doubt that ill health severely hampered Prout's career from the later 1820s onwards, interfering with his publication of the *Facsimiles* and delaying until 1839 the planned second volume, originally intended as 'Sketches from Geneva to Rome including Venice', which, under pressure from the publishers, became *Sketches made in France, Switzerland and Italy*. This was a more general and less imaginative exercise. During the 1840s there were weeks together when he was incapable of work. In April 1848 he told J.C. Grundy, who retailed his work in Manchester, that he had only managed to complete seven watercolours since the autumn.[38] Prout's ill health was very real and his acquaintances admired the cheerful stoicism with which he bore it.

Perhaps in connection with Ruskin's article published by S.C. Hall in the *Art Journal*, Hall wrote to Prout. After thanking him for a 'generous and liberal gift to the Hospital', he asks for a portrait: 'How shall I get yours? When last I saw you (at the meeting at Willis' Rooms) you were looking exceedingly well – so well as to contradict the suffering with which it has pleased God to inflict you. Your pleasant expression & kindly face is all I want a copy of.'[39] Hall added as an editorial note to Ruskin's article of 1849:

> His always delicate health, instead of, as it usually does, souring the temper, has made him more considerate and thoughtful of the troubles and trials of others; ever ready to assist the young by the counsels of experience, he is a fine example

of upright perseverance and indefatigable industry, combined with suavity of manners and those endearing attributes of character which invariably blend with admiration of the artist, affection for the man.

Samuel Prout, in a letter to Ruskin at Christmas 1848, explained that he 'had been favoured with assistance to persevere in living hope, and with a lively temperament'.[40]

NOTES

1. Sotheby & Wilkinson, 19–22.5.1852. Some 2900 drawings (there were only a handful of watercolours) sold for £1788, averaging 10 shillings. A drawing 'highly finished and heightened with white' (18 × 16 in) from the last foreign tour of 1846 fetched £15 10s., and the highest-priced watercolour, also of *St Pierre, Caen*, sold at £12 15s. The most expensive lot was Prout's subscription copy of Turner's *Liber Studiorum* at £65.
2. A. Graves, *Art Sales*, 2, 1921, 352/3.
3. Works, III, 194, 217–9.
4. Christie, Manson & Woods, 12.4.1880.
5. 'The aesthetics of the day can find little to like in these sincere and unambitious masters.' F. Wedmore, *Studies in English Art*, 2nd Series, 1880, 157, reviewing Ruskin's Fine Art Society exhibition and *Notes*.
6. A.J. Finberg, 'Early English Water-Colour Drawings', *The Studio*, 1919, 28.
7. I.A. Williams, *Early English Watercolours*, 1952, 182, saying of **51**: 'Personally, I dislike this sort of drawing very much.'
8. Oxford, 1959, 49–50.
9. Hardie, III, *The Victorian Period*, 1968, Ch. 1. Foreign Travel: Architectural Draughtsmen.
10. *British Watercolours 1750–1850*, 1977, 45/6 & 193.
11. March 1849, 76.
12. X, 1852, 339.
13. 'He was sent to preserve, in an almost innumerable series of drawings . . . the aspect borne at the beginning of the nineteenth century, by cities which, in a few years more, rekindled wars or unexpected prosperities, were to ravage, or renovate, into nothingness.' Works, XII, 362 (*Pre-Raphaelitism*, 1851).
14. Fifth edition, 1880, 3: 'Subscribers to the Illustrated Edition of the Turner Notes will, it is trusted, forgive the want of uniformity of size between the two volumes, it being found that the larger sheet now used shows to much greater advantage the delicate pencillings of Mr Prout.' The various editions are listed in Works, XIV, 369/70.
15. Royal Society of Painters in Water-Colours, Bankside Gallery, Jenkins Papers.
16. Hughes, *OWCS*, VI, 1929, 11/12.
17. See, e.g., W. Bradford, *Turner, Prout, Steer,* Courtauld Institute, London, 1980; E. Morris, *English Drawings and Watercolours,* Liverpool, Walker Art Gallery, 1968; D. Scrase, *Samuel Prout and David Cox: A Bicentenary Exhibition from the Museum's Collections*, Fitzwilliam Museum, Cambridge, 1983/4.
18. Albums A,B,F,H(1),J,K,N. The drawings in A and F have inv. nos.
19. In particular *Life in England 1770–1860*, 1952 & 1972 and *Travel*, 1, World, Europe, Africa, 1956 & 1972.
20. BL Add. Mss. 42523, f. 95.
21. Lots 69, 70.
22. Devon Record Office, Exeter.
23. Much work on the Prout family tree has been done by Richard Prout, a descendant of John Skinner Prout, and this information has been generously made available to the author.
24. Hine, 281.
25. c. Aug. 30, 1844. Yale Center for British Art, Bicknell Album.
26. BL Add. Mss. 42523, f. 23. Nov. 1833.
27. Ibid. f. 5.
28. Ibid. f. 13.
29. Hughes, *OWCS*, 12.
30. BL Add. Mss. 42523, f. 28. To E. Magrath, Secretary of the Athenaeum.
31. Unpublished diaries of Edward Webb. Quoted by kind permission of Canon John King. I owe this reference to E.E. Smith.
32. BL Add. Mss. 42523, f. 38.
33. 11 Dec. Transcription at Plymouth Museum.
34. Artists' Conversazione Attendance Book, 1825–37, Leeds City Art Gallery, presented by Misses E. and E.M. Lupton. Information kindly supplied by Alexander Robertson.
35. BL Add. Mss. 45883, f. 40. John Hornby Maw, surgical instrument manufacturer. For his friendship with Hunt see T. Jones, *William Henry Hunt 1790–1864,* Wolverhampton Art Gallery, 1981.
36. Transcription at Plymouth Museum.
37. Roe, 48.
38. John Clowes Grundy (1806–1867). Grundy & Roe, 176.
39. 11 March. Transcription at Plymouth Museum.
40. Works, XXXV, 630.

I Early years: 1800–1810

Samuel Prout was the fourth of fourteen children born to Samuel Prout senior, a naval outfitter in the dockyard city of Plymouth, and Mary Cater, the daughter of a 'shipping venturer'.[1] Samuel junior married Elizabeth Gillespie, whose father, Captain Gillespie, apparently had a large share of the Bahamas' trade. They did not benefit from his wealth but some family links existed, since Elizabeth's brother S.P. Gillespie wrote to J.C. Grundy in Manchester to convey the news of Prout's death in 1852. Samuel and Elizabeth had four children, all born in London, where they were married in 1810. Rebecca Elizabeth, the eldest Miss Prout, was born in 1813 and baptized in the parish church of Lambeth. Elizabeth Delsey was born in 1817, Isabella Anne in 1820 and Samuel Gillespie in 1822. Since Samuel Prout's will, proved in 1852, was made in 1811, it offers no information about his children, and most of the few glimpses of them belong to the Hastings years. They were still living with their parents in the early 1840s and their small allowances figure in Mrs Prout's household accounts.

Prout's education at the grammar school in Plymouth was helpful to his later career as an artist. The headmaster, Dr John Bidlake, was an amateur artist who encouraged both Samuel Prout and Benjamin Robert Haydon.[2] The wreck of the East Indiaman, the *Dutton*, in 1798 provided them both with a Romantic subject, some reflection of which we might see in Prout's more ambitious 'marines'. Both Prout and Haydon had an introduction to their fellow Devonian James Northcote when they reached London and it was through Northcote, if not through John Britton, that Prout got to meet Benjamin West, who gave him lessons in light and shadow. The crucial event in Prout's early career was, however, his meeting with Britton, at the very end of 1801, in the reading room of the bookshop run by Haydon's father. Such reading rooms were humble philosophical societies.

> In the reading-room of Mr Haydon, I met his son Benjamin, who afterwards became eminent in art and literature; Master Howard Nathaniel, a *protégé* of the good divine's [Bidlake], who published a very clever translation of Dante's 'Inferno' into blank verse; and Samuel Prout, then a youth of about seventeen. This party, with Mr Williams, a professional artist, interested me in an extraordinary manner, for the master and his pupils seemed imbued with one feeling – one ruling passion – a love of literature and of art.[3]

Mr Williams was Thomas Hewett Williams, a professional artist who anticipated the young Prout's cottage scenery and whose sketches Prout was given to copy, a fact of which he was reminded by his friend Ambrose Boyden Johns in 1830.

William Payne was resident in Plymouth at this time but did not apparently come into contact with these young artists. Prout's watercolours

circa 1805, such as the finished example in the Victoria & Albert collection (**5**), might suggest that he was aware of the work of Francis Towne, then living at Exeter. There is no evidence of this, but Towne's one-man exhibition in London in early 1805, was held before Prout was driven back to Plymouth by ill health.

According to Britton's account of Prout's beginnings, the seventeen-year-old artist had not progressed far enough by 1801 to manage the architectural subjects that were needed for the *Beauties of England and Wales*. Britton describes a Cornish sketching tour in some detail and Prout's mortification at failing the test. However, 'On proceeding further, we had occasion to visit certain Druidical monuments, vast rocks, monastic wells, and stone crosses on the moors north of Liskeard. Some of these objects my young friend delineated with smartness and tolerable accuracy.'

By 1805, Prout's lack of self-confidence had been replaced by a boyish enthusiasm that is revealed in his letters as well as in his sketches from nature such as *Denham Bridge* (**4**). Prout wrote to Britton in 1805:

> Dear Sir, – I am just returned after a months visit to the Dartmoors. I feel much strength from the influence of its pure air, and little Prout stands as firm as a Lion. My object has not been so much to make sketches as to find health. She lives on the highest torrs. I have her blessing. The subjects in my portfolio are generally rock-scenery, most of them colord and highly finished from nature. In my excursions on the moor from Torr-royal I saw several stone crosses, but most of them very plain. Piles of stone, very like cromlechs, but probably only known to the tinners or shepherds for shelter. I must not omit the mention of one days adventure in particular: A gentleman and myself, in spite of every remonstrance took horses to explore some parts of the moor, which is destitute of any habitation. To the surprize of many, our resolution carried us over its dangers and difficulties for twelve miles, not a trace of any road or footstep. I cannot describe the scenery as it impressed my mind. Masses of rock (to which the Cheezewring is a pebble) crowning every hill and broken in the valley, like the desolated ruins of an extensive city [colour pl. I] – bogs two and three miles in width – angry rivers foaming over broken paths of rock, awfully grand of itself, but as a whole more so from the terrific and savage wilderness of its hills and vales ... Unexpectedly we saw a very curious druidical circle (a proof with the crosses that Dartmoor was once at least partially inhabited, and might be known to the ancient-Brittons). I had not time to sketch, but it was double, each circle of about thirty stones, most of which were standing, and of the same proportion as the Hurlers.[4]

Prehistoric monuments (cromlechs) (colour pl. II), standing stones, or hanging boulders in the moorland landscape of the south-west of England, gave Prout his first specialism.[5] Britton, his first patron, devoted much energy and money to recording and theorizing about prehistoric monu-

ments, and the extent of Prout's involvement in this enterprise cannot be appreciated from the steel engravings of the *Beauties* alone. It is among Britton's papers at the Wiltshire Archaeological Society in Devizes that the intimate connection between Prout's early style and subject matter and that of his patron must be seen. Here drawings of the same subjects by Britton himself or commissioned by him from Prout, J.C. Smith, Frederick Nash, T.R. Underwood, F. Mackenzie and G. Shepherd, are found side by side. They are frequently indistinguishable.

The early drawings are in pencil, sometimes with the simplest of washes. Prout already uses a broken-line technique as in his mature graphic style associated with the 1820s.[6] In the first decade of the nineteenth century his debts are to an eighteenth-century tradition. Like Smith, Nash, Bartlett, and Mackenzie, Prout looks above all to Thomas Hearne. Hearne, more than any other member of the British watercolour school, had anticipated (with his *Antiquities of Great Britain*)[7] Britton's publications such as the *Architectural Antiquities* and *Cathedral Antiquities of Great Britain*.[8] Prout developed his earliest manner in the Britton school, a more specialized and prosaic parallel to the Monro school. Britton says that *circa* 1803 he employed Prout to copy sketches by Hearne, Alexander, Turner, Cotman, Mackenzie and others. If so, Prout learnt most from Hearne, Alexander and Mackenzie at this date.

Britton required illustrations of antiquarian subjects and country seats which could be translated into steel engravings. This translation was occasionally done by one of the originating artists, in particular by J.C. Smith.[9] Prout's drawings are otherwise translated by Storer, Woolnoth, Grieg and at least ten others, including Miss Hawksworth. Britton commissioned many more drawings than he was allowed to publish. His books concentrated upon the grander monuments; the wealth of graphic information that he collected on Wiltshire churches such as Devizes or Malmesbury was never exploited. As a result Prout is known (to those familiar with the *Beauties*, or the *Antiquarian and Topographical Cabinet*) as the author of some picturesque views of churches, monuments or prehistoric monuments, all in the form of miniature engravings. He is not known as a competent antiquarian draughtsman working in the same field as Nash, Mackenzie and Cotman. Drawings of Dunstable Priory (**1, 2**), or Malmesbury Abbey (colour pl. III), are highly informative from an antiquarian point of view and are devoid of misleading mannerisms.[10] There are several other drawings in the Devizes collection comparable to *Denham Bridge* (**4**) which are successful within the criteria of the picturesque and, had they been taken beyond the pencilled stage, could have been watercolours in

the manner of Alexander, Hearne or Webber. That the antiquarian details are not developed into architectural drawings as comparable to Nash, Mackenzie and Cotman, should be put down to lack of opportunity rather than to lack of ability on the evidence of the Devizes drawings. Because Britton preferred to use a team of artists for undefined and, in the event, unrealized antiquarian projects, Prout was never set the challenge of illustrating a complete monument, one of the cathedrals for instance, on his own.[11] More would be known of Prout as an antiquarian illustrator had the body of material commissioned by Britton remained together. The 1857 sale catalogue of Britton's library can only be a pointer:

> A Collection of 40 Sketches in pencil of Essex by Prout, Mackenzie, Bartlett and others including 12 of Colchester Castle;
> A Collection of 15 Sketches by Samuel Prout in pencil principally of Cromlechs and Stones at Avebury;
> 7 Lithographic Views of Germany;
> 15 other Engravings after Prout;
> Manuscript Memoranda of Essex, 1804;
> 30 very interesting autograph Letters from Samuel Prout to Mr Britton, chiefly related to the drawings and matters of art;
> 42 Sketches of Suffolk and Sussex by Mackenzie, Prout, Kitten, Bartlett.

This list reveals that Britton's patronage was limited to his own needs as an historian and publisher and did not extend to Prout's later independent achievements; such publications as *Illustrations of the Rhine* are conspicuous by their absence.[12]

Two of these items can be partly reconstructed. For the 15 pencil sketches of cromlechs there survives a small volume of sketches (F) at Devizes titled 'Cromlechs/Druidical Antiquities/Celtic Temples' in which there are 11 drawings attributed by Britton to Prout. A few are in pencil and hence show directly the appearance of the lost 15 while the majority, which are in a grey-to-blue wash, exemplify the subject matter (colour pl. II). The majority are described as by 'S. Prout from J.B.' and, of the remainder simply attributed to Prout, some if not all are also probably fair copies. It is not clear whether the dates, ranging from 1800 to 1810, refer to the date of originals or copies, but the former is the more likely. The volume contains an equal number of sketches or wash drawings by Britton and a further three by Nash and Underwood.

The other sale item that can be partially recalled is 'a small marble covered notebook', labelled '*Essex*. Memr. S. Prout July 1804'. This records a straightforward antiquarian tour during which the artist made extensive historical notes of monumental inscriptions as well as of architectural details.

To some of the villages the young Prout of twenty may have proceeded on foot, but in other cases a coach was chartered. Distances are always carefully put down – in all 58 miles – also the total expenses, amounting to £3. 5s. 5d. A few sketches are interspersed and the handwriting is neat … Spelling and choice of words are good, but Prout's Latin was far to seek.[13]

There are a few antiquarian notes with the drawings at Devizes.

Prout's sketch tours in the earliest years were almost certainly dictated by Britton's commissions – 1801, Cornwall; 1802, Cornwall and Devon; 1803, Essex and Cambridgeshire; 1804, Essex and Wiltshire; 1805, Devon; 1806, Cornwall, Devon and Wiltshire. Prout's copies after drawings by Britton are most likely to date from 1802–5 when the artist lodged with the antiquarian publisher. For the next three years, after ill health drove him back to Devon, Prout supplied Britton with illustrations for the *Beauties*, illustrations which did not necessarily appear in their engraved form for several years, if at all. The sketchbook filled with neat coastal scenes in Cornwall (**3**) is most likely to belong to those years also.

The most distinctive watercolours are of Plymouth itself, and there are several examples in the Plymouth and Exeter collections. These watercolours have the look of studies in the handling of dark and light rather than of anything more creatively independent as in the contemporary work of John Sell Cotman or Cornelius Varley. One of the best of them, because of its subject, is a drawing dated 'June 3rd 1807' which shows the building of Dartmoor Prison (fig. 1). This is one of a series of drawings made on successive days.[14] A finished watercolour in the same style is *Estuary scene* (**5**).[15] A more picturesque essay of the same period, in the Fitzwilliam, is a village scene, *Broadwater* (colour pl. IV) which is reminiscent of Rowlandson, an artist who often, if surprisingly, comes to mind in relation to Prout watercolours of c. 1810.[16] Even 20 or 30 years later, in the background streets of Prout's continental town views, Rowlandson is not far away.

A first period therefore can be reconstructed for Prout, one that took him from his late teens when he was 'discovered' by Britton in Plymouth and effectively moved by him to London as part of a team of antiquarian illustrators. Britton's interest in druidical monuments, and a taste for cottage picturesque perhaps learnt from Williams, become two Prout specialities. The former is developed into some accomplished and charming monochrome watercolours, eighteenth-century in feeling. The latter becomes a definite market line which Prout exploited through the printsellers and in London exhibitions until about 1820.

It should not be forgotten that by 1810, despite the hiccup caused by his return to Plymouth 1805–8, Prout had succeeded in gaining access to the

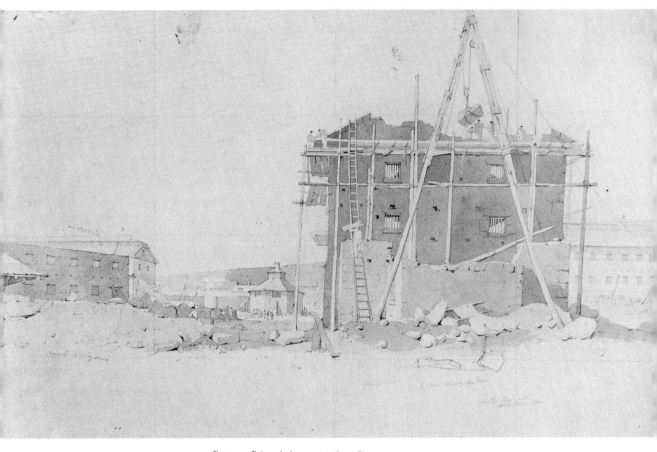

FIG. 1 *Dartmoor Prison during construction*, 1807
Plymouth City Museum and Art Gallery

major exhibition venues in London. He appeared at the Royal Academy immediately, in 1803–5 and again 1808–10, and at the British Institution from 1809–11.[17] At this stage of his career, before exhibiting with the Associated Artists in Water-Colour in 1810 and the Society of Painters in Water-Colours in 1815, Prout aspired to be an oil painter.[18] His *Watermill and manor near Plymouth*, shown at the British Institution in 1809, was 4 ft 10 in × 5 ft 7 in.

No attempt will be made in this work to assess the artist as an oil painter, and notice is restricted here to only a handful of pictures. There are two miniature shore scenes attributed to him at Exeter.[19] These are highly finished with the look of seventeenth-century Dutch paintings on copper and, although they look unutterably dull in black and white reproduction, are rather successful if viewed as imitations of Dutch landscape rather than as shore scenes painted *c*. 1810 when British artists were discovering the

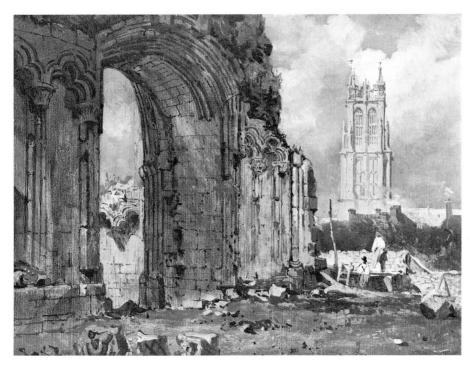

FIG. 2 *Chapel of Joseph of Arimathea, Glastonbury* (oil)
Tate Gallery

potential of their own shores. There is a portrait said to be of John Prout (Samuel's elder brother and father of John Skinner Prout) at Plymouth, where also is the view of *Plympton Grammar School*. This composition, quite eighteenth-century in feeling, was engraved for use as an illustration in James Northcote's *Life of Reynolds* in 1813. A much more individual effort is the *Chapel of Joseph of Arimathea, Glastonbury* (fig. 2) in the Tate Gallery, which should be dated *c.* 1818.[20] There are two small canvases at Barnstaple of (?) Alpine subjects which have not progressed beyond the stage of clearly defined outlines in pen on a prepared ground.

Prout did not abandon oil painting entirely in 1815 when he became a regular watercolour exhibitor, continuing to exhibit oils at the British Institution until 1818. Two oils (*Hastings boats*, and *Willows*) appear in the account book in 1816. He sold a *Bridge of Sighs, Venice* to Charles Holford for 15 guineas in 1825 and a *Doge's Palace, Venice* to J. Olive in 1826 for the remarkable sum of 100 guineas. The last mention of oils in the account book is in 1836. There are eight oil paintings in the 1880 sale, including a *Glastonbury* which might be the painting now in the Tate Gallery.[21] This could be the picture that Prout valued enough to deny it to his friend and

patron J.H. Maw in 1827.[22] Prout owned a few landscape oils by other artists, mostly marines and mostly seventeenth-century Dutch or eighteenth-century Italian (Canaletto, Guardi), if the attributions are to be believed.[23]

NOTES

1. These trade descriptions are taken from Plymouth, 1971, and Baring-Gould, 160.
2. Rev. John Bidlake, DD (1756-1814). A mezzotint portrait of him by Charles Turner after Charles Eastlake was published in 1813 – Plymouth, 1971 (62).
3. 7 Dec. 1830. Letter to Prout from A.B. Johns. Transcription at Plymouth Museum. T.H. Williams (fl. 1798-1830) published *Picturesque Excursions in Devon and Cornwall*, 1815, in partnership with Johns' bookseller father J.H. Johns. Williams also published *Outlines, the Subjects from the Scenery of Devon*, Exeter, 1812 (6 etchings).
4. Roget, 1, 348. See colour pl. I: *Maen Rock*, graphite and brown wash on cream wove, $12\frac{1}{4} \times 17\frac{1}{8}$ in (Barnstaple, N. Devon Athenaeum).
5. *Cors-y-Gendel near Barmouth, N. Wales/Prout after J.B. 1800*, graphite and watercolour, $7\frac{1}{4} \times 9\frac{1}{4}$ in (Devizes WAS, Album F. f. 13, 1982. 3236).
6. That this was a common graphic technique used by Turner, Girtin, Rooker, Hearne, Edridge and Cotman and one to be traced back to Canaletto, has been pointed out by Hughes, 75/6; Howgego, 3 (who adds Farington); Hardie, III, 7 ff.
7. T. Hearne & W. Byrne, 2 vols., 1807. Published in folio with a French as well as English text. In date this hardly preceded Britton but Hearne's illustrations were made many years earlier, e.g. drawings of Malmesbury Abbey comparable to (**1**) and (**2**) and to Prout's Malmesbury drawings at Devizes (colour pl. III) were made by Hearne in 1781.
8. *Architectural Antiquities of Great Britain*, 4 vols., 1807-18 and *Cathedral Antiquities of Great Britain*, 14 vols., 1814-35.
9. Joseph Clarendon Smith (1778-1810).
10. *Malmesbury Abbey nave, interior*, graphite and watercolour on cream wove (Devizes, WAS, Album H (1), f. 88).
11. His most extensive published series of drawings for one monument is in the *Antiquarian and Topographical Cabinet*, eight engravings of St Cross, Winchester, dated 1808.
12. Sotheby & Wilkinson, 4-8.5.1857.
13. *Essex Review*, 100. In 1928 this belonged to John Avery.
14. *Dartmoor Prison during construction*, graphite and wash, $10\frac{1}{2} \times 16\frac{1}{2}$ in, ins: June 3rd 1807. (Plymouth MAG, 1908.279, acquired from John Lane.) Exhib: Plymouth, 1971 (52).
15. Other examples of this finished watercolour style are: (?) *Launceston Castle* (Plymouth 37.69); *South Zeal, Devon* (Fitzwilliam Mus., Cambridge 3260) dated 1806, Scrase, 4; and *Babincomb near Teignmouth . . .* (Ashmolean Mus., Oxford, P. Barnard Gift).
16. Fitzwilliam Mus., Cambridge, 1408, $7 \times 9\frac{1}{2}$ in. If the identification (a later ins. on back of mount) and the relatively early date proposed here are acceptable, then a south-coast tour *c.* 1808-11 is necessary. Prout's illus. for Britton's Sussex *Beauties* were published in 1814.
17. A. Graves, *The Royal Academy of Arts . . . 1769-1904*, VI, 1906, 212; *The British Institution, 1806-1867*, 1869, 439.
18. Roget, I, 350. Prout exhibited 30 works at the Associated Artists 1810-12 (Devon and Kent subjects) and 28 works at the abortive series of exhibitions at Bond Street after the break-up of both watercolour societies in 1812. A nearly complete list of Prout's exhibits at the RA and OWCS is given by Hughes, *OWCS*, 23-30. See also Appendix 3.
19. 60.1953, 1 and 2.
20. Tate 3430, oil on wood, $12 \times 15\frac{1}{2}$ in.
21. Lot 130.
22. BL Add. Mss. 45883, f. 39.
23. There are several references in Prout's correspondence to his admiration for Canaletto and he took up opportunities to see those works at Woburn and Windsor. A graphite and stump drawing at Windsor (RL 17722) is ins. by Prout 'after Canlt'; however, this does not document the influence of Canaletto on Prout's graphic style, no doubt because the latter was copying a painting and because he was not using a reed pen. There are pen drawings by Prout imitating Van de Velde drawings at Greenwich.

II Establishing a career in London: 1810–20

From 1809 to 1816 Prout's career is less shadowy due to a surviving account book. The artist can be observed building up his financial position from four sources: a teaching post at Dr Glennie's school in Dulwich; peripatetic teaching to about 30 private pupils scattered around London (Greenwich, Wandsworth, Lambeth, Clapham, the City, St James's, Whitehall, Grosvenor Square); the supply of sketchbooks and drawing manuals to the print trade; the sale of watercolours and a few oils through the dealers or direct to the public through exhibitions.

Prout taught privately for seven shillings to a guinea a lesson and by 1813 was making about £60 a year by this means. His salary at Dulwich Grove rose from £50 in 1809 to £150 in 1815.[1] Prout taught at least six members of the Glennie family including the Revd J.D. Glennie and Arthur Glennie. J.D. Glennie later exhibited at the RA and published a book in Prout's special field, *Views on the Continent*, 1849. Arthur was evidently a close friend who became a prolific exhibitor at the OWCS. In 1829 Prout wrote to him: 'I am rejoiced to find that you are getting on in the essential. In talent you are much improved – go on – aspire – fag & perspire to much fame – and yet, what is it? – mutton and beef is better –.'[2] Some pencil sketches at Barnstaple, including a charming one of Miss Glennie, record the drawing class on Blackheath.

In these years Prout produced a series of sketchbooks or drawing manuals (the distinction is not strict) for both Palser and Ackermann. Palser published *Picturesque Delineations in the Counties of Devon and Cornwall* 'imitated from the original studies' in 1812, and *Prout's Village Scenery* in 1813 and *Marine Studies (Sketches in the Thames Estuary and on the South Coast)* in 1814. Apparently the artist was not paid royalties or a fee but merely 12 shillings to 2 guineas for each soft-ground etched plate. Practically the whole of Prout's artistic effort in 1813 was concentrated on the production of 110 soft-ground etchings for Palser and Ackermann. Prout's work for Ackermann included *Rudiments of Landscape* (1813), *Picturesque Studies of Cottages* (1815/16), *Studies of Boats and Coast Scenery* (1816), *Studies of Cottages and Rural Scenery* (1816), and *Progressive Fragments* (? the same as *New Drawing-Book for the Use of Beginners*) (1816). The plates for most, if not all, of these publications, would be issued as single plates, grouped together in parts for serial publication, and finally collected in book form, sometimes under more than one title.

Perhaps Prout's finest prints as compositions are the panoramic shore and estuary scenes in *Picturesque Delineations* of 1812. These can only have been printed in relatively small editions since they are so scarce today. The Plymouth Museum has examples in sepia as well as black (colour pl. V).[3]

These wide views are more ambitious in scale than the excellent 'shore-scapes' in the *Easy Lessons* of 1820 for which there are drawings in the Victoria & Albert Museum's collection (**37**, **38**).

Palser and Ackermann were also Prout's principal outlets for sepia and watercolour drawings. Between 1811 and the beginning of 1816, Palser acquired nearly 600 drawings and Ackermann nearly 750, for £460 and £340 respectively. Prout received 2 shillings for a pencil drawing, 3s. 6d. for a sepia, and 5 shillings for a watercolour. His rates had not risen much by 1816: 2 shillings for a pencil drawing, 8 shillings for a chalk drawing and 4s. 6d. for a sepia, 12 shillings for a coloured drawing, and £1. 10s. for a large watercolour. The artist could only better these small sums by moving from the printseller's shop-window to the London exhibition rooms. At the latter he raised his prices from a top rate of £3. 13s. 6d in 1811 to 10 guineas at the OWCS in 1816. For his few oil paintings Prout increased his prices from £1. 15s. in 1814 to 8 guineas.

Over the five years for which the full account is available, Prout managed to double his income from £173 in 1811 to £362 in 1815. In these years he appears to have sold 148, 480, 125, 293, and 292 drawings respectively. The huge total for 1812 is almost equally split between Palser and Ackermann and can be broken down into 350 watercolours and 122 sepias. Most of the watercolours were of the small 5-shilling variety. The sudden fall of output in 1813, is due to the artist's concentration upon the production of plates for sketchbook/drawing manuals.

Prout must have hoped to break his financial dependence on the dealers by establishing a large circle of private patrons. In 1812 Lord Hardwicke is listed as a client and in 1814 Sir J. Acland, the Marchioness of Lansdowne, the Duchess of Somerset and Lord Clifford. In 1815 Walter Fawkes, Esq., and Lord Buckinghamshire are purchasers at the OWCS. By this date Prout was an established exhibitor at the RA and at the British Institution (oils) and had been included in John Hassell's *Acqua Pictura* (1813), 'exhibiting the works of all the most approved modern water coloured draftsmen with their style and method of touch'.

It would be disappointing if Prout's 'style and method of touch' at this date was only that of the numerous and ponderous watercolours, generally signed 'S. Prout', that are represented in many public and private collections and which pass through the saleroom quite frequently. The smaller and most rudimentary of them I would take to be the 5-shilling coloured drawings that Prout manufactured in large quantities for Palser and Ackermann between 1810 and 1815, and for which there was presumably a large market.

Another variety of 'early Prout' watercolour should also be dated to these years, although, like the crudest watercolours just discussed, the second variety is less sophisticated than works from the earliest, Britton years. The second variety makes less use of strong blocks of unrelieved colour and gives a more variegated and picturesque surface to cottage or church wall by dabbing on colour with small, repeated brush strokes (e.g. **8**).

Both these watercolour varieties were used for Prout's established subject matter, 'Prout's Village Scenery', the rural landscape of the south-west of England purveyed to the public by Palser and Ackermann, either in the form of original sepias and watercolours or through their mirror images in drawing-book plates, soft-ground etching with aquatint and with hand-colouring (colour pl. VI).[4]

Rudiments of Landscape in Progressive Studies 'in imitation of chalk, Indian ink, and colours, drawn and etched by Samuel Prout', was published by Ackermann in 1813 and precisely documents the kind of 'demonstration' watercolours that the artist sold through the printsellers. The very brief letterpress that accompanies the parts explains that the lessons are intended to induce 'a bold manner' with 'shadowing marked in distinct degrees' which will enable the student 'to lay the tint with a freedom almost amounting to certainty of imitation'. 'The subjects that form this second series [i.e. part two in a serial publication], are intended solely to teach the young artist the first principles of breadth of effect.'

Roget offers a useful summary of the advice offered to students in the *Rudiments*:

> The letterpress is confined to useful practical hints, and does not attempt to deal with landscape art in its higher departments of composition and treatment of subject, except perhaps in some remarks pointing out the effects on the mind of introducing part only of an object to give a greater impression of its size ... He advocates the use of a large brush and good point, and the practice of copying from aquatints to give clearness and decision of handling. He tells the sketcher to acquire the habit of standing while he draws from nature, and to make careful studies of foregrounds for future reference. And he recommends the employment of scientific aids, such as the camera obscura, Dr Wollaston's camera lucida, and C. Varley's graphic telescope. [See **41**.][5]

Prout's teaching is eminently practical and gives attention to materials. 'Simplicity of form and breadth of effect' is achieved through the use of 'good chalk or black-lead pencils' on 'wove paper, with the surface rather coarse'. Other necessary materials (to be had from Ackermann's Reposi-tory) are an earthenware palette, with divisions to hold the liquid (Indian

ink or sepia), 'some well selected camel-hair and sable pencils, and paper of the same texture as the original drawings. Previous to making the outline, the paper should be damped, and laid upon a stretching frame.' Prout refers the student to a wide variety of artists, including Prout, Morland, Gainsborough, Hills, Delamotte, Huet Villiers, Francia, Pyne (*Microcosm*), Turner, Glover, J.J. Chalon, John and Cornelius Varley, Reinagle, G. Samuel, Stevens, Barret, Cox, Pugin, the Westalls, Cristall, Havell. His inclusion of Gainsborough, Morland and Stevens, is relevant to his own specialism in cottage scenery.

Many, perhaps the majority of Prout's watercolours in the years 1810–15 were limited in ambition and technique, being tailored to a specific market demand. His style, or styles, were developed for a commercial end linked to his other principal activity as an art teacher. These watercolours are, in effect, visual aids, the second (sepia) and third (watercolour) stages for a student learning by imitation 'in progressive studies'.[6] They represent neither his private sketches nor the most ambitious watercolour paintings that he put into the exhibition room.

The difference between the public teacher and the private artist can be demonstrated through a sepia of *Old Shoreham Church* (**19**). This betrays all the dull heavy-handed qualities of an 'early Prout'. The drawing on which it is based, however, (fig. 3), from a dismembered sketchbook watermarked 1812, exemplifies Prout's skill as an antiquarian draughtsman able to make subtle use of a limited wash palette.[7] Another study in the same sketchbook, the chancel of *Old Fincham Church* (colour pl. VII), invites comparison with Cotman.[8] The drawings in the '1812' sketchbook show Prout privately developing his graphic skills from the point at which we left him at the end of his first period. Four watercolours in this sketchbook are painted with a full palette and the brush only. They are fragmentary evidence for Prout's potential to become a genuine watercolourist such as de Wint, and one in particular, *A sailing boat*, would never be attributed to Prout if it floated free and became a mounted drawing! It recalls one of three oil sketches of Hastings painted by David Cox in 1811–12.[9] It is quite possible that Prout, armed with a brand-new sketchbook, should have been in Hastings in 1812, although his first documented visit there (one of ten days) was in 1815. Paul Sandby Munn was also in Hastings at this time, an artist whose style is sometimes relevant to Prout's.

The Victoria & Albert Museum is comparatively rich in finished watercolours of this 1810 to 1813 period (**14**, **15**, **17**, **18**). These rise above the heavy copy drawings and are a more obvious development from the picturesque style of *c.* 1805. The colouring is delicately laid over a slight

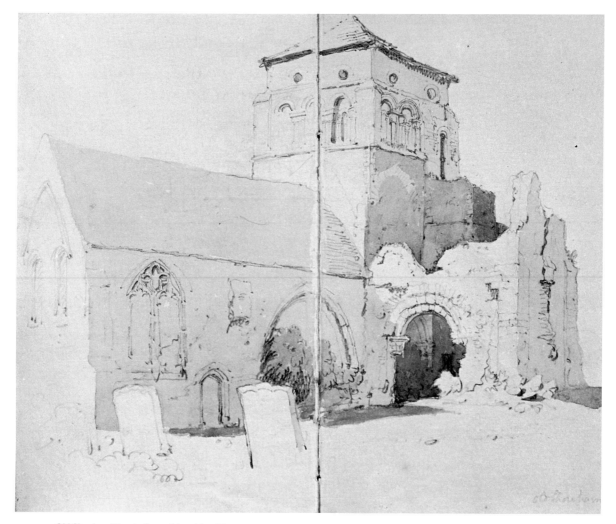

FIG. 3. *Old Shoreham Church, Sussex* (sketchbook)
N. Devon Athenaeum, Barnstaple

underdrawing and is characterized by a preference for yellows and light browns with touches of orange. The grey-blue-greens have generally faded but can be restored in the imagination through hand-coloured soft-ground etchings such as colour pl. VI. These watercolours are unpretentious, certainly unambitious by the standards of 1810–15 and are more typical, in their lightness of touch, of the eighteenth than of the early nineteenth century. Two shipping scenes (**10**, **11**) are marine equivalents of the more familiar cottages. All these may represent the kind of watercolours that Prout exhibited with the Associated Artists in the years 1810–12.

Francis Stevens' *Farm Houses and Cottages in England and Wales*, published by Ackermann in 1815, provides a useful cross-section of these 'rural beauties of our isle'. The etchings, arranged by county, are after Pyne, Chalon, Hills, Munn, Samuel, A. Wilson, Delamotte, Cristall, the Varleys, A. Pugin, Webster, G. Grainger, and James Norris, as well as Prout. This is almost the same recommended cast as in the *Rudiments*. Prout and his mentor in this field, T.H. Williams, as well as Cotman, were publishing comparable views slightly earlier.[10] Nevertheless, the cottage had fallen somewhat out of favour since the days of Gainsborough, to whom Prout specifically refers in the *Rudiments*. Rowlandson, who made tours of the south-west and frequently depicted cottage scenery, could be the connecting link.[11]

Another sketchbook at Barnstaple is inscribed 'Hastings Aug. 26th 1815' and 'S. Prout 1826'; it is watermarked 1813. To judge from the uniformity of style and subject matter (coastal), the contents date from one period. The pencil drawing technique and the addition of blocks of light-brown wash suggest an earlier rather than later date. The sketches follow on naturally from those in the '1812' sketchbook, and from Prout's earliest finished watercolours. Ackermann published books of coastal scenes by Prout in soft-ground etching in 1814 and 1816. Hastings and Worthing were among Prout's watercolour exhibits at the OWCS in 1816 and 1817. The early sketchbook bought from S.G. Prout (**6**) and another at the National Maritime Museum, as well as numerous loose drawings of coastal subjects, document Prout's use of pencil and brown wash at this point in his career (fig. 4).[12]

Prout further expanded his topographical repertoire in these years with a tour to South Wales in 1813 (Monmouth, Margam, Tenby – **23**) and to Yorkshire and south-east Scotland (Leeds to Edinburgh) in the summer of 1814 (Appendix 1).

Prout's summer tour diary of 1814 presents a clear picture of the artist's personality at this time. The diary reads as that of a young man, a nervous

FIG. 4 *Marine studies* (sketchbook). National Maritime Museum, Greenwich

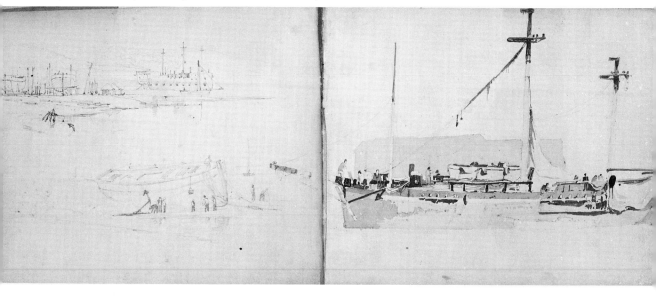

young man unable to stand up to the rigours of bad weather who waits for the postman to bring him news from home; Prout's eldest daughter was only one year old. He receives two letters from 'dear Betsey' while he is in the north. Prout was over 30, a late maturer both as a person and as an artist. His aesthetic appreciation belongs to the late eighteenth century. Kirkstall is 'a large mass of ruins without any form, yet so beautifully mantled with ivy and shaded by overtopping trees that the whole is picturesque in every point of view'. 'The stone houses and red-tiled roofs' of Chester-le-Street 'are so exceedingly unpicturesque that every house is passed without a second look'. He describes with some vividness the poor hovels of the coalminers at Newcastle, the smoking steam-engines, the burning coal heaps and blasted landscape, but does not see in this landscape any pictorial possibilities. His description of the castle at Warkworth reads like a quotation:

> The evening was beautifully serene, the moon shone full, lighting up the castle walls and sparkling on the sea. The dark woods were reflected in deeper shades in the river winding round the banks and retiring into indistinctiveness, while the hanging grey clouds and the streaked red twilight were reflected in this water-mirror, heightening by sudden contrast the blackness of the forest's shades...

His church-going was not interrupted by the tour and his comments on the clergy and their congregations are refreshingly Johnsonian. Prout's sense of humour also peeps through from time to time. When he walks across the sands to Berwick, gets his feet wet, takes off his shoes and hangs his

FIG. 5 *Durham from the south-west*, 1814. Private collection, UK

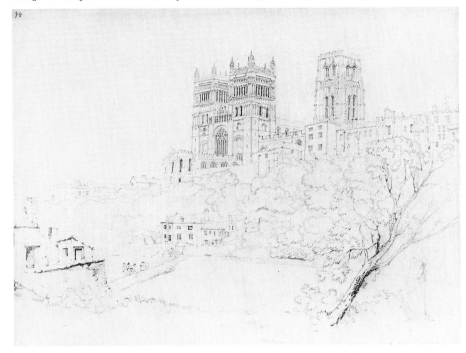

FIG. 6 *Ferring, Sussex*, 1815. N. Devon Athenaeum, Barnstaple

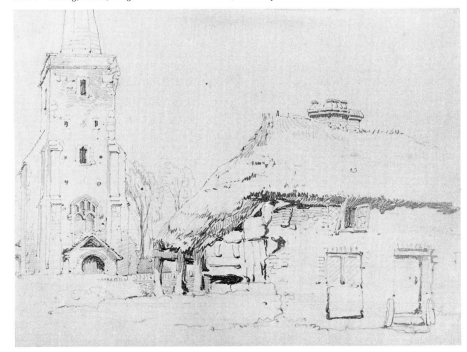

stockings over his portfolio, he realizes that 'dressed out with so many wet trappings', he presents a comic figure.

No sketchbook apparently survives from the 1814 tour, but 29 likely sketch subjects are among the lots in the 1852 and 1880 sales. There are three of Roslin, although Prout in his tour journal remarks that the architecture was too elaborate to be sketched in the available time. The tour dominated his exhibits at the OWCS in 1815 and a few views can be found among the illustrations to his drawing-book, *Progressive Fragments*, published in 1817. A pencil drawing of *Kirkstall Abbey Crypt* and a pencil with brown wash of *Jedburgh Abbey* are in the Ashmolean Museum.[13] *Durham Cathedral from the south-west* (fig. 5), on paper watermarked 1811, can be dated to this tour.[14] This demonstrates a control of emphasis within a composition and Prout's favourite device of placing a cottage or similar building in the foreground at one side. The architectural subject is carefully detailed.

Ferring, Sussex (fig. 6), dated by Isabella Anne Prout to 1815, is comparable and has all the virtues of Prout's best work; it is equal to any contemporary work in this genre taken to this degree of finish.[15] Every essential of the west front of the church, from the antiquarian point of view, is caught, although relatively little detail is included. Nothing is laboured, and a light touch describes the background trees. The foreground cottage, despite the artist's familiarity with the subject, is freshly seen, with every line purposeful, delicately forming the chimney pots and strongly marking the shadows under the thatch eaves. The latter is a feature of many of Prout's earlier watercolours (**13, 15, 17**).

Christchurch Priory, Hants (fig. 7), represents the fruition of Prout's training as an antiquarian artist and rivals any pencil sketch done by Cotman with the same intentions.[16] Prout has nothing more to learn about architectural description, compositional arrangement or relative emphasis through weight of pencil and degree of detailing. The total scene is caught and inhabited. There is nothing in his later continental drawings that cannot be found here. Prout's maturity as a draughtsman was achieved before his first continental tour in 1819, in fact by 1815-16.

Prout must have made a second tour to Yorkshire and Scotland in 1818 in order to account for a *Series of Views of Cottages in the North of England*, published in 1821, since he is most unlikely to have had time for a northern tour in addition to his continental journey in 1819 and 1820. The *Views* are much less limited than the title suggests, and include for example the *Peak Cavern* (fig. 8), as well as drawings of Kirkham and several of York which, thanks to the transcription of the 1814 tour journal, cannot be dated to that year. Drawings of York, Helmsley, Wakefield, St Peter's

FIG. 7 *Christchurch Priory, Hampshire.* N. Devon Athenaeum, Barnstaple

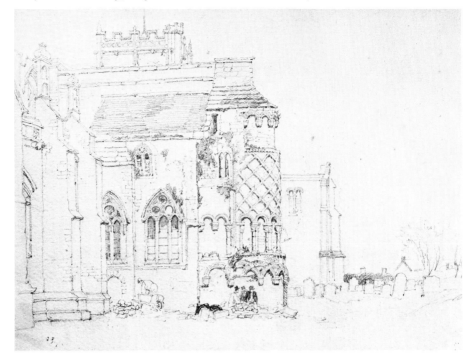

FIG. 8 *Peak Cavern, Derbyshire*, soft-ground etching, 1821
Pub. by R. Ackermann in *Samuel Prout's Views in the North of England*

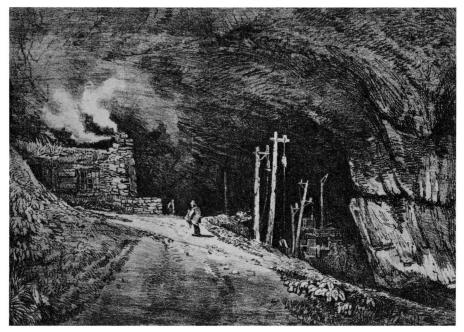

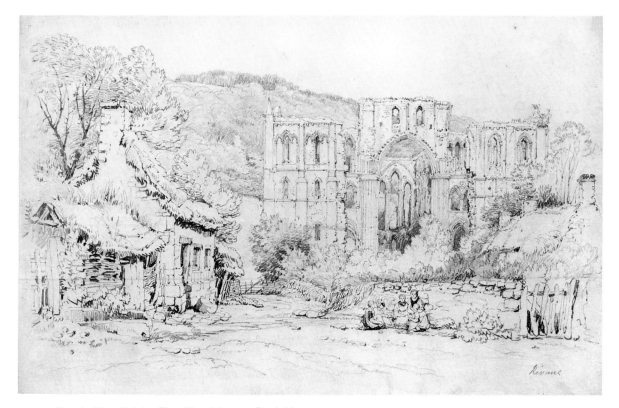

FIG. 9 *Rievaulx Abbey, Yorkshire.* Fitzwilliam Museum, Cambridge

Well, Kirkham, Thirsk and Whitby from this second northern tour are now, via Ruskin, in the Ashmolean collection[17] and there is a pencil drawing of *York, Micklegate Bar* at Exeter.[18] A *Rievaulx Abbey* (fig. 9) brings together the full range of Prout's repertoire of subjects and graphic techniques: the cottage, the medieval ruin, rustics and the picturesque paraphernalia of troughs and gates.[19]

Stirling Castle (fig. 10) could also be dated to these immediately precontinental years. As a piece of controlled drawing it ranks very high and justifies Ruskin's admiration for Prout's descriptive technique and instinct for the placing of figures. The artist has used the grey paper preferred for many of his continental drawings and makes considerable use of the stump. The tonal range is completed with a few touches of white.[20]

Prout's choice of exhibits for his first appearance at the OWCS in 1815 mark a break from his previously south-western bias. Marines are mixed with his new northern views: Durham, Jedburgh and Kelso. *Part of Durham Bridge* is probably not the same as a large watercolour ($17\frac{1}{2} \times 23\frac{1}{2}$ in) which could be described as *Durham from the north-west* (fig. 11).[21] This takes

exactly the same point of view as a watercolour of *c.* 1796 by Girtin[22] and is even closer to a Cotman that has been dated 1809-10.[23] Prout's OWCS view is more likely to have been a composition such as Girtin's *Wetherby Bridge*[24] or Turner's *Shrewsbury Bridge*[25] and akin to Prout's own *Monnow Bridge*.[26] In handling it was perhaps similar to his *Glory Hole, Lincoln* (fig. 12).[27]

A comparison between *Durham from the north-west* of (?) *c.* 1816 and the Cotman of *c.* 1810 is instructive. Cotman eschews almost all use of the careful separate brushstroke such as Prout employs to describe courses of brick or roof tiles. The Cotman view is composed in contrasts of strong lights and darks. Prout's broadest sweeps of the brush are reserved for the water and the bridge. Elsewhere the technique is much closer to Girtin's and Turner's in the mid-to-late 1790s, particularly in the detailing of architectural features. Prout's *Durham* is in most respects an old-fashioned picture for its time. In the context of his own *oeuvre* it is forward-looking, and is populated by the parents of Prout's characteristic figures. The pale forms of castle and cathedral are forerunners of the towers that break up the skies in his later continental townscapes.

As the artist's selection for his first showing at the OWCS implies, he realized that marines were among his most effective subjects and the critics took this view even after Prout had added continental subjects to his armoury. The marine is not represented in the Victoria & Albert Museum's collection except in sepia (**29**, **30**); it is hinted at in some fully coloured shore scenes (**26**, **27**, **33**). There is a fine example in the Leeds City Art Gallery (fig. 13).[28] The Museum also lacks one of Prout's 'hulks', a subject which he had attempted with success by about 1812 – see for example a large but badly faded watercolour in the Plymouth City collection.[29] There is a good, somewhat smaller and later example in the Manchester City collection comparable in palette to **26**.[30]

The limitations of Prout's finished watercolour technique at this time is perhaps best expressed by quoting from the advice that he offered to students in the drawing book that he issued in 1820 – *A Series of Easy Lessons in Landscape Drawing*; the hand-coloured soft-ground etchings with aquatint are the relevant illustrations.

> Some of the subjects are first tinted with *grey*, that is, neutral tint, producing the general effect of a drawing, except what blue is in the sky, and the darkest touches. The whole is then washed over with a warm tint of red and yellow; after which, a little local colour is necessary on the different parts. It is then to be finished with a few dark touches, to mark more decidedly the features of the picture. But few colours are necessary, it being the balance of warm and cold colours which produces brilliancy; some of the cold tints being carried into the

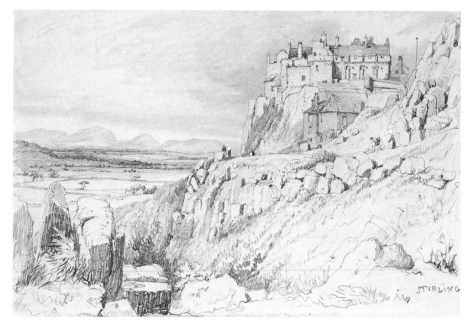

FIG. 10 *Stirling Castle, Scotland.* British Museum

FIG. 11 *Durham from the north-west.* Private collection, UK

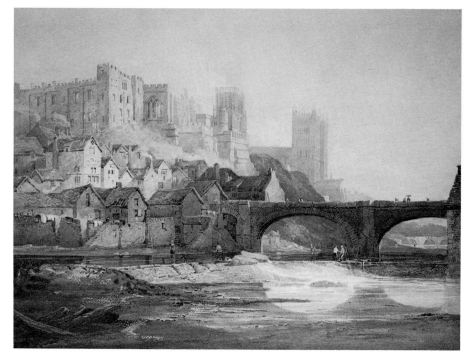

FIG. 12 *Glory Hole, Lincoln.* Usher Art Gallery, Lincoln

FIG. 13 *Coast scene.* Leeds City Art Gallery

warm masses, and the warm tints balanced with cold ... Light and shade should be distributed in large masses, uniting light to light, and shade to shade, to prevent confusion and distraction to the eye, which is always the effect of a number of prominent objects scattered about the picture.

The hand-coloured illustrations document Prout's watercolour style at the end of the decade, at least for smaller works. Plate 34 is very close to *Beach at Old Folkestone* (**33**), for instance. This leads on to the large exhibition piece, *Beach at Hastings* (**34**). Items **29-32** epitomize sepia drawings made at this date.

Easy Lessons was almost the last of Prout's books for which soft-ground etching was the preferred medium.[31] In 1817 he had contributed a small lithographed seascape to Ackermann's *Repository of the Arts* and two years later another single plate to Ackermann's edition of Alois Senefelder's *Complete Course of Lithography*.[32] In 1821 Prout adopted lithography for some *Marine Sketches* published by Rowney and Forster (a new publisher for him)[33] and for his novel *Picturesque Buildings in Normandy*, printed by Charles Hullmandel. Lithographs by or after Prout were published in almost every year during the 1820s, and Prout could claim to have been the first important lithographic artist in England, although Swenson has pointed out that he was not *the* first, the Varleys and Paul Sandby Munn having preceded him.[34] Cornelius Varley included a few lithographs in his *Etchings of Shipping, Barges, Fishing Boats and other Vessels* (1809) which anticipated the beach subjects to which Prout's sketchbooks are largely devoted in the years 1811–13.

NOTES

1. Byron was a pupil at the school ten years before.
2. Plymouth Mus. transcript.
3. *Teignmouth/Hamoaze*, plate $12 \times 13\frac{1}{2}$ in, pub. T. Palser, July 1811. Somers Cocks, S. 38 (10).
4. *Old Shoreham* (**19**), and *Near Saltash, Cornwall* from *Prout's Village Scenery*, 1813.
5. Roget, I, 351/2.
6. **19**.
7. Graphite and watercolour, $4\frac{1}{4} \times 7\frac{1}{8}$ in. Barnstaple, N. Devon Athenaeum.
8. E.g. *Walsoken Church, interior* (Birmingham. Mus. 147'22) illus. S.D. Kitson, *John Sell Cotman*, 1947, pl. 73.
9. Birmingham Mus. 2486'85.
10. J.S. Cotman, *Miscellaneous Etchings*, 1811.
11. See, e.g., Arts Council, *British Watercolours 1760–1930 from the Birmingham Museum*, 1979 (18), 'Cottage at Lanherne'. Rowlandson published some aquatint *Views in Cornwall c.*

1813 and etchings with aquatint after Gainsborough drawings in 1789.
12. National Maritime Mus., PR 51/370, graphite and watercolour on cream wove Whatman 1811 paper, folio $10\frac{3}{4} \times 10\frac{1}{4}$ in.
13. Educ. 111 (presented by Ruskin); presented by Rev. F. Palgrave, 1941. Drawings in the Educational Series are listed in Works, XXI.
14. Graphite on white wove, $13\frac{1}{4} \times 18$ in (priv. coll.)
15. Graphite on cream wove, $8\frac{1}{8} \times 11\frac{1}{8}$ in, Barnstaple, N. Devon Athen.
16. Ibid.
17. Educ. 55-57, 111, 129, 133-5; Long Cabinet 2, 3, Works, XXI. The drawings of this fine series, all on white wove, are made with graphite and stump to which some colour wash is occasionally added.
18. Exeter Mus., 95. 1949. 1.
19. Fitzwilliam Mus., Cambridge, 1413, Scrase, 5.

20. BM, 1852-10-9-1134 (LB4), *Catalogue of Drawings by British Artists*, III, 1902, 181.

21. H.L. Mallalieu, *Dictionary of British Watercolour Artists to 1920*, 2, 1979, 485.

22. Birmingham Mus., P 20′53, illus in colour, A. Rose, *English Watercolours and Drawings: The J. Leslie Wright Bequest*, 1980 (31). For a closer but very similar view see F. Hawcroft, *Watercolours by Thomas Girtin*, Whitworth AG, 1975, pl. 22.

23. A.W. Moore, *John Sell Cotman*, Norwich Mus., 1982, p. 61.

24. BM, 1855-2-14-7, Hawcroft, op. cit., pl. 33.

25. D 20. 1892, illus. in colour, C. Hartley, *Turner Watercolours in the Whitworth Art Gallery*, 1984 (5).

26. Yale CBA, B. 1975.4.19.54., L. Hawes, *Presences of Nature: British Landscape 1780-1830*, 196 and pl. 86. Hawes cf.s the Turner (n. 25) and Girtin's *The Ouse Bridge, York* of 1800: 'Indeed, in a number of ways, the work is a creative amalgam of Girtin and Cotman, with a hint of Varley. This points to a date no later than the mid 1810s.'

27. Lincoln, Usher Gall., 1844.

28. *Devonshire coast scene*, Leeds CAG, 5. 176/52, $10\frac{1}{4} \times 15\frac{1}{2}$ in.

29. *Plymouth Dock*, Plymouth MAG, 1938. 32, $16\frac{3}{4} \times 23\frac{1}{4}$ in. s. *S. Prout*.

30. Manchester CAG, 1920. 649, $11\frac{1}{4} \times 21$ in.

31. *Views of Rural Cottages in the West of England* (1819) and *in the North of England* (1821) are included here among the soft-ground etchings. The latter and sometimes the former are usually described as lithographs.

32. Twyman, 193/5 and Swenson, 20.

33. T.F. Dibdin, *A Bibliographical and Picturesque Tour through France and Germany*, 3 vols. 1821, III, 319 n.: 'Mr Prout's little Sea Views ... delightful evidences of the rapid improvement of the art [of lithography] amongst us'. Dibdin was describing Munich, the cradle of the art'.

34. Swenson, 12. Thomas Barker and amateurs in Bath should be added (M. Twyman, *Henry Bankes's Treatise on Lithography* [1813, 1816], 1976, xiv) as well as some eighteenth-century experiments.

III The grand tours: 1820–30

During the 1820s Prout became completely divorced from his established subject matter, until recently fattened on the usual diet of annual sketching tours in the British Isles. These had been much more limited than those undertaken by his contemporaries. In contrast, Prout's continental touring was most adventurous; he probably toured abroad every year during the decade with the exception of 1828. It is easy to forget that Turner had yet to publicize the Rhine and Cotman to 'discover' Normandy in the London exhibition room. None of the leading British landscapists had visited Saxony, Bavaria or Bohemia.

In 1849 Ruskin has Samuel Prout finding himself 'about the year 1818 . . . in the grotesque labyrinths of the Norman streets'. There is little doubt that Prout made a northern tour in 1818 and, prompted by Edridge's views of Beauvais and Rouen at the RA in 1819, went abroad to Normandy for the first time that year. Normandy dominated his selection of exhibits at the OWCS in 1820. Prout did not have this new territory entirely to himself and, in 1821, William Scott and Charles Wild also showed views of Rouen, as well as of northern French cathedrals. Exhibition titles suggest a journey up the coast from Le Havre to Fécamp and back to the Seine for a journey upriver as far as Pont-de-l'Arche or Louviers. The tour, like Cotman's in 1817, was concentrated in the Pays de Caux. It is unlikely that Prout reached Honfleur, Lisieux, Caen, Bayeux, St-Lô, Coutances, Granville or Mont-St-Michel on this first tour and most probable that he returned to Normandy in 1820. As on the Rhine and in Venice, he exhibits a taste formed on the south coast of England for boats, shipping and river traffic. Some small sketches of this kind from all these continental locations are in the National Maritime Museum, including an Etretat with the *roche percée* of 1819–20![1]

Although he exhibited at least a hundred Norman subjects at the OWCS between 1820 and 1851, and there are at least a further 50 mentioned in the account books for these years, it is difficult to cite a Norman watercolour as an example from the 1820s. A large (28 × 21 in) successful *Café de la Place, Rouen* (fig. 14) is apparently the 25-guinea exhibition piece of 1845.[2] If this is the case, then Prout was capable of high-quality work towards the latter end of his life. The introduction of the diligence in the centre of the composition is particularly well managed.

The only watercolours that can be attributed to the first Normandy tours with certainty, are painted in a much lighter palette than Prout used for his later English views. Two Norman street-scenes closely following tour drawings are in the Manchester City Art Gallery (fig. 15).[3] These are as close as Prout came to reproducing the effect of Edridge's Norman

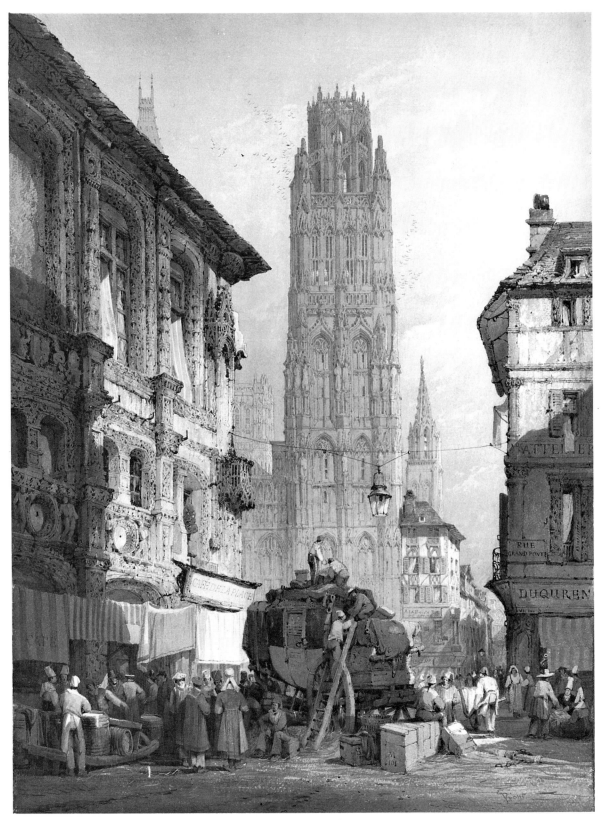

FIG. 14 *Café de la Place, Rouen, Normandy*, 1845
Private collection

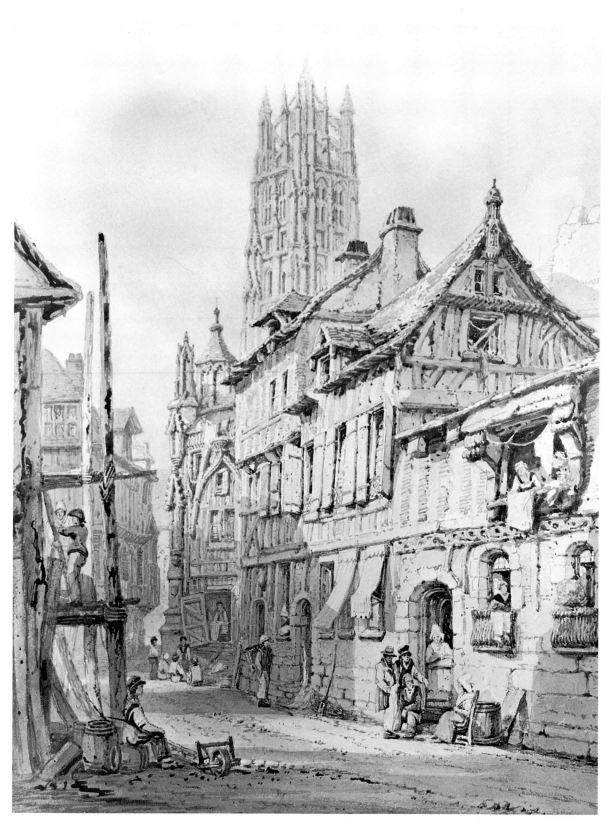

FIG. 15 *Street view with St Laurent, Rouen*
Manchester City Art Gallery

watercolours, while the drawings on which they are based are even more mistakable (fig. 16).[4] Although there was no master–pupil relationship between them, there is no doubt that Prout's typical Norman subject matter was first discovered by the older artist and that Edridge's graphic style, developed in the Monro school, anticipated Prout's.[5] The problem of attribution can sometimes be acute, particularly when Prout tries his hand at pure landscape. There are several drawings from the Holliday collection now at Birmingham, one a view of Box Hill, Surrey, and the rest views of the Alps, the Mediterranean coast and Italy, made on a tour in 1824, where the closest parallels can be found in Edridge's work.[6]

Due to the survival of a *Goldsmith's Almanack* for 1821, the artist's first journey down the Rhine is precisely recorded. This almanack shows that he was still teaching at Dr Glennie's and that he had some invested savings. On 24 July Prout left London for Dover, to which he did not return (by steam boat) until 10 October. Shortly afterwards he is back into London life and dines with Mr Allnutt in the company of Mr Ward and Mr Robson on 9 November.[7] Earlier in the year, we can follow Prout's journey almost daily as he progressed from Gravelines to Dunkirk, Cassel, Lille, Tournai, Brussels, Louvain, Namur, Huy, Liège, Aix-la-Chapelle, Juliers, Cologne, Remagen, Koblenz, Andernach, Lahnstein, Boppart, St Goar, Oberwesel, Baccharach. He visits Bingen with George Ackermann and then continues to Rüdesheim, Wiesbaden, Mainz, Frankfurt, Offenbach, Darmstadt, Heidelberg, Strasbourg, Metz, Verdun, Chalons-sur-Marne, Reims, Soissons, Paris, Rouen, Abbeville, Calais, and Dover. Prout was on tour for two and a half months making numerous highly finished drawings, seldom staying for more than a couple of days anywhere, with the exception of Cologne and Strasbourg (**39**).

It is only the Rhine views of 1821 and his much earlier estuary scenes that bear witness to Prout's capacity to become a landscape artist rather than a painter restricted to the architectural picturesque (fig. 17).[8] The Rhine sketches and related lithographs are extremely varied in composition as well as being technically brilliant in execution. Prout had given some notice of this in *Views in the North of England*, a follow-up to *Views in the West of England*, published in 1821. This picture book included two or three powerful views of York and an uncharacteristically Romantic 'Peak Cavern' (fig. 8). The Rhine views, however, generally evidence a real gift for landscape description, capturing the sweep of water, the distant towns nestling at the feet of the mountains, and the castles rearing up on their peaks, with barges passing below (fig. 18).[9] These are themes to which Prout did not return in print or indeed in finished watercolours. It was

FIG. 16 *Street view with St Laurent, Rouen*
Birmingham City Museum and Art Gallery

FIG. 17 *The Drachenfels, on the Rhine*
Notes, 5th ed. 1880, pl. 11

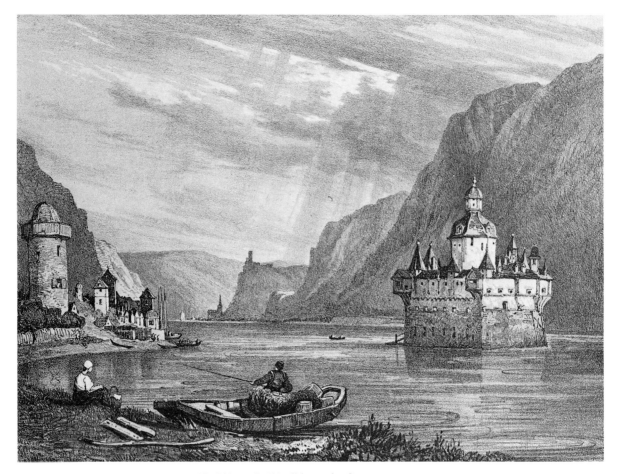

FIG. 18 *The Pfalz, on the Rhine*, lithograph, 1824,
Illustrations of the Rhine

only the town squares and market corners, close-ups of the urban pictur-
esque, that outlasted the tour and the magnificent lithographic publication
that followed. Prout's journey to Saxony and Bavaria in 1823 (**42, 48, 51,
52**) and his 1829 journey through Brunswick, Saxony and Bohemia (**49,
50, 55**) produced only urban views; the surrounding landscape, travel by
coach or sail barge, which had such an impact on Turner, went unre-
marked by Prout. His response to Italian landscape was much more varied,
but he kept this to himself, and no published *Views* resulted.

> The *Illustrations of the Rhine* is the finest example of Prout's early lithographic
> works, and it is the first of many projects he did with Hullmandel. The prints
> are full tonal drawings, demonstrating Hullmandel's rapid perfection of chalk
> lithography as well as Prout's sympathy for the medium.

The publication history of the *Illustrations* is complicated and three different
publishers had an interest in the project between 1822, when the first plates
were issued, 1823 when the first of the serialized parts came out, and 1826
when the published plates were reissued with a supplement of *Views in
Germany*.[10]

Prout should have set off for his 1822 tour in high spirits following the
birth of his son Samuel Gillespie and the sale of all his exhibits at the
annual OWCS exhibition on the first day. His itinerary is a matter of
deduction from the 1823 exhibition catalogue and probably included
Ypres, Ghent, Malines, Antwerp and perhaps Utrecht. Both his 40-guinea
exhibits in 1823 were of Flanders, a *Malines* sold to Jesse Watts Russell and
a *Hotel de Ville, Louvain* to George Haldimand. 1822 is the most likely
moment for Prout to have sketched alongside Bonington at St-Omer where
the former made his most striking drawings in the antiquarian tradition
(**40, 41**). There is no evidence to support a meeting between the two artists
in Normandy that year.

In 1823 Charles Wild again showed some continental views (his speci-
ality was cathedrals) of Flanders and Normandy, Reims and Chartres. This
may have prompted Samuel Prout to look further afield. By June he is
asking Brook Taylor to organize the necessary travel documents. His prob-
able itinerary later that summer was to Frankfurt, Würzburg (**52**), Nurem-
berg, Regensburg (**51**), Munich, Augsburg, Ulm (**42, 48**), Strasbourg,
Basle, and back to Strasbourg, Metz and Trier. In the succeeding OWCS
exhibition of 1824, Prout raised his top price to 50 guineas for a *Munich*
which was bought by the Duke of Norfolk.[11] In the same exhibition Ar-
rowsmith bought a 25-guinea *Cologne* as well as *Utrecht, Augsburg* and a
Marine, which were shown at the 1824 Paris Salon alongside works by
Bonington, Constable, Gastineau, Copley Fielding, Thales Fielding, J.D.

Harding, Sir Thomas Lawrence, James Roberts, John Varley, and Charles Wild.[12] Otherwise Prout's name was known in France through the dealers Schroth, Ostervald and Taylor, and through illustrations in Nodier and Taylor's *Voyages pittoresques*.[13] He supplied 'stones' to Baron Taylor in 1828 and drawings for others to lithograph in 1835.[14]

The pattern was firmly established and the 1825 exhibition duly reflected the Italian tour of 1824 with a *Ponte di Rialto, Venice* at 50 guineas. A passport for this tour records a few relevant places and dates: Paris, Geneva, Lausanne (10, 21, 24 August), Domodossola, Milan, Padua (7, 19, 29 September), Rome (22 October), Florence, Ferrara (10, 17 November), and the return journey in January 1825 via Chambéry, Paris, and Calais (10, 11, 21).[15] Prout must have made two visits to Rome, as he wrote home from there on 9 December:

> Rome tho it is called (improperly) the Eternal City ... is now an exceeding filthy place – having many fine palaces, & some fragments of its ancient grandeur. Mr. J.H. & myself have been rambling by moonlight amidst the amazing ruins of the Coliseum [**66**] or amphitheatre, sufficiently large to contain a hundred thousand persons ... where the celebrated gladiators used to fight with the wild beasts.[16]

Prout also visited Venice. Before leaving, Prout had written to the Hon. Mrs Agar-Ellis to accept 'the invitation to Rome in November' and to request her husband to favour him with a letter poste restante at Venice.[17] The *Somerset House Gazette* announced on 25 September: 'Mr Prout, whose admired topographical drawings taken in France and Germany, formed so interesting a feature of the last Exhibition of the Painters in Watercolours, is now at Venice.'

Only a highly strenuous and only just possible itinerary would account for a large number of landscape drawings (**43, 44, 45**) as well as the engraved views published in the *Landscape* and *Continental Annuals* and the *Continental Tourist* some years later.

After 1824 Prout's foreign tours are not precisely established. A tour to Normandy and Touraine is possible for 1826, the tour perhaps from which he had to make a hurried return due to 'the alarming illness of Mrs Prout'.[18] He may have undertaken another trip to Venice in 1827 in connection with an Ackermann project for a book to be written by Thomas Uwins and illustrated by Samuel Prout, a project later realized by John Murray.[19] Ackermann's project failed to attract Uwins:

> I entirely give up the temptation offered me by Ackermann and Prout. Had I not been to Venice I might have seized on it as an opportunity of visiting that

scene of poetry and enchantment. But having been there, the case is different, and I can now only think of it in the light of a money speculation . . .[20]

The next definite news of Prout's travels belongs to 1829, the year that he was appointed 'Painter in Water-Colours in Ordinary'. In reply to a letter from Sir William Knighton, conveying George IV's wish to have some drawings, the artist writes: 'Circumstances make it almost imperative that in a fortnight I should visit the Continent as far as Dresden & Leipsig . . . As a visit to Hanover &c. can easily be accomplished, I am anxious to add to my selection from the ancient towns of Saxony . . .''[21] If Prout visited Leipzig and Hanover, he appears to have made no drawings of them. His probable itinerary was Frankfurt, Würzburg (**52**), Bamberg, Karlsbad, Prague (**50**), returning via Dresden (**49, 55**). On August 28 he writes home:

> I did not think of writing again from this place but there is some difficulty of getting onwards, & as I can find a little to fill up my time, altho with subjects that are not very interesting, I may go further, & fare worse, so that I will not write any lamentations. The weather is variable & today so hot that I have been driven away from three broiling corners . . .[22] (Bamberg)

Turner's pre-eminence as a tourist as well as an artist has obscured the fact that, initially, his influence in topographical terms was more private, more exclusive, more focused upon a small class of discerning patrons. Turner's huge impact on the wider British public as the man through whose eyes the Continent could be seen, was exerted in the 1830s through steel engravings – the *Rivers of France* and *Turner's Annual Tour*(s).[23]

Turner travelled the Rhine as early as 1817, selling his great series of related watercolours to Walter Fawkes, but it was Prout who published Rhine views in 1822, Turner's plans for a publication with 38 engraved views in 1819 having come to nothing.[24]

Prout's rivals as a popularizer of the Rhine were lesser men. He had been preceded in the OWCS annual exhibitions by John Glover in 1815, but this initiative had not been followed up. Turner's 1819 plans came to nothing. All the realized projects for books with Rhine illustrations suffered from the fact that they offered second-hand views, usually aquatints, made after drawings by amateur authors.[25] None of these tour books could rival steel engravings made under Turner's eagle eye or lithographs 'drawn on stone' by the then leading exponent of this new medium in England. Prout's *Illustrations of the Rhine* of 1822–6 was not matched until Clarkson Stanfield published his *Sketches on the Moselle, the Rhine, and the Meuse* in 1838. This was illustrated with 26 tinted lithographs. Stanfield had visited the Rhine much earlier, in 1823 and 1828, but was not then technically

equipped to publish a convincing series of views. A Stanfield oil, *The Rhine at Cologne*, dated by Pieter van der Merwe to 1826, makes an interesting comparison to the *Cologne* (fig. 19), a watercolour for which a date in the 1820s is proposed here. The Stanfield is a more varied and complicated composition but is insecure and a relatively immature work. The Prout is less ambitious, but is firmly within the artist's technical powers.[26]

The slightly earlier exploration of Normandy is another example of Prout being the first to exploit new ground rather than the first to visit it. Apart from antiquarians such as Dawson Turner and T.F. Dibdin, several artists had already made the journey, including Thomas Phillips (1815) and a strong East Anglian contingent – J.B. Crome, George Vincent, Joseph Clover and, of course, John Sell Cotman. Charles Stothard, who was primarily, but not exclusively, interested in recording monumental effigies, was in Normandy in 1817 and 1818 but died in the line of duty from a fall from scaffolding.[27] Henry Edridge, who was in Normandy in 1817, 1819 and 1820, also died shortly afterwards. Cotman was there in 1817, 1818 and 1820. Edridge exhibited watercolours of Norman subjects from 1819 (in the RA) and Prout (OWCS) and Cotman (Norwich Society of Artists) from 1820. W. Scott, Charles Wild, R.P. Bonington, R.H. Essex, and F. Mackenzie all joined in immediately afterwards and, finally, David Roberts in 1824.

It has frequently been noted that Cotman restricted himself to antiquarian subjects in his publications or to the Norwich Society of Artists for his watercolours. He is rightly accepted as the greatest British interpreter of Norman landscape when he abandoned his antiquarian chronicling of monuments in favour of more distant, usually rock-strewn, views of Norman towns. His Normandy watercolours were noticed by the *Somerset House Gazette* when exhibited in Norwich in 1824, and Cotman promptly exhibited similar subjects in London the following year.[28] Due primarily to Prout, Norman subjects were by then no longer novel and had been taken up by other artists such as Roberts.

Cotman was well known in England for his antiquarian work, in particular for the *Architectural Antiquities of Normandy* (2 vols. 1821–2), for which Dawson Turner wrote the text. This and Stothard's posthumous work and other relevant literature were reviewed in John Britton's *Architectural Antiquities of Normandy*, which was published in 1828 with illustrations by Pugin. Britton makes it clear that he believed that the Cotman work had fallen between two stools, lacking measured drawings and plans that would have made it suitable for the architectural market, without being cheap enough to secure a wider public. He acknowledged 'its tasteful and beautiful pic-

FIG. 19 *Cologne Cathedral from the Rhine.* Royal Albert Memorial Museum, Exeter

turesque views'. Britton gave only a brief notice to T.F. Dibdin's remark-
able *Bibliographical, Antiquarian and Picturesque Tour through France and Germany*
(3 vols. 1821). Dibdin, incidentally, states that Cotman's work was already
known in Normandy.[29] His own illustrator, G.F. Lewis, he claimed, could
bear comparison with Coney, Mackenzie, Blore, Nash, Wild and Cotman,
i.e. contemporary British artists with an established name for architectural
subjects. 'Mr Lewis is nearly as powerful in the delineation of Gothic
remains, as of picturesque appearances of nature, and of national character
in groups of common people.'[30] This would be a relevant description of a
Prout watercolour of 'street scenery', to use Dibdin's term. Lewis is far less
accomplished than Prout, but comes quite close in a view of the *Rue du Bac,
Rouen.*

Also in 1821, there appeared J-B-B. Sauvan's *Picturesque Tour of the Seine,*
with aquatints by Thomas Sutherland after drawings by John Gendall and
Augustus Pugin. As the title suggests, the book reflects the fact that the
Seine was a major route between the coast and Paris and in fact only a
part of the book is devoted to Normandy. Although the text was by a

Frenchman, the book was a British venture and was published by Acker-
mann.

By 1820, French writers, and to some extent artists, had woken up to
'les traditions merveilleuses de ces temps ingénus et crédules, âge d'ignorance
et d'imagination . . .',[31] i.e. the romantic potential of Normandy. Two early
volumes of Nodier, Cailleux and Taylor's *Voyages pittoresques et romantiques
dans l'ancienne France* were given over to *Ancienne Normandie*, and these were
liberally illustrated in lithograph. The illustrations represent a fusion of
antiquarian and romantic, specialities of Joseph Nash and George Catter-
mole in England a few years later. Bonington, who helped to pioneer the
costume piece in France, contributed only contemporary townscapes to the
Voyages pittoresques. In fact the majority of his Norman lithographs appeared
in his own *Restes et fragments d'architecture du moyen âge*, published in 1824.
Bonington's 'street scenery' sometimes follows that of Edridge and Prout
both for selection of viewpoint and disposition of groups.[32] His lithographic
style, however, is smoother, finer and apparently less studied than Prout's,
and proved more influential, in particular on the work of Thomas Shotter
Boys, William Callow and J.D. Harding, in the 1830s.[33]

Prout's contributions, like Bonington's, to the *Voyages pittoresques*, were
restricted to a contemporary description of landscape and were therefore
more typical of publications without the romantic additions, such as De
Jolimont's *Monumens . . . de Rouen* (1822).[34] Unlike Bonington, Prout never
attempted history pictures, although the invention of figure groups in six-
teenth or seventeenth-century costume does not now look a tough obstacle.
For Dibdin in Rouen, at any rate, the imagination needed little prompting:
'it is with difficulty I am persuaded that I am not living in the times of our
Henry VIII and of their Francis I'.[35] Cotman occasionally transformed his
Normandy views into history pieces, Prout never. Of the ten Normandy
subjects exhibited by Prout at the OWCS in 1821, only one made any
historical allusion, and then only in its title – *Place de la Pucelle, where Joan
of Arc was burnt, at Rouen*. Historical and romantic associations had to be
supplied by Prout's patrons.

The artist must have set to work immediately on return from Normandy
in 1820 to finish exhibits for the following spring. He was also busy (Feb-
ruary–July) preparing the eight lithographs which made up his *Picturesque
Buildings in Normandy*. All this activity immediately preceded his great
Rhine tour, which resulted in the much more ambitious *Illustrations of the
Rhine*. The Normandy publication is relatively modest, but then the art of
lithography in England was at a very early stage in its development in
1821. Rodwell and Martin, the publishers, were probably uncertain as to

the market. Prout's eight large lithographs mark a significant contribution to the development of the new medium. The figures are characteristic of the artist, as is the frequent choice of an oblique view of timbered buildings in the foreground. The stones are well worked and given the all-over toning typical of continental lithographs. *L'Abbé de Jumièges* in particular belongs with the *Voyages pittoresques* and typifies the close relationship at this moment between publishers and artists in London and Paris. Prout's contribution to this co-operative moment has been overshadowed by the slightly later and more important contribution of Bonington.

It is perhaps arbitrary to single out the Low Countries as a distinct topographical area for pictorial discovery, since many tourists would go through it *en route* for France and Germany (via the Rhine). One early book devoted exclusively to it, Robert Hills' *Sketches in Flanders and Holland* of 1816, was motivated by the associations of the Battle of Waterloo, which reopened the Continent to British artists and tourists alike. Hills' illustrations are delightfully eighteenth-century in feeling and the text shows a lively interest in local architecture, costumes and customs and, in general, anticipates the contemporary atmosphere that a Prout watercolour seeks to convey. Hills was followed to the Low Countries by Turner, Stothard, Prout, Wild and Stanfield, in that order. In 1824 Flemish subjects by Prout and Bonington were exhibited at the Paris Salon, and by J.B. Crome at the British Institution; before the end of the decade David Roberts was exploiting the same territory at the Society of Artists. Prout, as usual, had taken an early lead at the OWCS (in 1823) and consolidated his position in Flemish market places with his privately published *Facsimiles of Sketches in Flanders and Germany* ten years later.

For the more distant parts of Germany extending as far as Bohemia, Prout had no rival during the 1820s, although, unlike Stanfield and Roberts, he did not attempt to exploit the novelty of new territory, beyond watercolours and lithographs, by making oil paintings. Prout tried hard to establish Bavarian views at the OWCS, particularly in 1824 and 1830, i.e. immediately after his two tours of 1823 and 1829. But German towns, to judge from the artist's productivity, never won the same response as views of Normandy, Italy or the Rhine. Perhaps the relative inaccessibility of central and eastern Germany meant that there were fewer tourists to buy watercolours as 'recollections'. The historical link of the British royal family with Hanover also proved uncommercial. Despite Prout's attempt to fly a Hanoverian kite before Sir William Knighton, he does not seem to have completed his portfolio of Hanoverian subjects, and concentrated instead on more distant cities such as Dresden and Prague.[36]

There was nothing novel about Italy as far as British artists and collectors were concerned, although the familiarity of British connoisseurs, and certainly of tourists, had been lessened by the interruption of the Napoleonic Wars. The significance of Prout, Harding or Stanfield lay in their popularizing role, their extension of the Italian experience to a wider public through the print trade. The most important visits of British artists to Italy in the earlier nineteenth century, in this sense, were those of Turner in 1819, Prout in 1824, and Harding and Stanfield in 1830. In addition to Turner's influence on this wider public through steel engravings, his watercolours and oil landscapes dominated the way in which later British artists looked at Italy. Bonington's Italian tour of 1826 also made an immediate impact through the handful of oils that he exhibited at the British Institution before his death two years later.

Besides the 1824 tour, one or two further visits to Italy by Prout in the later 1820s are likely to have taken place, and a sketchbook filled with the freest and hastiest of drawings probably belongs to the 1830s. Nonetheless, it is possible that the 1824 tour alone provided all the material for the uninterrupted series of watercolours shown at the OWCS between 1825 and 1841 and for the illustrations of the two first *Landscape Annuals* published in 1829 and 1830. During the later 1820s Prout's images of Venice were the most familiar ones to interested members of the British public with no first-hand knowledge of Italy. His influence on artists can be seen in the Venetian views that Edward Pritchett began to exhibit in 1833.[37] By this date Stanfield and Harding had ousted Prout from the *Annuals* and, therefore, increasingly from the popular imagination. Stanfield must have made a particularly strong impact on the London public with his 'Diorama of Venice and the adjacent Islands' exhibited in 1831; this combined his recent experience of Venice with his skills as a leading designer for the contemporary theatre.[38] There is only one slight hint from the 1830s that Prout had any interest in the latter (see **60,** a sketchbook containing a theatre ground plan).

Although his decision to visit Venice may not have been determined by Prout, Bonington was directed to particular sketching sites there by the older artist. It is worth noting that Prout's 1824 tour sketches (including **44** and **45**) are closer than his other drawings to sketches by Bonington and it would be fascinating to know whether or not Prout's advice on landscape subjects was accompanied by any inspection of his 1824 Italian tour portfolios. One instance of the two artists adopting the same sketching point (at Verona) is discussed in the Catalogue (**44**).[39]

The observation that Ruskin's praise for Prout has been counter-produc-

tive is particularly true for Venice, which is described in poetry by Turner
and Bonington while Prout sticks to prose. The critical view, Ruskin's
included, has the advantage of hindsight. Thomas Uwins' contemporary,
indeed anticipatory, opinion provides a helpful historical corrective. 'When
I left England, one of my waking dreams was to do a series of views of
Venice for publication. I had hardly descended the southern side of the
Alps when I heard of Prout being there for the same object, and as I knew
he would do the thing much better than myself, I instantly abandoned
it.'[40] This was written of 1824 in 1826, the year that Bonington made his
visit to Venice. Prout's Venetian views never materialized as a single vol-
ume like the *Illustrations of the Rhine*, although Prout in 1833 planned a
Sketches from Geneva to Rome, including Venice. Instead, Prout's Venetian views
were distributed among a number of lesser publications or appeared as
incidental illustrations. *Sketches made in France, Switzerland and Italy* (1839)
gives the closest idea of what might have been, but these lithographs are
comparatively large and heavy-handed beside the *Illustrations*, which are
much closer in date to Prout's 1824 tour and indeed far more accurately
capture the character of many of Prout's landscape drawings made on the
Italian lakes (fig. 20)[41] or near Rome (fig. 21)[42] and Naples. Ruskin's
enthusiasm was sparked off by some of these tour sketches, and it is these
which must be used as a measure of Prout's achievement in any comparison
between himself and the more brilliantly gifted Turner and Bonington.

This *caveat* to distinguish between published lithographs and site draw-
ings (fig. 22) needs to be made even more strongly in relation to the
watercolours of Venice (**56, 63**).[43] When Ruskin wrote *Modern Painters* (first
edition 1843), he knew only Prout's watercolours and lithographs, the
latter (*Facsimiles of Sketches made in Flanders and Germany*) having inspired the
Ruskin family's first tour abroad. His father had begun to buy Prout
watercolours from the OWCS about ten years earlier. For this reason,
and because he was writing about contemporary British painting rather
than the 'Elements of Drawing', Ruskin's critique of Prout as an interpreter
of Venice in *Modern Painters* was less eulogistic than, for instance, in the
later *Stones of Venice*. Nevertheless, even in 1843 Ruskin placed Prout be-
tween Turner and Stanfield:

> Let us pass to Prout. The imitation is lost at once. The buildings have nothing
> resembling their real relief against the sky; there are multitudes of false dis-
> tances; the shadows in many places have a great deal more Vandyke-brown
> than darkness in them; and the lights are very often more yellow-ochre than
> sunshine. But the effect on our eye is that very brilliancy and cheerfulness which
> delighted us in Venice itself, and there is none of that oppressive and lurid

FIG. 20 *Como, Lombardy*
Yale Center for British Art, New Haven

FIG. 21 *The approach to Rome*. Laing Art Gallery, Newcastle-upon-Tyne

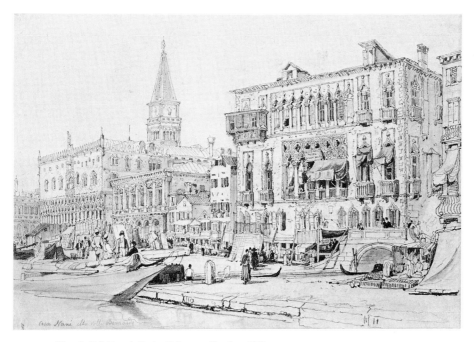

FIG. 22 *Riva degli Schiavoni, Venice*. Private collection, UK

gloom which was cast upon our feelings by Canaletti. And now we feel there is something in the subject worth drawing, and different from other subjects and architecture. That house is rich, and strange, and full of grotesque carving and character – that one next to it is shattered and infirm, and varied with picturesque rents and hues of decay – that farther off is beautiful in proportion, and strong in its purity of marble. Now we begin to feel we are in Venice. ... But let us look a little closer; we know those capitals very well; their design was most original and perfect, and so delicate that it seemed to have been cut in ivory; – what have we got for them here? Five straight strokes of a reed pen! No, Mr Prout, it is not quite Venice yet.[44]

When *Modern Painters* was first published, Prout was still living in Hastings and had not yet become a neighbour of the Ruskins at Denmark Hill. It was therefore surprising that he had the courage, in 1843, to write to the art critic about this passage. In reply Ruskin modified his criticism and amplified it:

the author *does* regret that he has not said more in praise of your works, and that, after going the rounds of Nash, Roberts, and many other architectural painters, he has come to the conclusion that there is more *genuineness*, more pure and impressive *truth* in your finest works, than in *any* of them, perhaps in all of them. I know he does not like your *brown* works, nor the *red* little bits that appear sometimes in the water-colour rooms, but your grey and cool works he says are the finest things, the most characteristic and impressive existing.[45]

Ruskin's public appreciation of Prout grew as he concentrated more and more on Prout as a draughtsman – a shift of emphasis that followed from Prout's return to London and Ruskin's first opportunity to see the sketches in Prout's studio. The critic expressed his new insight into Prout's art in a comment on the passage quoted from *Modern Painters*:

In spite of all that can be alleged of the mannerism, and imperfections of Prout as an artist, there is that in his drawings which will bring us back to them again and again, even after we have been rendered most fastidious by the exquisite drawing and perfect composition of the accomplished Roberts. There is an appreciation and realization of continental character in his works – a locality and life which have never yet been reached by any other of our architectural draughtsmen ...

By 1857, in the *Elements of Drawing*, Ruskin actually advocates learning to draw by copying from works by Prout, from the *Illustrations of the Rhine* of 1824 to the *Microcosm* of 1841[46] – a method of instruction proposed by Prout himself in his drawing manuals published between 1813 and 1821! According to the *Somerset House Gazette* in 1824, 'many young persons ...

struck by the simplicity of his style, have set sedulously to work "*to draw from Prout*".'[47]

Prout's status in the hierarchy of British watercolourists was high by 1821 when he received a long notice in a review of the OWCS in the *Magazine of the Fine Arts*, a review that otherwise concentrated on Copley Fielding, Joshua Cristall, and G.F. Robson. The reviewer picked out *A man-of-war ashore* (a very large watercolour measuring $26\frac{1}{2} \times 38\frac{1}{2}$ in), which was bought by Thomas Griffith for £25 including the frame and glass (fig. 23):[48] 'Mr Prout's broad large style is extremely well adapted to subjects containing large masses, such as shipping, old buildings, and distant groups, and his mode of execution seems most rapid and masterly.' The reviewer, however, shared the doubts of later critics: 'the use of a brown colour which is substituted for shade, preserving the chiaro-scuro, and obtaining warmth where it ought not to exist'.[49] Walter Fawkes bought a cheaper (8 guineas) and, no doubt, smaller *Shipwreck*, in the same exhibition. Buyers in the 1823 exhibition included the Marquis of Lansdowne, J.W. Russell, Francis Broderip, C.H. Turner, Sir Abraham Hume, George Haldimand and several members of the Stafford family. Charles Holford, George Morant, Lord Brownlow, Sir William Watkins Wynne, the Duke of Devonshire, the Duke of Bedford, and Richard Bernal had joined the list of Prout's patrons at the OWCS by 1830.

Prout received his most flattering notices from the *Somerset House Gazette*, which was an Ackermann house-magazine edited by W.H. Pyne, Ackermann's *cicerone*. This short-lived periodical naturally favoured watercolour painting above the other arts and attempted a serialized history along the way. Again, it was one of Prout's large wreck scenes that most forcefully struck the reviewer:

> When we look at the gigantic style displayed in this pictorial representation of that ingenious work of man, a huge ship; when we behold its stupendous bulk, thus portrayed on thirty inches of paper ... we are lost in the disparity of human intellect and see in this picture, as in the writings of Shakespeare ...

There then follows the well-known passage pointing out that Prout's continental subjects had brought a welcome change of menu to the annual exhibitions:

> Much of the additional interest of the two or three last exhibitions of this Society has been derived from the introduction of many fine topographical works, from the pictorial scenery of the Continent. We had begun to tire of the endless repetitions of Tintern Abbey from within, and Tintern Abbey from without, and the same by moonlight, and twilight, and every other light in which taste and talent could compose variations to the worn-out theme. So

with our castles – old Harlech, sturdy Conway, and lofty Caernarvon, have every year of late, lost a century at least of their antiquity, by being so constantly brought before us, and if not let alone, will soon cease to be venerable.

With particular reference to an *At Frankfort*, a *South porch of Rouen Cathedral* and a *Porch of Ratisbone Cathedral* (**51**), Pyne continued:

Such original examples of the picturesque give a new impulse to art. The above-mentioned subjects, however, are of a more sketchy character, and not on a large scale. There are some views of towns, and some river scenes, of large dimensions, by Mr Prout, which, for pictorial character, originality of effect, depth of tone, and general energy of style, excel all his former works, and may be regarded as wonders in water-colours.[50]

The watercolours reviewed were bought by Francis Chantrey and Charles Turner.

Haydon's idiosyncratic view of the state of the arts in 1826 and 1827 finds a place for his old schoolfriend. He sees all that was significant in contemporary British Art as descended from Wilkie, Turner, and himself. From Turner descends 'Water-Colour Painting – the whole', and the children entered on the family tree are Calcott, Constable, de Wint, Prout, and Hofland. Stung by 'a member of a Foreign Embassy' who made the mistake of being patronizing about an exhibition in 1827, Haydon mentions 'Robson & Prout' among Lawrence, Calcott, Etty, Collins, Mulready, Wilkie, Hilton, Martin and Havell.[51] To those who restrict their unfavourable criticism of Prout to a comparison with Cotman, it is worth noting that Cotman owned Continental views by Prout and that the two artists exchanged publications.[52]

There is little information available with which to chronicle Prout's social life. However one can picture him going about London in the 1820s and being welcomed into the homes of the aristocracy as he came to teach their daughters and sons. Among patrons with whom Prout was not connected through his teaching was Lord Northwick, who showed him the pictures at Connaught House and told the artist that he intended to hang one of his pictures in the drawing room because of 'the delightful Recollections it recalls'.[53] Prout was, naturally, on even closer terms with lesser patrons such as John Allnutt and Francis Broderip ('my *patron extraordinary*').[54]

Prout's artist friends included John Jackson, Francis Chantrey and Charles Eastlake. Clarkson Stanfield and David Roberts can be added in the 1830s, if not before. Several of Prout's friends belonged to the print-publishing trade and he was familiar with the Ackermanns, the Cookes,

FIG. 23 *An East Indiaman ashore*
Whitworth Art Gallery, University of Manchester

Thomas Boys, and a fellow Devonian, William Brockedon. In 1829 Prout began to attend the Artists' Conversazione quite regularly; this gathered fortnightly on Saturday evenings from January to April. E.W. Cooke records two occasions when Cotman and Prout met at the Conversazione in January 1829: 'Dined & went with Father [George Cooke] & Mr Cotman to the Conversazione at Freemason's Tavern, very full meeting, saw Sir Thos. Lawrence, Mulready, Stanfield, Prout, Harding, Cox etc. etc.' Three days later, 'about 4 o'clock Messrs Cotman, Prout, Cox and Cox Junr, came, after which Stanfield and Robson, then Mr Upcott and Burnett, dined about $\frac{1}{2}$ past 5 ... Thos Boys came ... Mr and Mrs Gillham came. All put our autographs in Mr Upcott's book. About 11 all the Artists left.' At the Conversazione in March, Cooke 'saw some magnificent drawings by Turner, Stanfield, Prout, etc. etc.'[55]

At this time of year Prout's efforts must have been focused on finished watercolours for the OWCS exhibition which opened in April. After the close of the annual exhibition the artist would be free to organize a summer tour.

Due to the survival of account books, much more is known about Prout's financial position after 1824. His income averaged £600, to which fees for teaching of £60–£100 a year should be added. His income must have

reached about £1000 in 1830 due to a payment of £360 for the second *Landscape Annual*; typically David Roberts was able to do better for the 1835/7 volumes, getting £420 rising to £500.[56] Prout was producing about 70 drawings a year, and more during the *Annual* years. His production was mostly of small watercolours (called small drawings), rather than sepias or ink sketches which are also mentioned. Despite the fact that he was at the height of his career, Prout still received around two-thirds of his income from the dealers. It is significant that the number of his private clients, as distinct from dealers, fell from 23 in 1824 to only nine in 1830.

Prout was doing business with about 20 dealers who retailed his water-colours or, increasingly, bought them at the OWCS. About half his income was derived from fees for book illustrations; from W.B. Cooke for *Picturesque Views on the South Coast* (1825); from George Cooke for *Views in London and its Vicinity* (1827); from W. & E. Finden for Brockedon's *Road Book from London to Naples* (1831) and *Lord Byron* (1832); from John Murray for *Sketches for Venetian History* (1839). (The bracketed dates refer to the year in which Prout received payment.)

The dating of the continental views in watercolour remains uncertain. It will be noticed that precise dates can be suggested for only a very few of those catalogued here, e.g. *Porch of Regensburg Cathedral* (**51**), which ought to be that purchased by Richard Ellison at the OWCS in 1832. Similarly the *Munich* (fig. 24) at Arundel ought to be that bought by the Duke of Norfolk at the OWCS in 1824. Other watercolours tentatively assigned to the 1820s here are: a *Forum of Nerva, Rome* (**46**) (see colour pl.), *Domodossola* (**47**) and *Porch of Ulm Cathedral* (**48**) (see colour pl.). For none of these last is there firm documentary evidence for dating.

With the exception of *Munich*, this group does not exhibit any charac-teristics that cannot be found in pictures apparently painted towards the end of the artist's career such as *Café de la Place, Rouen* (fig. 14) of 1845, or *The Arch of Constantine, Rome* (**65**) (see colour pl.), presumably that acquired by Townshend at the OWCS in 1850. The latter is very similar in handling to the *Forum of Nerva*! One is therefore forced to the lame conclusion that Prout, like other artists, retained more than one style for different purposes throughout his career, rather than a single style or a manner that developed and changed and which could be described as on a graph. Prout's perform-ance was dictated by the scale and relative importance of an individual production, rather than on the date at which a watercolour was painted. It was also no doubt affected by ill health, but did not noticeably deterior-ate after 1830, by which time his health was already intermittently bad.

Munich (fig. 24) is a much more studied performance than is usual for

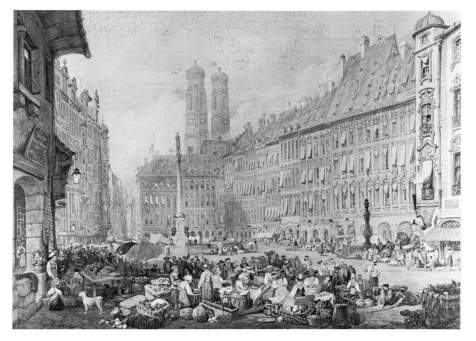

FIG. 24 *Munich, Bavaria*
Arundel Castle Collection

Prout and should not be taken as exclusively characteristic of the 1820s
except perhaps for his largest works of this decade. It measures 29 × 43 in
and carried the exceptional price tag of 50 guineas. The exceedingly elab-
orate figure groups, and careful repetitive vertical markings for the receding
buildings surrounding the market place, no doubt justified the price to
Prout's tender conscience. There is a pair to this picture – *Milan Cathedral
from the west* – bought for 50 guineas by Lord Surrey at the OWCS in
1826.[57] The crowded piazza and rather monotonous setting out of the
receding space is common to both pictures, although the figures in *Milan*
are less carefully (and less well) described. Whereas the emphasis in *Munich*
is on the left (a Tuchhandlung shop) with shadows cast left to right, *Milan*
has a 'Cafee Duomo' on the right with the shadows cast from right to left.
The site drawing for *Milan* (Oldham Art Gallery) lacks this degree of
management. The engraved view in the 1830 *Landscape Annual* employs the
same arrangement of shadows but not the detail of the extreme foreground
right and left, which was dictated by the arrangement of the foreground in
Munich.

 On the evidence of *Munich* and *Milan*, other large and elaborate water-
colours suggest themselves for the 1820s. A *Tournai* in the Whitworth collec-
tion (fig. 25) is one such and is the same view as pl. 8 in the 1833 *Facsimiles*

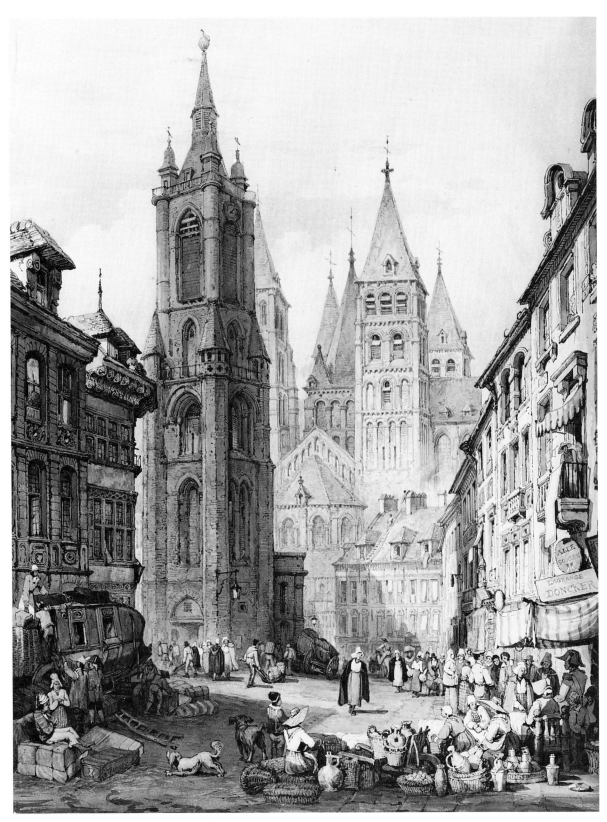

FIG. 25 *Prison and Cathedral at Tournai, Flanders*
Whitworth Art Gallery, University of Manchester

of Sketches made in Flanders and Germany.[58] The figures and general 'staffage' in the watercolour are closely comparable with those in *Munich* and also to those in *Ulm* (**48**). The view is exactly that taken by Joseph Farington in a pen-and-wash drawing dated 1793.[59] This coincidence is worth mentioning because of Farington's use of the broken pen-line style, a graphic technique through which he and Girtin, amongst others, have been associated with a tradition that may go back to Canaletto's drawings. Farington's pen-and-wash drawing, *The Prison and part of the Cathedral at Tournay*, entirely anticipates Prout's division of a watercolour into foreground and background, and a contrast between a strongly drawn and warmly coloured foreground articulated with the reed pen, and an indefinite and coolly coloured distance.

Another candidate for the 1820s is the magnificent panoramic view of *Cologne Cathedral from the Rhine* (Exeter Museum, 23.1948.2), formerly in the Nettlefold collection (fig. 19). This is far too ambitious to be the OWCS exhibit (5 guineas) of 1823, and more likely to be the 25-guinea *Cologne* bought by Arrowsmith the following year and subsequently exhibited by him in the Paris Salon. This is essentially the same formula as *Durham* (fig. 11) of nearly ten years before, but *Cologne* is more studiously and neatly worked, with scores of figures from contemporary life. If this definition of a large watercolour style in the 1820s is accepted, and it is assumed that Prout did not use it in later years, then other candidates can be proposed on a purely stylistic basis.[60]

Notes

1. There are four other identified drawings at Greenwich: *Rouen* (3), *Pont-de-l'Arche* and *Caudebec*.
2. Colnaghi, May 1984, *English Drawings and Watercolours* (35), Christie's, 15.11.1983 (211).
3. *Rouen, St Laurent*, watercolour, 15¾ × 13 in, Manchester CAG 1890.21, based on a drawing ins. *St Laurent/Rouen*, Birmingham MAG P 106'51. The companion watercolour at Manchester (1890.20), *Harfleur* is based on a drawing at Barnstaple.
4. Williams, *Early English Watercolours*, 1952, figs. 280 & 281 juxtaposes the two artists. For comparable Edridge drawings see H. Smith, 'The Landscapes of Henry Edridge ARA', *OWCS*, 52, 1977, pl. VI & VIII.
5. H. Smith, 'British Landscape Artists working in France 1814–1824', 1975, unpub., 38, 40 and op. cit., 1977, 18 ff. See also Roget, I, 476/7; Williams, op. cit., 182; Howgego, 5; Hardie, III, 4.
6. Birmingham MAG P 125.79. Another Birmingham drawing (P 79.79) of *Chamonix* together with a *Geneva* (BM 1922-10-17-42) are, in my view, indistinguishable from some Edridge drawings e.g. *Eton from Windsor Castle*, 1806 (Yale CBA B 1975.3.1007). Prout's *Bolton Abbey* (Yale CBA B 1977.4.5458) of *c*. 1818, parallels an Edridge *Exeter Cathedral* (Sotheby's 16.3.1978, lot 58).
7. Presumably James Ward and G.F. Robson.
8. *Drachenfels*, illus. Ruskin, *Notes*.
9. 'The Pfalz', *Illustrations*, pl. 19 pub. 1824. 'Lahneck' and 'Ehrenbreitstein' are other particularly fine landscapes.
10. Swenson, 22. See also Abbey, *Travel*, 219.
11. Taylor wrote to Lord (?): 'I shall indeed be happy if he stays long enough at Munich to undertake a drawing for me of the Market Places where he will find some curious old Buildings as well as a variety of Costumes amongst the Natives.' Barnstaple, N. Devon Athen.

12. B.S. Long, 'The Salon of 1824', *Connoisseur*, 68, 1924, 66 ff.
13. Smith, 1975, op. cit.
14. Twyman, Ch. 15 and 245 n. 6. Prout's three original lithographs appeared in Vol. 3, *Franche-Comté*, 1825.
15. Plymouth MAG transcript.
16. BL Add. Mss. 42523 f. 5.
17. Ibid. f. 4.
18. Ibid. f. 7. to John Jackson, who painted a portrait of Prout in 1823 (NPG 1618) illus. Halton, pl. II.
19. *Sketches from Venetian History*, 2 vols. 1831/2.
20. Uwins, II, 12, 27/30: 'Ackermann and Prout proposed to me to do the literary part of their work on Venice.'
21. A.N.L. Munby, 'Letters of British Artists of the 18th & 19th Centuries', *Connoisseur*, 118, 1946, 112 and illus. Chas. Turner's portrait of Prout (NPG 1245.)
22. BL Add. Mss. 42523, f. 13.
23. *Wanderings by the Loire* (*Turner's Annual Tour 1833*); *Wanderings by the Seine* (*Turner's Annual Tour 1834 & 1835*); Samuel Rogers, *Italy*, 1830 ed.; Samuel Rogers, *Poems*, 1834.
24. Tate Gallery, *Turner 1775-1851*, 1975, 84/5; A.J. Finberg, *The Life of J.M.W. Turner, R.A.*, Oxford 1939, 256/7.
25. E.g. Dr T. Cogan, *The Rhine, or a Journey from Utrecht to Francfort*, 1794; Sir John Carr, *A Tour through Holland . . . to Germany*, 1807; Baron I. von Gerning, *Picturesque Tour along the Rhine*, 1820; Capt. R. Batty, *Scenery of the Rhine, Belgium and Holland*, 1824; W. Tombleson, *Views of the Rhine*, 1832.
26. P. van der Merwe, *Clarkson Stanfield*, Tyne & Wear, 1979, 134; *Cologne* by Prout (fig. 19): watercolour, 16¼ × 24¼ in (Exeter Mus., 23/1948.2), illus. in Grundy & Roe.
27. Mrs C.A. Stothard, *Letters written during a Tour through Normandy . . .* 1820. 'Singular to observe he received his death blow from one of the very effigies that had so long been the subject of his pencil.' *Magazine of the Fine Arts*, 1821, 304.
28. II, 328: 'The coloured drawings by Cotman are rich delineations of art . . . his more remarkable pictures . . . are not often equalled by any representations . . . at the London exhibitions.'
29. 51: 'the drawings and etchings of M. Cotman, of which I heard much from the inhabitants'.
30. Ibid., viii/ix.
31. *Voyages pittoresques*, I, 1820, 2.
32. E.g. the *Tour du Gros Horloge, Evreux* in lithograph by Bonington (C. Peacock, *Richard Parkes Bonington*, 1979, 101) and a drawing by Prout (Ruskin, *Notes*).
33. J.D. Harding, *A Series of Subjects from the Works of the Late R.P.Bonington*, 1830, represents an obvious example of transmission.

34. *Monumens les plus remarquables de la Ville de Rouen*.
35. T.F. Dibdin, *A Bibliographical and Picturesque Tour through France and Germany*, 3 vols. 1821, III, 45.
36. Lt Col R. Batty made a similar attempt at precisely this time: *Hannoverian and Saxon Scenery*, 1829. His *Wernigerode* is Proutish.
37. E.g. Parkin Gallery, *The English in Venice*, 1972.
38. Merwe, op. cit. (127, 128).
39. C.R. Grundy, 'Richard Parkes Bonington', *Connoisseur*, 72, 1925, 57, illus. the Verona drawing. In this instance the two artists looked in different directions; for an almost identical view of the Ducal Palace, Venice see Peacock, op. cit., 63 and Ruskin, *Notes*.
40. Uwins, I, 387 quoted by Hughes, *OWCS*, 11.
41. *Como*, graphite and stump and white on buff, 26.3 × 37.2 cm. (Yale CBA B 1975.3.1072).
42. *The Approach to Rome*, graphite and stump and white on grey, 10½ × 16¾ in. (Newcastle, Laing AG, 26.190 r.)
43. *Venice, Riva degli Schiavoni*, graphite, stump and rubbing on white wove, 10 × 14½ in, ins. *Casa Nani altre volte Bernardo* (priv. coll.); Prout sold a watercolour under this title at the OWCS in 1839.
44. Works, III, 256.
45. Ibid., XXXVI, 336.
46. Ibid., XV, 221/2.
47. II, 151.
48. *East Indiaman ashore*, Manchester, Whitworth AG, D 5 1899, watercolour, 19½ × 27½ in; i.e. smaller than the premium-sized picture reviewed.
49. 121/2.
50. II, 477/8.
51. W.B. Pope (ed.), *The Diary of Benjamin Robert Haydon*, Harvard, Vol. 3, 1963, 100 & 203.
52. M. Rajnai, *The Norwich Society of Artists 1805-1833*, 1976, 76.
53. Plymouth Mus., transcript.
54. Cambridge, Fitzwilliam Mus., Ms. 169.1949.
55. Transcript of the diaries of E.W. Cooke by John Munday. Quoted by kind permission of C.G. Cooke, OBE, and John Munday.
56. J. Ballantine, *Life of David Roberts, R.A.*, Edinburgh 1866, 73/6.
57. Watercolour (Arundel Castle Coll.). Notes at Plymouth Mus. quote a payment to Lord Surrey of £72 in connection with a *Milan*, the OWCS 1826 picture and one other.
58. D 22.1904, 25 × 19 in. The related lithograph is illus. by Halton, pl. XIX.
59. Pen and watercolour (priv. coll.). The 1793 tour was related to a projected publication of Low Countries views by Boydell. Farington also anticipated Hastings as a

picturesque site. A sketchbook filled with
Welsh views on 1795 paper, at Barnstaple,
attributed to S.G. Prout (from whom it no
doubt reached this collection) is ins.
Farrington (*sic*) and should be attributed to
Joseph Farington, and is evidence of a
connection between Samuel Prout and the
older artist.

60. Among other candidates for the 1820s are:
Würzburg (fig. 33), (Manchester, Whitworth
Art Gall., D 21.1904) and another *Würzburg*
(fig. 34), (ibid., D 23.1924) for which see **52**;
Strasbourg (Ashmolean Mus., Oxford, W.V.
Patterson Gift 1943), a watercolour, $24\frac{1}{2} \times$
$18\frac{1}{2}$ in, of the highest quality and in
excellent condition, is a prime candidate for
the OWCS 1822 exhibit (85) sold to B.
Oakley for 35 guineas. This last is the same
view as *Fascsimiles* (1833) pl. 36 illus. Halton
pl. IX.

IV London and Hastings: 1830-40

Although it may not have been evident to Samuel Prout or to anyone else, his career was in decline from 1830. He broke no new topographical ground at home or abroad thereafter. He did not attempt to raise his watercolour prices beyond the 60 guineas ceiling that he had imposed on himself, and his attempt to publish his own work directly rather than through the trade was only a partial success. Two factors were against him: his lack of health was now well established, and political conditions in Europe during the early 1830s were unsettled and discouraging for lengthy tours. There were years when a sketching tour to Holland, Belgium, France, North Italy or even Switzerland must have seemed uninviting. Those of Prout's journeys for which there is evidence are relatively unadventurous – to Calais and Paris and perhaps the Loire in 1833, and to the Seine in 1834, when he was taken ill and had to lay up for three weeks in Paris. No tour abroad can be definitely established for him between 1834 and 1845, when he was welcomed in Brussels as a significant contemporary foreign artist who had specialized in portraying Flemish towns.

Prout's one novel experiment of the 1830s was his publication by subscription in 1833 of *Facsimiles of Sketches made in Flanders and Germany* (fig. 26). A subscription notice was circulated in July 1832 when he and his family had to put in a great deal of effort to solicit support from friends and patrons. Much correspondence to 4 Brixton Place survives and this expresses considerable affection for the artist, wishing him better health and ordering copies, 'india' or 'grey'. Sir George Beaumont wanted a copy on grey paper, and Lord Dover the same: 'I should prefer my copy not on Indian paper – I may be wrong, but I own I think the thicker & tougher paper suits better the sort of lithographic drawings which your work is to consist of.' Lady Howard de Walden 'wishes she could hear that Lisbon had been pointed out by Mr Prout's medical attendants as the best place for him to pass his winter in'. Some of this correspondence relates to the follow-up volume planned for 1834 to cover the ground from *Geneva to Rome*, a more specialized work than the *Sketches in France, Switzerland and Italy* that finally emerged in 1839.[1]

The artist had 300 copies printed on grey paper at 5 guineas and 150 copies on India paper at 6 guineas. Hullmandel undertook the printing for £550. The Prout family distributed copies to the subscribers and some ten dealers sold copies to non-subscribers at a considerable discount, allowing them to buy at just over £3 and £4. H.W. Burgess, E.W. Cooke, W. Brockedon and Prout's surgeon received complimentary copies, and Prout exchanged publications with Britton, Allnutt and Cotman. In 1834 50 unbound copies, together with the reprint rights, were sold off to Charles

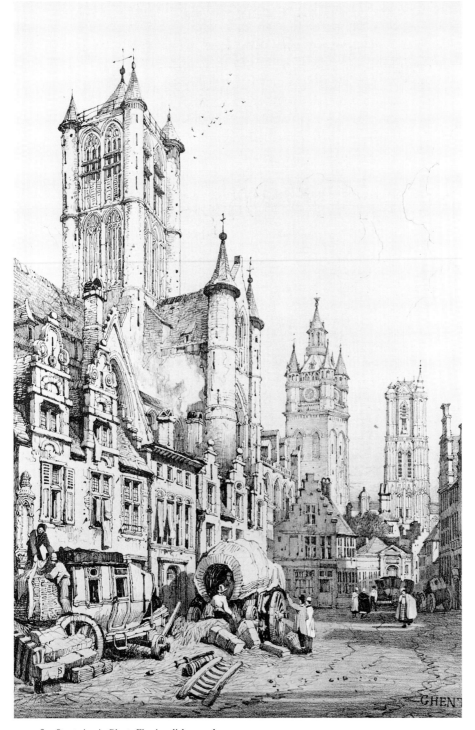

FIG. 26 *Street view in Ghent, Flanders*, lithograph,
Facsimiles of Sketches made in Flanders and Germany, 1833

Tilt for £375. The overlapping accounts are difficult to interpret but the profits may have amounted to around £2000 over three years, as against £450 that Prout received from Hodgson & Graves for the second volume published in 1839. Clearly, if his health had allowed, Prout would have attempted to publish this second volume himself. One suspects a lack of skill in negotiation; Clarkson Stanfield received 750 guineas from the same publishers in 1838 for his *Sketches on the Moselle, the Rhine, and the Meuse.* Ironically, the contract made specific reference to Prout's *Facsimiles* of 1833.[2]

The *Facsimiles of Sketches made in Flanders and Germany* was the publication that sent the Ruskin family off on their first tour abroad, and its novelty in 1833 should be stressed, since similar but technically more sophisticated works by artists such as T.M. Richardson, J.D. Harding, T.S. Boys, Clarkson Stanfield and Louis Haghe still lay in the future. The fact that many of these featured the Low Countries attests to the continuing novelty of this landscape as far as the British public was concerned.[3] It is surprising how long it was before Prout's *Facsimiles* appeared, since the relevant sketches had in many cases been made up to ten years earlier, although the featured cities of Prague and Dresden belong to the tour of 1829. The *Facsimiles* are now perhaps the best known of Prout's lithographs, because E.G. Halton included 42 out of 50 of them in his 1915 *Studio* special number. Of the few plates not reproduced, the majority are of the Rhine.

Halton's reproductions convey Prout's mastery of his subject; street views thronged with local inhabitants and local transport. The skill in composition is belittled by repetition, however, and the *Facsimiles* fails to reach the same heights as the *Illustrations* because it lacks the variety of landscape. More compositions such as the river view of *Würzburg with the Marienberg* (Halton, pl. XXIX) would help to point up the brilliance of the *Ulm Rathaus* (Halton, pl. XXXVIII). On the whole, Prout rested his case on the sheer novelty of his subject matter, presenting first glimpses of foreign towns such as Regensburg (**51**) and Dresden (**55**).

Halton does point out the size of the original lithographs, approximately 17 × 11 in, but his small-scale reproductions are nonetheless misleading as to the quality and effect of the *Facsimiles*, which is more monumental and less delicate in effect than the *Illustrations*. The figures, on the larger scale, are heavy. Although the architectural detail is closely modelled on that of the smaller site drawings, the overall effect is different and prevents them from fulfilling the promise of *Facsimiles*. The lithographs are akin to drawings, with liberal use of the stump but, like contemporary French lithographs, they are more evenly and fully toned.

There is no doubt, however, of the impact made by the *Facsimiles*, and when David Roberts acknowledged a debt to Prout a few years later, it was probably these lithographed tour sketches that he had in mind. A direct influence can be proved for T.S. Boys, who used exactly Prout's viewpoint of the *Porch at Ratisbon Cathedral* (**51**) (Halton, pl. XXXV) and the *Hotel de Ville, Louvain* (Halton, pl. XV) for his *Architecture pittoresque dessiné d'après nature*, published in Paris in 1835, and in his *Picturesque Architecture in Paris, Ghent, Antwerp, Rouen etc.*, published in London in 1839.[4]

The street view in Ghent is a good example of Prout's skill at introducing contemporary life. In this case the street furniture features a diligence and covered waggon in the foreground and other carriages further off. One of the site drawings shows that the artist actually found the foreground diligence and waggon much further down the street but, appreciating their picturesque value, caused them to call at a different address in the later lithographed composition.[5]

Just as Prout played a leading role in launching the lithograph, so he was in the forefront of the development of the 'annual'. Beginning with Ackermann's *Forget-me-Not* in 1826, Prout went on to provide illustrations for the *Keepsake* (from 1830), the *Remembrance* (1831) and *Fisher's Drawing-Room Scrap-Book* (1837). Robert Jennings selected him as the illustrator for the first two *Landscape Annuals* for 1830 and 1831. These were illustrated guided tours with anecdotal stops along the way: 'The Englishman who visits Verona eagerly seeks for some authentic relic to connect the Scene before him with that most touching of all dramas – Romeo and Juliet.' (Rome) – 'To an Englishman it is not amongst the least interesting associations with which the Capitol is invested that it was the scene of Gibbon's meditations when he conceived the vast design of becoming the historian of the ruins around him.'

The two volumes together give some idea of the selection of subjects which might have appeared in his planned second volume of lithographed 'Sketches containing Fifty Architectural and Picturesque Subjects From Geneva to Rome, including Venice'. The 52 prints after Prout, which included several expansive views of the Alps and of the Italian Lakes, were produced by 23 engravers 'under the direction of Mr Charles Heath' (figs 27, 28).[6] The character of Prout's landscapes comes across surprisingly well and this implies close contact between originating artist and supervising engraver:

> Pray pardon my not sending the touched proof before. I have altered the effect by taking away a good deal of dark in the interior, & giving the shadow over two of the columns which will produce a middle distance. The left side should

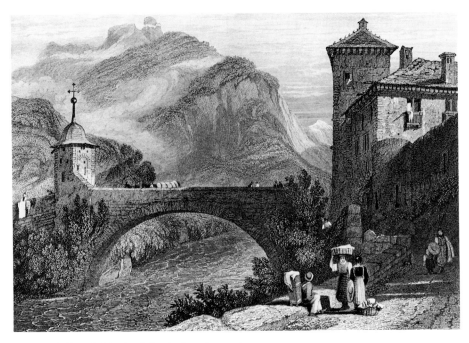

FIG. 27 *Bridge at St Maurice, Switzerland,* steel engraving
by J. B. Allen after Prout, *Landscape Annual, 1830*

FIG. 28 *Barbarigo and Pisani Palaces, Venice,* steel engraving
by W. R. Smith after Prout, *Landscape Annual, 1831*

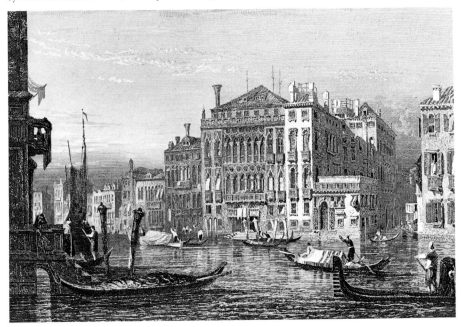

also be much lighter, and the foreground one tint darker. If you approve of the alterations, I am satisfied it will be a more pleasing print. . . .'[7]

The relationship between illustrator and author was less close. There is a letter that proves that Thomas Roscoe, the journalist chosen for the project, depended on Samuel Prout to identify his sketches![8] These seldom relate to or are illustrative of the text. Roscoe, for intance, disapproved of the wash-houses at Geneva which Prout makes a feature of his foreground.

The publisher probably originally intended to exhaust Italy in one volume and then pass on, but, 'Rome and Venice are not places to be passed over in a season', and Roscoe and Prout were given a second bite at the Italian cherry (fig. 28). In fact a third Italian volume was allowed in 1833, but Roscoe's text on this occasion was accompanied by illustrations after J.D. Harding, Prout's principal rival as a lithographer and (soon afterwards) as an exponent of the published drawing manual. Prout expected to be retained for this third Italian volume and his displacement does not reflect well on Harding. Had Prout illustrated this final Italian volume which included Naples and Genoa, then the three *Landscape Annuals* might have covered the same territory as the sketches (mostly in the Birmingham collection) given here to the 1824 tour.

Samuel Prout was evidently on very good terms both with David Roberts and with Clarkson Stanfield in the 1830s.[9] His correspondence with Roberts and with his Hastings friend J.H. Maw, however, makes it clear that he had had a serious quarrel with Harding – a unique circumstance in Prout's biography. He described the 'cause of Mr H's violent and virulent dislike' as 'an ancient affair' in a letter to Roberts in 1840:

> I was candid, & I thought friendly in endeavouring to convince him that he had done wrong & was premature in accepting the Landscape Annual, without mentioning the circumstance to one of his best friends, especially as his agreement was to his [? Prout's] disadvantage ... the insulting letter accused me of being mean, narrow-minded, ungentlemanly, & that my tendency to crooked behaviour influenced me to accuse others. The affair of the plate to Mr Griffiths is news, being ignorant of it, I grieve that after such a length of time he still feels bitterness. Accept my warmest thanks for your kind interference.[10]

In an undated letter to Maw, Prout says: 'Mr Harding is a gentleman ... to you, his observations are most respectful, but he has called me "mean, narrow minded, & unmanly", & has "expressed his conviction that my tendency to crooked behaviour makes me stiffly persist in accusing others".' Prout had apparently written to Harding, a letter shown to Thomas Griffith 'who considered it that of a gentleman'.[11]

The rift with Harding, if it occurred in 1831 when the illustrations for the 1832 *Annual* would have been commissioned, must have been awkward since they were jointly to provide illustrations for another Roscoe annual published by 'Peter Jackson, Late Fisher & Co', namely the *Continental Tourist*: 'Views of Cities and Scenery in Italy, France, and Switzerland'. This ran to three volumes. Harding provided 73 of the 132 plates, and Prout 56, the balance coming from W.H. Bartlett, a co-worker for Britton with Prout way back in the first years of the century. This publication had a parallel French text. Prout's contributions are reused from the *Landscape Annuals* and, according to the account books, he did not receive any further payment for them.

Work for the print trade dominated the artist's life in the 1830s, and between the publication of his two great volumes of tour sketches in 1833 and 1839, Prout made a large number of lithographs for two Ackermann publications, *Interiors and Exteriors* of 1834 and *Hints on Light and Shadow, Composition etc.*, of 1838. He was paid £84 for the first and £250 for the second. The contract as recorded in the account book seems simple enough: 'Hints on light & shadow with 20 sheets of illustrations drawn on stone – with the original sketches for'. This hardly describes the fact that the 20 plates are made up of 93 individual lithographs, which are accompanied by 16 pages of introductory text, with further text for each plate. The text is unexceptional, but a much-corrected draft shows that the artist took a good deal of trouble over it.

Interiors and Exteriors, as its title implies, is a miscellaneous collection of views. These are taken from sketches made as early as 1818 and perhaps as late as 1833, and largely from the foreign tours that Prout made in the 1820s. A view of a ruined church in Edinburgh reminiscent of *St-Omer* (**40, 41**) shows the artist seated on the ground sketching. This would depend on an early sketch, while *At Blois* and *At Tours*,[12] could derive from a very recent visit to the Loire. The style of these lithographs seems to be moving to the new style promoted by Harding, Boys and Callow.

Hints is a much more attractive production, offered up with disarming simplicity: 'It is a mere attempt to convey instruction, in the simplest manner, and in the plainest language.' Prout disapproves of 'artists who make *high finishing* their resting place; whose laborious works are ostentatious displays of dexterity, with contracted feelings ...' He draws the students' attention to the Dutch Schools for light and shadow, and especially to Rembrandt.

The plates are all small, several to a page, and are admirable for their economy; Prout's means are limited, nothing more than black, buff and

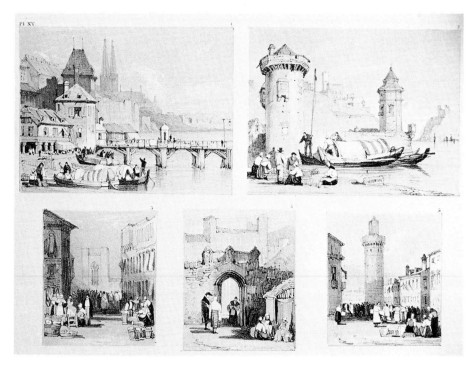

FIG. 29 *Hints on Light and Shadow, Composition etc.*,
lithograph, 1838

white (fig. 29). And yet the character of Venice comes across more con-
vincingly in these miniature, educational demonstrations than in the more
formal published engravings or in his finished watercolours. In general, the
variety of landscape composition is greater in the *Hints* than anywhere else
in Prout's *oeuvre*; it revives memories of the Rhine and the 1824 *Illustrations*
and reintroduces his early developed talent for seascapes. Among the figure
groups is the man in the tricorn hat (in reverse) familiar from the *Porch of
Ulm Cathedral* (**48**). Altogether, *Hints* fulfils its purpose and is a masterly
performance.

Prout completed a decade of work with *Sketches in France, Switzerland and
Italy* in 1839, a work planned to come out five years earlier as a second
Facsimiles of a tour 'from Geneva to Rome, including Venice', to quote
from the advertisement. By 1839 Prout was stylistically old-fashioned beside
Harding, Boys, Stanfield, Callow and newer tourists such as Lear and
Müller. The *Sketches* are less monumental in scale and effect than the *Facsi-
miles*, but once again Halton's reproductions (of 21 out of 26 plates) blur
the differences between them. Halton has made these two series of litho-
graphed views accessible to us, just as Prout made foreign streets accessible
to a wider public in the early Victorian age (the *Sketches* were dedicated to

Her Majesty). Even today, the view of the ambulatory of *Chartres Cathedral* (Halton, pl. III) is powerfully evocative and, with *San Marco, Venice* (fig. 30) and the *Duomo, Milan*, makes a trio of dramatic interiors of which few of Prout's contemporaries would have been capable. A drawing of *Tours* repeats the successful *Thein Church, Prague* and *Zwinger Pavilion, Dresden* of 1833. Prout's ability to handle a broader sweep of landscape, as in 1824, is evidenced in the 1839 volume through views of Basel, Lyons, Como and Venice. *Basel from the river* (Halton, pl. LX) puts one in mind of Boys and Callow, but should be related back to Prout's own sketches made on the Rhine tour of 1821 or the earlier sketches of 1819/20 on the Seine.[13] In general the *Sketches* are full of life, with accents carefully marked and occasional strongly marked outlines. The white highlights are sparingly but deftly applied.

The lithographs succeeded the soft-ground etchings as representing Samuel Prout's formal drawing style and, although described as sketches or facsimiles of sketches, are more aptly called finished drawings. *Amiens* (**53**) is proposed as an example of an actual on-site sketch from which the artist might have made a studio lithograph in the 1830s. Its more robust handling matches the enlarged scale of the *Facsimile* lithographs. A larger sample, however, is needed to establish a change of on-site sketch style from the more carefully worked drawings made in the 1820s. There are drawings, some with watercolour washes, and often on grey or buff-tinted paper, which could have been made on tours either in the 1820s or in the 1830s. These record the corners of streets and figure groups in France, Germany and Italy, and staffage appropriate to views of Venice (colour pl. VIII).[14]

A different style does occur when the artist makes rapid notes in his sketchbooks. There are three sketchbooks at Barnstaple and four at the Victoria & Albert Museum that are relevant, all but one of them used for tours at home. The Museum's sketchbooks are somewhat confused by the fact that they were used by others besides the artist; a book taken by Samuel to Northumberland and Cornwall, for instance (**57**), contains a drawing initialled *RP*, perhaps his eldest daughter Rebecca. It should also be mentioned that some sketches in this and also in **58-60** are very similar to the sketchbook (**71**) attributed to Samuel's nephew, John Skinner Prout. Several drawings invite comparison with the new and soon fashionable graphic style of Harding, Boys and Callow, and indeed of W.J. Müller, with whom J.S. Prout sketched in the early 1830s. Direct contact between uncle and nephew, either as master and pupil or as sketching companions, is not documented. It is also uncharacteristic that some of the drawings in

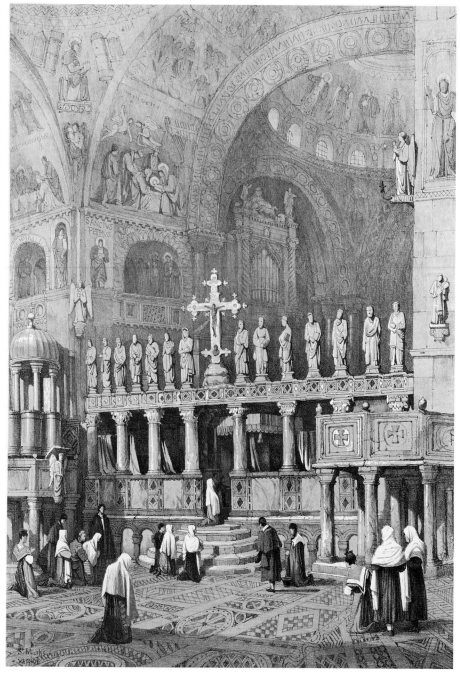

FIG. 30 *Interior of St Mark's Cathedral, Venice*, lithograph,
Sketches in France, Switzerland and Italy, 1833

the Museum sketchbooks (which came from the same source) are dated, which would put Prout in Northumberland in May 1836 and in South Wales in January and February 1835, not usually a time of year that he liked to stir out of his studio. Another book (**60**) contains some surprising Avon and Wye landscapes, two of which are enlivened with some colour wash in the manner of Lear in the mid 1830s. The sketchbook also has some quite characteristic fragments of Oxford, which Prout certainly visited in September 1840.

The three Barnstaple sketchbooks are less problematical. One, water-marked 1835, has coastal subjects and 'bits' that appear in *Prout's Elementary Drawing Book* of 1840. The coastal scenes, one inscribed *Hastings*, are freely treated and have colour notes, i.e. indicate an intention to make finished watercolours. Another sketchbook, inscribed by the artist *Hasty Sketches in Dovedale, Derbyshire*, also has a few colour notes, but otherwise belies any intention of turning sketches into finished works. The drawings are very hasty and for some reason Prout had acquired a sketchbook of the lowest-quality paper, which gave his pencil no assistance. The drawings do show that he could note the bones of a landscape without any difficulty.

The last of the three Barnstaple sketchbooks is similar in style and rapidity to *Dovedale* but is filled exclusively with continental landscapes on (unusually for Prout) a fine white laid paper bought in the Strand. The landscapes are distributed between France, Switzerland and Italy, with a street scene inscribed *Bayonne* on a folio between drawings of the Italian Lakes. The other French towns visited by the artist were Orléans and Poitiers (fig. 31) on the Loire, and Amiens, Laon and Reims in the north. There are numerous Alpine scenes and many views of the Italian Lakes; Arona, Bellinzona, Como and Lugano. Several folios are devoted to Venice. This sketchbook possibly reflects a tour made to supplement Prout's existing stock of drawings 'From Geneva to Rome, including Venice'. Again, however, the sketches are of such a hasty nature that it is difficult to see how the artist could have used them for finished compositions either in lithograph or in watercolour.

To the late 1830s, no doubt following the move to Hastings, should be dated many pen-and-ink drawings with sepia wash and white highlights, often on a smooth blue paper. These are commonly of marine and shore subjects such as groups of fishermen and fishing-boat tackle. The personality of these drawings is exactly expressed by figure groups in the *Hints* of 1836 and the *Microcosm* of 1841 (fig. 32). As in the 1820s, it is extremely difficult to characterize Prout's watercolour style in the 1830s in the sense of distinguishing it from his work at an earlier or later date. There are,

FIG. 31 *Interior of Poitiers Cathedral, France* (sketchbook)
N. Devon Athenaeum, Barnstaple

FIG. 32 *Prout's Microcosm*, lithograph, 1841

however, two watercolours in the Museum collection from the Ellison Bequest which can be dated to the 1830s with confidence, since they were both acquired by Richard Ellison at the O W C S exhibition of 1832. *At Ratisbonne* (**51**), the first of these, was published in the *Facsimiles* in 1833 and inspired Boys to make a lithograph of exactly the same viewpoint in 1835. The scene is complex: an oblique view through a Gothic portal laid out on a triangular plan so as to feature the richly carved free-standing pier silhouetted against the sky. A buttress of the west façade can be seen outlined through the arch. The ground falls away steeply to the west so that market place and streets lie at a much lower level. Prout further stage-manages the site through the introduction of figure groups on different scales, and dramatizes the whole with superimposed shadow forms. To distinguish this 1832 watercolour from another and, it is suggested, later version in the Manchester City collection, attention might be drawn to the carefully designed and balanced figure groups and the relatively even spread of watercolour across the paper. In the Manchester version the grain of the paper is frequently visible through the more thinly applied washes.[15]

The second Ellison purchase at the O W C S in 1832 was almost certainly bought as a pair with the first; the two pictures are identical in size, as they were in price (18 guineas each). *At Würzburg* (**52**) epitomizes Prout's work set just below the level of his most ambitious and expensive exhibition pieces. To compare Ellison's paintings with the grandest works dated here to the 1820s such as *Munich* (fig. 24) and *Tournai* (fig. 25), is to argue that the artist's talents were better suited to the B-team. At this scale, or at any rate in these two pictures, Prout's virtues are displayed to best advantage: the well-judged contrasts of graphic detail or weight and warmth of colour, the clever disposal of dark shadow forms. *At Ratisbonne* takes the palm for the management of figures; *At Würzburg* demonstrates how Prout, whose repertoire of subjects gathered on tour was now complete, attempted to maintain novelty by making variations on themes through different combinations of real views. *At Würzburg*, like many of Prout's continental scenes, is a capriccio. Some elements are taken from a highly elaborate horizontal format *Würzburg* (fig. 33), itself partly invention (see **52**), and others are borrowed from a vertical composition (fig. 34), both watercolours in the Whitworth collection.[16]

Prout's fortunes, as measured by the O W C S, were mixed during the 1830s. In 1830 itself he managed to sell a large 50-guinea *Ducal Palace, Venice* to the collector James Morrison, which impressed Dr Waagen with 'the great power of foreground peculiar to him ... here combined with an

FIG. 33 *At Würzburg, Bavaria*
Whitworth Art Gallery, University of Manchester

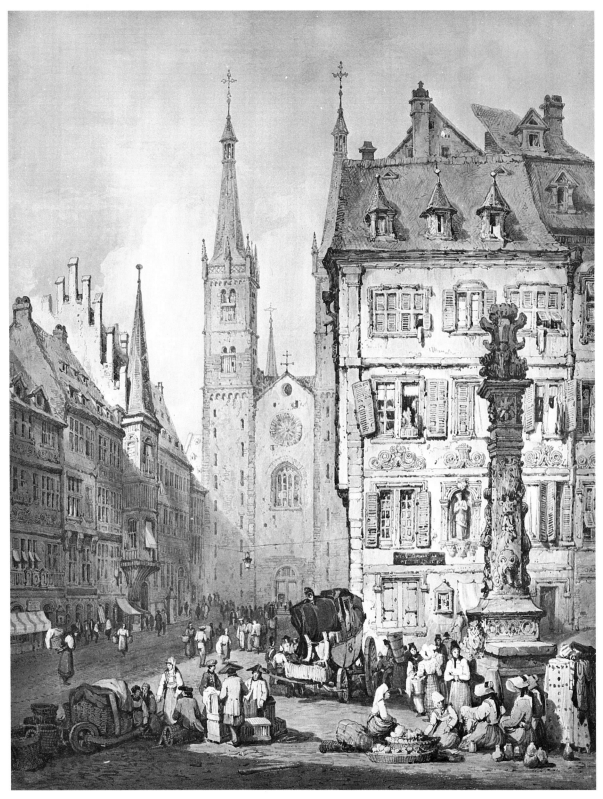

FIG. 34 *At Würzburg, Bavaria*
Whitworth Art Gallery, University of Manchester

unusual gradation in the various distances'.[17] Waagen did not notice too many watercolourists on his travels in Britain besides Turner and Copley Fielding. Fortunately, in 1839 J.H. Maw bought a 50-guinea marine picture, as this was a year when the artist had five watercolours returned to him unsold; maybe Maw was performing for Prout the role played by Archdeacon Fisher for Constable. Prout had given up teaching by this time and thereby lost one avenue to private clients. Ruskin senior, a buyer in the mid-1830s, scented a decline in the artist's reputation as measured by the art trade: 'The man in Newgate St says Prout is a mere Schoolboy now. Nevertheless I bought a small 6 Gs bit of Frankfort after hearing more of Prout's sufferings' (1838).[18] Queen Victoria was unaware of this decline and bought at the OWCS between 1838 and 1842; Prout was, of course, 'Painter in Water-Colours in Ordinary' both to herself and to Prince Albert. Prout was also included amongst 'the most eminent artists of the day' in *The Gallery of British Artists* (Vol. 2, 1836) and found by Ruskin junior on the walls of Lord Carew's Oxford rooms in 1837.[19] In 1840 the *Art Union* insisted: 'The always excellent artist maintains his ground; in some of the higher and better qualities of his art, he is still without a rival.'

The financial high point of Prout's career came in 1833-4 when his income was boosted by the privately published *Sketches*. If we include this unrepeated success, his average income from 1830-50 was £550, but if we look at his accounts for the years 1836-44 (Hastings) and 1845-50 (back in London), then the figure reduces to £425. In other words, any reserves that he may have been able to build up in 1833-4 were gradually eroded. There is an account book for part of the Hastings period (1839-44) which covers the domestic expenses of the Prout household, i.e. Mrs Prout's accounts. The outgoings for 1839 were £532, perilously close to Prout's income over the longer period and about £100 above his average earnings at that time. In 1839, however, his income had been temporarily boosted to £870 by the *Sketches in France, Switzerland and Italy*. His income fell dramatically to £497 in 1840 and to £361 in 1841.

Mrs Prout's accounts chronicle a middle-class household struggling for gentility. One of the children, at least, was learning the violin purchased for £1. 6s. Mrs Prout had three domestic servants who together earned £30 a year. The rent for the house was £11. 5s a quarter, or £45 a year. Poor rates, street rates, taxes, and church rates amounted to £15. The Prouts gave at least as much to their local church by supporting parochial schools, missionary societies, church sittings, etc. This particular household also had to bear an annual retainer of £12 for a surgeon. The three Prout daughters,

who were all living at home, received a quarterly allowance of £4. 5s., totalling £50 a year. Samuel Gillespie, then in his late teens, did not get an allowance and so some of his individual expenses are recorded, such as clothes (£12), hat (£1) and an excursion with his father (£12). There were few frills in the Prout household, where the ladies spent less than £10 on clothes in 1839. The butcher and wine merchant represent the essentials.

Notes

1. Barnstaple, N. Devon Athenaeum
2. P. van der Merwe, *Clarkson Stanfield*, Tyne & Wear, 1979 (203), 125/6.
3. E.g. Haghe's *Sketches in Belgium and Germany* (1840), with 26 tinted lithographs and his *Portfolio of Sketches* (mostly of Belgium) of 1850 with 27 tinted lithographs; Harding's *Sketches at Home and Abroad* (1836) with 50 tinted lithographs.
4. A view of *Dresden* from the river (Birmingham MAG, 274'27) illus. *British 19th Century Watercolours and Drawings*, British Council 1983 (5), is another example of Boys following in the footsteps of Prout (Christie's, 17.11.1981, lot 85).
5. Plymouth MAG, 162.14, graphite on buff wove, 16¾ × 11¼ in, sight size.
6. *Bridge, St Maurice*, eng. J.B. Allen for *Landscape Annual, 1830*; *Barbarigo and Pisani Palaces, Venice* (Titian's House), eng. W.R. Smith for *Landscape Annual, 1831*.
7. Fitzwilliam Mus., Camb. Ms. 175.1949. Prout to Charles Heath, n.d.
8. Plymouth Mus. transcript. July 14 1830: 'Never having ever enjoyed the pleasure of travelling in Italy, may I entreat before you leave, that you will pencil the names of the places on each drawing, to obviate the possibility of any mistake.'
9. Prout *c.* 1827 (watermark) declined to touch

an engraver's proof after a drawing by Stanfield 'as I ever wish to keep with him the best of friends'. BL Add. Mss. 42523 f. 9.
10. Ibid. f. 53.
11. BL Add. Mss. 45883 f. 42.
12. A foreign tour in the summer of 1830 may be implied by Roscoe, see n. 90.
13. For a comparable Callow of 1836 see Arts Council, *British Watercolours 1760–1930 from the Birmingham Museum*, 1979 (47) illus.
14. E.g. Birmingham MAG, 942–947'27 and Fitzwilliam Mus., Camb., 1421 a-w, all J.R. Holliday Bequest 1927.
15. Manchester CAG. 1917.267.
16. E. Morris, *English Drawings and Watercolours*, Liverpool, Walker Art Gallery, 1968, has noted this tendency in relation to a version of the *Arch of Constantine*, 42.
17. *Galleries and Cabinets of Art in Gt. Britain*, 1857, 112. He also noticed works by Prout in the collection of Sir William Knighton, to whom the artist sold 20 drawings at 3 guineas each in 1828.
18. V.A. Burd (ed.), *The Ruskin Family Letters*, 2 vols. 1973, 518.
19. Ibid. 429: 'Lord C. is learning German – was quoting passages from Schiller – he had many beautiful drawings by Nash and Prout.'

V Last years: 1840–52

By 1840 Samuel Prout had taken a first step back to London by taking some accommodation for himself in Torrington Square.[1] The family returned to London in 1844, to De Crespigny Terrace, Camberwell. The artist fared quite well by his own modest standards at the OWCS during the 1840s and began with a good spread of clients in 1840. In 1843 his major exhibit, a *Munich* at 60 guineas, was bought by Miss Burdett Coutts. In 1848 a number of leading contemporary architects suddenly took an interest in Prout's work – Edward Blore, Decimus Burton and Philip Hardwick. Charles Dickens was a buyer in 1849, Prout no doubt being more to his taste than the Pre-Raphaelites! One would not guess these relative successes from the correspondence between the artist and his major patrons among the dealers, Hewett in Leamington and the Grundys in Liverpool and Manchester.[2] These letters focus on his struggle against ill health, his difficulty in keeping up the necessary productivity and the attempts of his son to become an artist like his father, but without the application that the father expects.[3] Prout did in fact remain surprisingly productive, making around 60 drawings a year during this final decade of his life. The majority of these drawings were for the published lithographs and the continuing publications of drawing manuals and tour sketches. His watercolours, apart from those sent to the annual OWCS exhibitions, were retailed by the provincial dealers including a Mr Mann, carver and gilder, in Hastings. *Prout's Elementary Drawing Book*, published in 1840, was a modest production of 24 plates with no letterpress, and Charles Tilt paid the artist a mere £90 for the 'drawings on zinc'. The book displays some of the virtues of the earlier *Hints* and the relatively small scale of the lithographs encouraged a delicate technique. The book is nostalgic, recalling the artist's early specialism in cottages, mills, boats and bridges. Given the similarity of subject matter to that illustrated in the earlier soft-ground etchings, a comparison can be made between Prout's later style and that of 20 years before.

A list of book titles at the end of the *Elementary Drawing Book* declares *Prout's Microcosm* to be 'nearly ready'. *The Artist's Sketch-Book of Groups of Figures, Shipping, and Other Picturesque Objects*, published by Tilt & Bogue in 1841, is a book of very similar character, with only two pages of text preceding the 24 plates. These much larger plates are tinted like those in the *Hints* and were printed by Hullmandel to resemble drawings on buff paper with white highlights. Most of the figure studies show a decline in handling, but the plates illustrating sea and land transport are successful (fig. 32). Prout's students must have begun to recognize some of the artist's favourite corners from Würzburg or Dover. But the artist still has some

surprises for the critic only familiar with cottage or continental town.

As previously, watercolours with documented dates are hard to find. One such is the *Palazzo Contarini-Fasan, Venice* (**63**) which Ruskin says was widely distributed in the form of a chromolithograph and which was based on a drawing made by himself in Venice in 1841.[4] The most likely date for the loan would be post-1844 when Prout became a neighbour of the Ruskin family at Denmark Hill and began to attend the annual birthday parties to which Stanfield, Turner, C.R. Leslie, Mulready, David Roberts and the Richmonds were also invited. The *Palazzo Contarini-Fasan*, as the *Art Union* remarked of the *Porch at Ratisbonne*, shows no falling-off of skill and is a happy performance with Prout's usual cast of characters. The reed-penwork describing architecture and the strong abstract shadows are still perfectly controlled. If there is an unhappy note, it is sounded by the touches of gouache, the overly static figures and the still, glassy canal water.

The Hotel de Ville, St-Quentin in the Whitworth Art Gallery is the 1845 OWCS picture described in the catalogue as 'from a sketch by John Ruskin, Jun., Esq.' This is lightly and gaily coloured, but is not a successful composition, for which we must blame Ruskin and not Prout (fig. 35).[5] Prout would not have placed the principal building (whose architecture would demand the reed pen) so centrally or at such an angle that it is flanked left and right by weak screens. The inherited composition has also contributed the monotonous strip of figures along the lower horizontal edge of the picture. In fact this watercolour, through its faults, helps to point up Prout's skills as a composer of townscape.

The Arch of Constantine, Rome (**65**) was purchased at the OWCS by the Revd C.H. Townshend in 1850, but it is one of the painter's most effective compositions, a model lesson in light and shadow. What other technical means besides the reed pen and 'Prout's Brown' could so well convey the character of Roman relief sculpture set into Roman stonework?[6] Ruskin, standing before the Roman triumphal arch at Orange in Provence that same year, observed: 'It is Proutism of the purest kind, so much so that I think Prout is in art precisely the representative of Romanism in architecture. No one so fit to draw Roman ruins . . .'[7]

Prout's friendship with the young Ruskin was not exclusive and he was friendly with several artists including Roberts, Stanfield, Gastineau and Bright. He no doubt enjoyed their respect. 'How often I have said I founded what little I possess on your good works', Roberts wrote to him in 1833.[8] Prout returned the compliment in 1844: 'I am now an old man and have watched art and artists, and rejoiced when such bright talent as yours is acknowledged by everybody.'[9] Shortly afterwards Prout was in Brussels

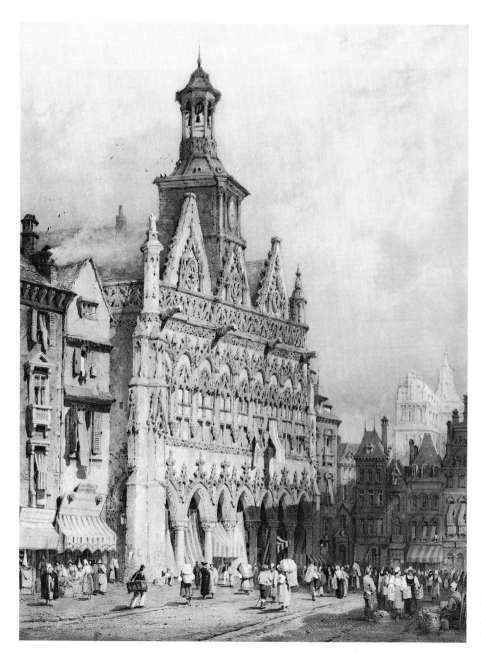

FIG. 35 *Hotel de Ville, St Quentin, France*
Whitworth Art Gallery,
University of Manchester

in company with Roberts and Haghe, and Roberts saw to it that Prout received notice from those present. 'Being in the Rooms of the Exhibition during the accidental Visit of King Leopold and his Queen, The Officer in attendance presented Mr Prout Mr Haghe and myself which was followed by an invitation to dine at The Palace ...'[10] At the banquet, 'Prout says he was never so pushed and squeezed since he was born ...', and shortly afterwards he retreated back to England, leaving Roberts to communicate the Queen's interest in his work and health.[11]

Back home, Prout's principal excitements were probably the Ruskin birthday parties. Tom Richmond, who attended them, coined the term 'Proutism' to describe Ruskin's enthusiasm for old buildings and the asso-

ciated admiration for the artist who preserved them through his drawings. This was four or five years before the third edition of *Modern Painters*, in which Ruskin first publicly declared his high opinion for the work of Samuel Prout. Richmond was at the 1852 birthday party following which Ruskin senior wrote to his absent son: 'Prout I never saw in such spirits, and he went away much satisfied. Yesterday at church we were told that he came home very happy, ascended to his painting-room, and a quarter of an hour from his leaving our cheerful house was a corpse, from apoplexy.'[12] 'Apoplexy! – hardly the kind of man one would have expected to go that way', the young Ruskin replied from Venice.[13] It may spoil the story to add that Prout died of a stroke, aged 68.

Towards the end of Ruskin's own life, M.H. Spielman visited Brantwood and observed that Ruskin, as in Venice in 1852, still had Prout by him: 'Prout, of whom you have seen several beautiful examples here, is one of the loves which always remain fresh to me; sometimes I tire somewhat of Turner, but never of Prout. I wish I could have drawn more myself ...'[14]

NOTES

1. Fitzwilliam Mus., Cambridge, Ms. 172. 1949.
2. Roe, *passim*; Roget, 2, 55/8.
3. R.W.S. Bankside Gallery, Jenkins Papers. Prout wrote to Hewett in 1845: 'My son proposes "to try his luck" as an artist in Leamington. You are aware that he has made a trial at Tonbridge and the result has been a great loss of property to himself and his parents. Another such speculation would be overwhelming ... Bright, false visions hurry him on like false lights into frightful difficulties.' In 1848 the artist told his son: 'the faults in your drawings are *too much dexterity*, which degenerates into mannerism and places nature out of sight ...' BL Add. Mss. 42523, f.15.
4. Works, XXVIII, 756. Ruskin's drawing is now in the Ashmolean Mus., Oxford. A high quality watercolour of Dresden (18 × 15 in) said to be ex. Decimus Burton, is presumably OWCS, 1850 (251), which strengthens the argument relevant to **65** that Prout continued to be capable of his best work to the end – Thomas Le Claire, Kunsthandel II, (38), Hamburg, Nov. 1984, illus. in colour.
5. D 60. 1924, $28\frac{7}{8} \times 21\frac{3}{4}$ in.
6. Roget, 1, 478, quoting the Jenkins Papers, says: 'Mr Prout told me that he used a particular grey he made himself.' Whichelo told Jenkins that Prout kept his own mixtures of brown and grey 'in bottles in a liquid state'.
7. Works, IX, 299 n.
8. Plymouth Mus. transcript.
9. Yale CBA, Bicknell Album.
10. Journal, 162 (under Nov. 12 1845), National Library of Scotland, Edinburgh, David Bicknell coll.
11. The banquet was given by Belgian artists for their foreign fellow professionals such as 'Monsieur Proust'. Roberts and Prout were also asked to dine with the Duc de Beaufort, the Minister of the Interior. (David Roberts to Christine Bicknell, 25 Sept. 1845, ibid.). I owe all information about Roberts and Prout to Helen Guiterman.
12. Works, XIV, xxxiv n.
13. Ibid., XXXIV, 668 (*Pall Mall Gazette*, April 21, 1884).
14. Ibid., IX, 301 n.

Catalogue of watercolours and drawings by Samuel Prout in the Victoria & Albert Museum, London

Measurements are given inches before centimetres, the former only to the nearest quarter-inch. 'Watercolour' stands for transparent wash; bodycolour (gouache) for non-transparent watercolour including white. The colour and texture of wove paper is not precisely defined. 'Graphite' is preferred to 'pencil', the latter continuing to be used by Prout (e.g. in drawing books) and the colourmen in the eighteenth-century sense of 'brush', although also frequently in the modern sense, e.g. Prout bought H, HB, B, etc. pencils from Brookman & Langdon in 1817!

Catalogue

1a
Dunstable Priory, Bedfordshire; architraves, capitals and voussoirs

Graphite on fine cream wove, laid down;
$7\frac{1}{2} \times 5\frac{3}{4}$ (19×14.5)
Ins. *Dunstable Priory/S. Prout* (only *Dunstable* by the artist)
D 331.1890(a)
CONDITION: Good
PROV: Purchased 1890

Three different architectural elements of the west façade arranged on a single sheet.

This, together with the three other architectural drawings of Dunstable Priory, was commissioned by John Britton for his *Architectural Antiquities of Great Britain*. The drawing is the basis for the plate *Parts and Ornaments of the Western Front of the Priory Church, Dunstable*, engraved by W. Woolnoth and published in Vol. 1 in 1807. The engraving is described as published in June 1805. *Architectural Antiquities* has another plate engraved after Prout – *The Western Front of the Priory Church Dunstable* – originally published in April 1805. The volume has six other engraved plates after Prout: *St Botolph's Priory, Colchester; King's College Chapel, Cambridge; St Sepulchre's Church, Cambridge*. Prout made his tour to Cambridge for Britton in 1803 and to Essex in 1803 and 1804. Cotman's famous view of St Botolph's was made *c.* 1804/5. Prout did not supply any drawings for the later volumes of the *Architectural Antiquities*, but Britton did employ Cotman for Volume 2, published in 1809.

This drawing is tightly controlled and one can follow the artist's pencil moving on from point to point. It is entirely objective and describes the Romanesque mason's work without any misleading anachronistic stylization. With the other three Dunstable drawings, this is therefore the most valuable kind of antiquarian record, which was of course its function. It is not Prout's first drawing, since the seven different parts have been arranged on the sheet with the engraved plate in mind. This distinguishes it from the other three, which would seem to be drawings made in front of the subject. Interestingly, the engraver can only have made his plate with this and **1b** and **2b** in front of him, since the detail included in the plate had to be gathered

1a

from all three.

Volume 1 of the *Antiquities* is intimately connected with the 'Britton School' (pp. 24–27), since its plates are engraved after drawings by Frederick Nash, George Shepherd, William Alexander, J.C. Smith, Frederick Mackenzie and J.A. Repton as well as Samuel Prout, all of whom feature among the ex-Britton drawings now at Devizes. In the later volumes Britton turned to Cotman, Munn, Wild, Gandy, Blore, Cattermole and Pugin.

1b
capitals and voussoirs (not illustrated)

Graphite on fine cream wove, laid down;
$4\frac{3}{4} \times 6\frac{1}{2}$ (12×16.7)
Ins. *2nd Moulding/Capital of 2nd – zig zag/ Capital of 3rd/Dunstable/S. Prout* (gone over) in gr. (*S. Prout* is not by the artist)
Stamped *NAL* in mon.
D 331.1890(b)
CONDITION: etc. see **1a**

Drawings of three architectural elements arranged side by side on the same sheet.

This shows three of the architectural details in greater detail, including the shading of the voussoirs, as given in the engraved plate in the *Architectural Antiquities*. See **1a**.

2a

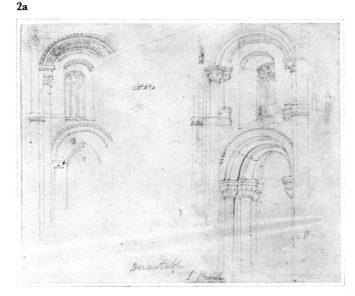

2a
Dunstable Priory, Bedfordshire: details of nave elevation

Graphite on fine cream wove, laid down;
$5\frac{1}{2} \times 7$ (14 × 18)
Ins. *Dunstable/S. Prout* in gr. (not in artist's hand) and stamped *NAL* in mon.
D 332.1890(a)
CONDITION: etc. see **1a**

The drawings on this sheet are the only ones in this series of four which were not used for the engraved illustrations in the *Architectural Antiquities*. They exemplify Prout's skill as an antiquarian draughtsman. Given Britton's anecdote about the young artist's limited skills in the winter of 1801, it is clear that he quickly developed an ability for precise delineation of architectural detail. Drawings such as this would have supported the claim made for him in 1829 when he was proposed for election as a Fellow of the Society of Antiquaries by Chantrey, Britton and Meyrick (a pundit on armour) as 'a gentleman conversant in the history of antiquities of this country'. (London, Society of Antiquaries, Minute Book, 1823-, p. 543.)

2b
capitals and voussoirs (not illustrated)

Graphite on fine cream wove, laid down;
$5 \times 7\frac{3}{4}$ (13 × 19.5)
Ins. *capital to 4/4 moulding/under niche Great door/[?] moulding/capital/Moulding to this broke away/ Dunstable/S. Prout* in gr. (*Dunstable* and *S. Prout* not by the artist)
D 332.1890(b)
CONDITION: etc. see **1a**

Five architectural details arranged on a single sheet.

Three out of five of these details were used by the engraver for the plate in the *Architectural Antiquities*.

3
Sketchbook – Sketches in Cornwall
(Title stamped in caps. on front cover)

A flyleaf and 17 leaves of brown wove, some interleaved with mauve tissue paper, bound in purple leather; folios $6 \times 11\frac{1}{2}$
(15.2 × 29)
Graphite with a double-line frame to each composition
Signed and ins. *Samuel Prout/Brixton nr London* inside front cover
E 705.1923
CONDITION: Good; six folios removed at end
PROV: Bought from Ernest Brown & Phillips, 19 April, 1923
LIT: *Accessions*, 1923

Drawings in folio order ins.: *Roundwood nr. Trevisick; The Parsonage at St Feock; Land's End; Penzance Harbour, and St Michael's*

3 f.8

3 f.13

Mount; Kynans Cove; The Loo Pool near Helston; The Church, Vestry, and Tower of St. Feock; The Coast at the Land's End (illus.)*; Coast nr Kynan's Cove; View of the entrance into Falmouth Harbour, from Philip Daniel's; View near Troyne Castle by the Logan; View from the Parsonage, St. Feock; Truro from Kenwyn Church Yard* (illus.)*; Mopur Ferry; Botalick Mine; The Logan Rock; Kynan's Cove.*

The earliest date at which Prout gives Brixton as his address is 1811 (RA catalogues), by which date he had developed a broad, strong and confident sketching style, as in **6**. This style is matched by the strongly etched plates of the first published drawing books and sketchbooks such as *Picturesque Delineations* of 1812, *Prout's Village Scenery* of 1813 and *Rudiments of Landscape* 1813–14. There is only one drawing in **6**, of Mount's Bay, which is comparable. There is also kinship with some of the 1824 Italian tour drawings such as **45** (*Casamice*). A third comparison can be made with an early drawing of Launceston in the album at Barnstaple (f. 41) probably made *c*. 1805.

An early date is preferred here, i.e. in the 1803–8 years when Prout had been driven back to his native territory by ill health. These tight, repetitive, 'framed' coastal landscapes are most likely to have been made at this early date, the volume being bound up and inscribed later.

4
Denham Bridge, (?) Suffolk

Graphite on fine white wove, partially washed with brown; $8\frac{3}{4} \times 14\frac{3}{4}$ (22.7 × 37.5), sight size
Ins. *Denham Bridge/Augst. 14th 1806* by the artist in gr. and *S. Prout* (?) by another hand
E 3193.1948
CONDITION: Good, a few spots top left
PROV: Given by the Ven. Archdeacon F.H.D. Smythe, 1948

A two-arch bridge joins the left bank to the right bank which is covered by trees.

This, together with **5**, represents Prout's earliest phase in the Museum's collection. The delicacy of this drawing, to which

4

enough wash has been added to stimulate
the imagination, may come as a surprise
since it is so different from an 'early Prout',
i.e. the heavy and brown cottage or
marine. The delicacy of the wash is found
in moor landscapes, of which there are
several examples in the Exeter Museum,
dated between 1805 and 1807, and in the
early volume of cromlech sketches some by
Prout, put together by John Britton *c.*
1810. *Denham Bridge* suggests that Prout, no
doubt via Britton, was familiar with
landscape drawings by Henry Edridge.

5
Estuary scene

Watercolour over graphite on fine cream
wove, with pen work, lights reserved and
scraped, fixed; $7\frac{1}{2} \times 10\frac{1}{4}$ (19 × 26.1)
Stamped *VAM* in mon. at centre and
centre right
107.1892
(see colour plate between pp. 120 and 121)
CONDITION: Good, particularly as it has
been 'in circulation'
PROV: Purchased 1892

View across an estuary towards a fishing
village and from a causeway ending in a
bastion or fortified quay, with a stone cart
in the centre.

This is a most uncharacteristic
watercolour and represents Prout's first
finished watercolour style. A closely
comparable work – *Oreston* (Exeter 46/
1925) – is dated on its reverse by I.A.P.
(i.e. Isabella Anne Prout) August 6th 1807.
Oreston is composed in exactly the same
manner, perhaps a view taken from nearer
the mouth of the estuary, with the
exception that the central feature is a sail
barge. Again a very fine pencil defines neat
miniature buildings or boats and a well-
mannered landscape. The Exeter drawing
is, however, only partly coloured with a
monochrome wash. The closest comparison
in a completed watercolour is *South Zeal,
Devon* (Fitzwilliam Museum, Cambridge,
3260 – Scrase, p. 4) which is signed *S.
Prout/1806*. A small finished watercolour in
this style, (?) *Launceston Castle with
Cottage*, in the Plymouth Museum
(1937.69) was said by the donor, H.B.
Hunt, to have been 'painted by Prout

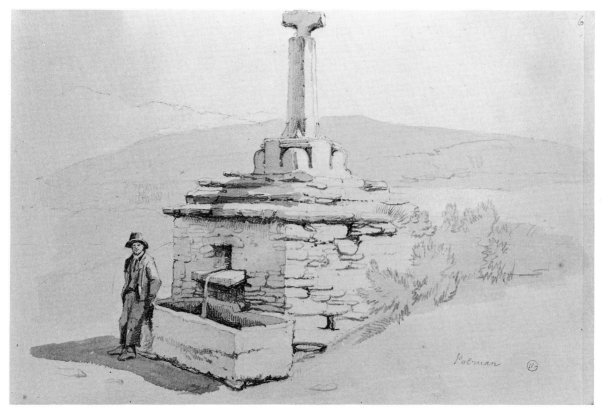

6 f.6.

when tutor to the Hunt family of Egg Buckland', a clue to his activity before returning to London in 1808.

6
Sketchbook – Sketches in Cornwall

33 leaves of cream wove, bound in brown paper-covered board with leather spine (replaced) and corners (worn); folios $10\frac{1}{4} \times 6\frac{3}{4}$ (26.2 × 17)
Graphite, sometimes with stump or brown wash
Signed by cut out *S. Prout* (with pen) on white paper stuck on inside cover and ins. *Cornwall* in gr.; notes and sums erased
A partly legible, humorous (?) saying ins. inside back cover. Most folios stamped *NAL* in mon. lower right
D 45.73.1902
CONDITION: Good apart from the crude fixing of the loose f.1 and the removal of 11 folios
PROV: Bought from S.G. Prout, 1902, for £20

The sketchbook contains a wide variety of Prout's early specialities: ancient monuments such as churches and stone crosses; harbours and boats; villages and cottages.

Drawings with ins. in folio order: *Stonehouse; Sandy-cove; W. Looe; Garland. W. Looe; Polruan* (illus.)*; Penryn; St. Mawes; Falmouth; Gweeke; Burian; Lemena; Lemena; Mts. Bay; St. Ives; Lelant; Carn-bre* (illus.)*; Probus; Grampound; St Austle; Lostwithiel; Liskeard; Liskeard; Crafthole; St. John's.*

The subject matter is typical of Prout's early soft-ground etchings of 1812–16. He uses a strongly accented style for antiquarian and cottage subjects, and the pressure of the pencil for the darks is clearly visible on the reverse of the thick wove pages. The control of light and shade is already masterly and he uses a variety of 'leads' to achieve this. The shadows in windows and beneath eaves are characteristically deep and he uses repeated strokes to depict layers of stone or

6 f.17

tiles, usually arranged horizontally or
vertically. Parallel hatching is used for trees
and his radial hatching for shrubs and
bushes. *Mount's Bay* and *Carnbre* (f. 14 and
17) are unusually fully toned with the
stump and anticipate one of his graphic
techniques fully developed by 1820. The
drawing of a head of a *Boy asleep* (f. 31v)
comes as a complete surprise, reminding us
that at least one portrait in oil is attributed
to him (*Portrait of John Prout*, Plymouth Art
Gallery). There is no watermark or other
internal evidence for dating this
sketchbook, and *c.* 1810 is suggested.

7

Bridge on the Ouse, near York

Watercolour over graphite on fine cream wove, with penwork, dry colour and gum, lights reserved and scraped, laid down; $10 \times 14\frac{1}{2}$ (25.9 × 37.1)
Ins. *345* in ink, lower left and bearing the stamp of the National Gallery of British Art in mon., lower left and lower right
FA 345
CONDITION: Discoloured and faded
PROV: Acquired in 1860

View across the river towards the bridge which stretches from left to right with cottages in the centre ground.
 This is a fully coloured and no doubt later river landscape of *c.* 1810 that Prout first attempts *c.* 1805, as in *Denham Bridge* (**4**). This later, but still early, work retains some of the delicacy of the monochrome-wash days and uses the palette of yellows and orange as livening touches that Prout developed 1805–10. The subject might equally be some other bridge e.g. Yealmpton or Riverford, but the traditional title for this watercolour has been retained.

8

Entrance to a country church

Watercolour over traces of graphite on white wove, with penwork, dry colour and gum, lights reserved and rubbed, laid down; $8\frac{1}{2} \times 8\frac{1}{2}$ (21.8 × 21.5)
AL 4620
Stamped *VAM* in mon.
CONDITION: Some discoloration, (?) bleached
PROV: Acquisition date unknown

A view taken close-up and just to the left, of the porch and west façade of the church.
 This is not a typical Prout subject and some doubts about the attribution have had to be overcome.

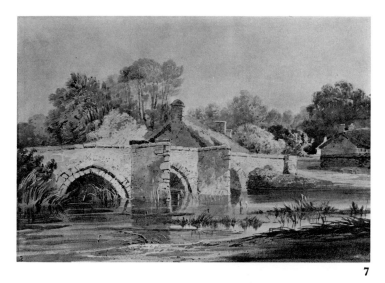

7

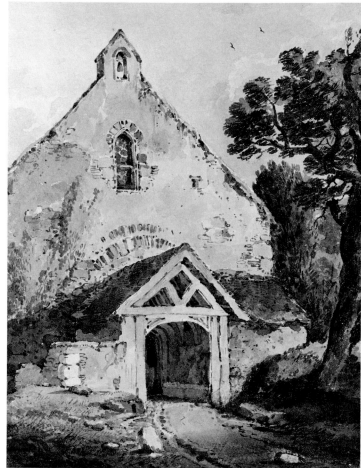

8

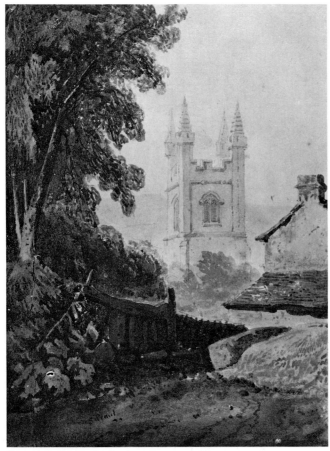

9

9
Village lane with cottage and church
(?Widecombe, Devon)

Watercolour over graphite on cream wove, with gum, lights (?) reserved and scraped; $10 \times 7\frac{3}{4}$ (2.55 × 19.5)
Signed *S. Prout* in pen, lower left, ins. *9.75* in ink and stamped *VAM* in mon., lower right
9.1875
CONDITION: Discoloured and faded with an original vertical crease at left
PROV: Bought from Miss M. Carlton, 1875 – in circulation

A lane runs along a fence, behind which is the church tower in the centre, with large framing tree to left and cottage to right.

The palette includes yellow and orange, which is characteristic of Prout's watercolours *c.* 1810. A touch of red enlivens the foxgloves at the left. The faded and discoloured condition of the watercolour now makes it somewhat harsh.

It is probably unwise to be too dogmatic about the identification of churches and bridges in Prout's early watercolours, since there is often more than one equally strong candidate; assuming, that is, that these elements in a landscape are 'portraits', and not variations on a familiar theme.

10
Quay with boats

Watercolour with pen work and gum, lights reserved; $8\frac{1}{2} \times 12$ (21.8 × 30.3)
Signed *S. Prout* in grey ink with pen, lower left
E 3401.1922 (95.H.55 f. 41)
CONDITION: See **11**

11
Coast scene with boats

Watercolour and bodycolour on white wove, with pen work and gum, lights reserved, rubbed and scraped; $9\frac{3}{4} \times 8\frac{1}{2}$ (2.5 × 2.16)
E 3396.1922 (95.H.55, f. 36)
CONDITION: Some of the lights are maladroitly handled and may be by a later hand, otherwise in excellent condition
PROV: Presented by Douglas Eyre, 1922 in an album with front cover stamped in gold: *Drawings the gift of Dr. Penrose to Henry R. Eyre*

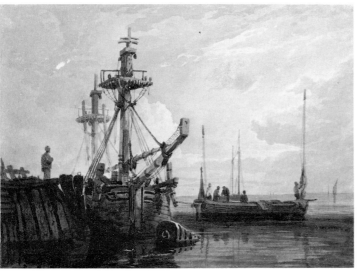

10

The signature on **11** has been misread as *Samuel Read* and not *Samuel Prout*, and therefore neither **10** nor **11** have previously been attributed to Prout. Both these watercolours are, however, characteristic, and in their palette provide a marine parallel to the watercolours here dated *c.* 1810 (**14, 15, 17, 18**). The colouring is relatively bright, favouring yellows and touches of orange. No doubt because they have been kept in an album, this and **10** are still unfaded and can be appreciated as being in their original state.

12

Cottage at Tamerton, Devon

Sepia over graphite on heavy wove; $5\frac{1}{2} \times 8\frac{3}{4}$ (13.6×23.0), sight size
Ins. *5771* in ink, stamped *NAL* in mon., lower right, and *Purchased Department of Science and Art* top right, with number brutally inscribed and erased
AL 5771
CONDITION: Discoloured with slight foxing and brown spot, lower right; principally damaged by the Museum's stamps
PROV: Purchased for the Art Library at an unknown date

A cottage in the left foreground with another behind, a woman walking away centre right.
 Despite the abuse to which this sepia drawing has been subjected since entering the care of the National Art Library, this simple but charming work remains an excellent example of Prout's cottage architecture, which must have been widely disseminated through his numerous soft-ground etchings published between 1810 and 1820. A single plate combining four subjects in fact reproduces this as *Tamerton*, a plate published by Palser in Feb. 1812. It exemplifies Prout's mastery of light and shade as taught through his drawing books such as *Rudiments of Landscape Drawing* (1813). Prout was at his best in line, and next best in line and monochrome wash. In 1811, the earliest date for which there are records, Prout was receiving 3s 6d for a sepia from both Palser and Ackermann, and was supplying sepia drawings in large quantities. The delicacy of this particular sepia suggests an earlier rather than a later date, say 1810. It may possibly have been

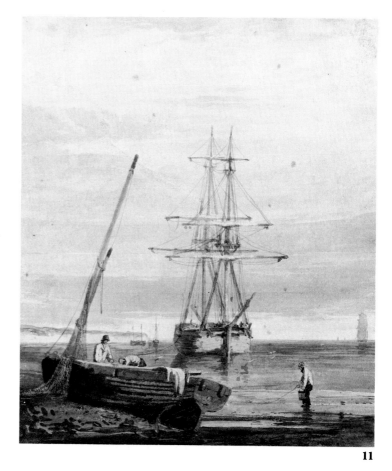

11

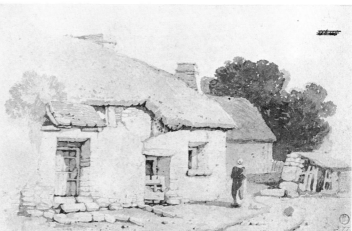

12

conceived for the educational purpose to which it was subsequently put. A glimpse of Prout's private teaching practice in 1813–14 shows him supplying to the Misses Barlow three drawing books at 5s 6d each, three cakes of sepia at 2s 6d, nine camel-hair brushes stick'd at 1s 6d, swan-quill brushes at 9d and *Rudiments* Nos. 2 and 3 for 12 shillings.

13
Farm at Torbryan, Devon

Watercolour over traces of graphite on cream wove, with penwork and gum, lights reserved and scraped; $10\frac{1}{2} \times 15\frac{1}{4}$ (26.6 × 38.5), sight size
E 1058.1918
CONDITION: Discoloured (sky) with some rubbing (centre) and cuts
PROV: Presented by Arthur Myers Smith, 1918

A farmhouse with attached buildings to the right is viewed across a small pond.

The harsh colouring can be matched in some hand-coloured soft-ground etchings of *c.* 1813, and the composition is almost identical with the finely worked and powerful etching *Torbrian*, published by Thomas Palser, 15 Feb. 1811. The watercolour could therefore be the *Torbrian* sold in Bond Street for 2 guineas (Account Book) in May 1812. The best features of the watercolour are the deft, repeated brush strokes to represent layers of brick or stone and the deep shadows underscoring the rococo outline of the thatch eaves. The related etching is far more impressive, and has a well-described hillside in the background omitted here. The barn and barrel on the extreme right of the composition are reproduced in reverse in a soft-ground etching, pl. 17, *Progressive Fragments*, pub. 1817.

13

14

Farmhouse and cottage

Watercolour over graphite on cream wove, with penwork and gum and some dry colour, lights reserved; 9 × 13 (23 × 32.8) Signed *S. Prout* in pen, bottom left
P 39.1968
CONDITION: Some discoloration and fading
PROV: Dr Herbert Powell Bequest through the National Art Collections Fund, 1968
LIT: *Catalogue of the Herbert Powell Collection of the Early British School*, 2nd ed., 1947 (100)

A cottage in the right foreground leads towards the adjoining farmhouse, with a group of cows and cattle and farmworkers.

The subject matter and technique are similar to **15, 17, 18**. The underdrawing is sensitive and the watercolour handled quite finely. Despite its faded condition, this is a charming example of Prout's style *c*. 1810. Prout, then aged 27, was hardly an innovator as far as technique was concerned. His palette included a partiality for yellow and touches of orange, a taste that in more muted form appears in the few finished watercolours of *c*. 1806 (**5**). An anaemic 'to scale' copy by an imitator is in the Exeter Museum (75/1917). The original appearance of **14** can be gauged from pl. 52 of *Rudiments of Landscape* (1813–14), a hand-coloured soft-ground etching (Print Room copy). The colouring of pl. 52 is characteristic also of the hand-coloured plates in *Prout's Village Scenery*, also published in 1813.

14

15
Cottage at Penguswick, Cornwall

Watercolour over graphite on cream wove,
with gum and dry colour, lights reserved;
$7\frac{3}{4} \times 10\frac{1}{2}$ (19.8 × 26.8)
Signed *S. Prout* in pen, lower right, ins.
2966.76 in ink bottom right and stamped
VAM in mon.
Ins. verso *Penguswick Cornwl* (partly erased)
in gr.
2966.1876
CONDITION: Discoloured and faded, the
surface rubbed in places
PROV: William Smith Bequest, 1876

A thatched cottage with figures to the left,
windows and doorways of Romanesque
and Perpendicular detailing suggesting that
the building had a grander past.

As with **12** and **14**, the unpretentious
nature of the watercolour drawing gives it
charm. It belongs with these to *c.* 1810 and
shares with them a relatively light palette
with yellow, rusty red and orange to
enliven the browns.

The verso identification conflicts with
the evidence of a soft-ground etching – *near
Helston, Cornwall* – in *Prout's Village Scenery*
(June 1813), in which most of this cottage
appears in reverse. The watercolour is no
doubt one of numerous instances when the
artist has chosen to be inventive rather
than factual.

16
The Picture House, Poundsbridge, Penshurst, Kent

Watercolour and bodycolour over graphite
on cream wove, with penwork and some
dry colour, lights reserved and scraped;
$12 \times 17\frac{1}{2}$ (30.5 × 44.6)
Ins. *2964.76* in ink, lower right
2964.1876
CONDITION: Badly discoloured and faded,
with ink spot at top
PROV: William Smith Bequest, 1876

The Elizabethan house is viewed from
almost directly in front with implements in
the left foreground and two figures near
the centre by the loggia entrance.

This watercolour is so damaged by over-
exposure that its original quality is
impossible to judge and even the
attribution might be doubted. Is it before
or after the published soft-ground etching
with aquatint (pl. 43, *Rudiments of Landscape
in Progressive Studies*, published R.
Ackermann, 1813), which is slightly
smaller in scale and lacks the foreground
details? The latter are clumsily drawn.

The middle part of the façade is
excerpted for pl. 16 of *Progressive Fragments*,
pub. 1817. *The Picture House* was plundered
again for an imaginary landscape by S.G.
Prout in the Plymouth Museum
(1937.81.454).

15

16

17

Cottage scene

Watercolour on white wove, with gum and dry colour, lights reserved, laid down; $9\frac{1}{4} \times 10\frac{1}{4}$ (23.3 × 26.1)
Signed *S. Prout* in pen, bottom right
1806.1900
CONDITION: Discoloured and faded with glue stains at the edges top and right
PROV: H.S. Ashbee Bequest, 1900

A lone figure walks out of the village with cottages to the left and a building to the right.

This watercolour is unusually square in shape and may have been cut down. Such an idea is supported by a comparison with a very similar composition in soft-ground etching, *Near Plymouth*, which is extended to the left. The etching was published by Palser in Oct. 1815.

The watercolour is fairly elaborate, detailing walls and roofs with repeated brushstrokes and introducing strongly marked shadows to break up the otherwise straightforward path leading to the horizon. This watercolour might represent a type that the artist produced in large numbers and sold to Ackermann for 5 shillings each from about 1810. Ackermann

no doubt retailed them as drawings for copying. Despite its condition this unpretentious watercolour has charm.

18

On St Michael's Mount, Cornwall

Watercolour and bodycolour over traces of graphite with penwork and gum, lights reserved and scraped; $10 \times 13\frac{3}{4}$ (26.1 × 34.7)
Signed *S. Prout* in pen, centre bottom, and ins. *2965.76* in ink, bottom right
Ins. verso *St. Michls Mount*
2965.1876
CONDITION: Some discoloration and fading, fox marks top left
PROV: William Smith Bequest, 1876

Stone cottages fill the right and centre with the church in the distance to the left.

The composition appears in reverse, with only minor variations, as pl. 13 in *Studies of Cottages & Rural Scenery* published by Ackermann in August 1816. The soft-ground etching is smaller, omits the figure in the centre and the lobster pots and gives more bulk, but the same emphasis, to the church in the distance. Prout exhibited a *St Michael's Mount* at the RA in 1813 but this is likely to have been the more familiar, distant view towards the Mount.

Prout made several sketching tours in Cornwall which was relatively close to his home town of Plymouth. His earliest tour was in 1801 and the latest probably in the 1830s. The most likely moment for making the sketch upon which this watercolour is based, would have been between 1802 and 1808 when he moved to London for the second time. Prout was making watercolours in this style *c.* 1810. *On St Michael's Mount* is closely comparable to **14**. They share a delicate use of brush and pen and a distinctive palette which includes yellow and orange. The composition is characteristic, with a subtantial foreground structure receding towards another point of interest in the distance. This is essentially the same formula that Prout was to employ for his continental cities. The detailing and general handling of the principal foreground feature is set off by the more indefinite and mistier colouring of the background worked with the brush and little or no penwork.

17

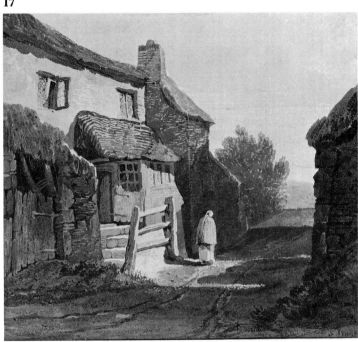

19

Old Shoreham Church, Kent

Sepia wash over graphite on cream wove, with penwork and gum, lights reserved and scraped; $7\frac{1}{4} \times 10$ (18.3 × 25.4)
Signed *S. Prout* in pen, lower left (on tombstone)
E 1951.1919
CONDITION: Generally good but some foxing, repaired tear, top right, and a crease bottom left
PROV: Presented by Arthur Myers Smith, 1919
LIT: C. Johnson, *English Painting*, 1934, 198

The church is viewed from the north-east, close up.

Old Shoreham, which is a studio production, can be matched up with the on-site drawing that Prout made on two pages of a now dismembered sketchbook watermarked Fellows 1812 (fig. 3). Prout's original sketch is viewed from slightly below the line of sight adopted for the sepia, as if the artist was sitting down for the sketch and standing up for the sepia. Despite the solid virtues of the sepia, it must be said that the earlier washed pencil sketch is much the more attractive. It is also more informative, showing the west wall and west window of the semi-ruined church and the line of an earlier pitched roof over the nave. The large blocks of ashlar at the corners of the tower in the sepia are an invention in accord with the altogether larger treatment second time around. Prout retains the original lighting but cuts off the west wall and introduces a rectangular tomb as a strong feature on the left in place of the simple standing gravestone that was there before. The Barnstaple sketchbook otherwise has views made at Brighton, Worthing, Winchelsea, Old Fincham (colour pl. VII), Launcing, and Sompton. Perhaps Prout did not wait long to turn his south-coast tour sketches into watercolour; he sold an *Old Shoreham Church* at the OWCS in 1816 for 6 guineas.

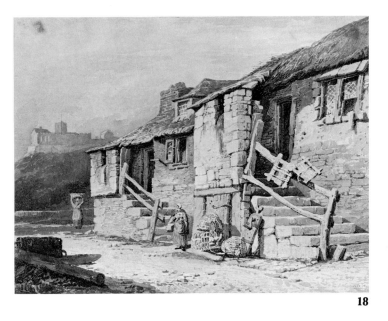

18

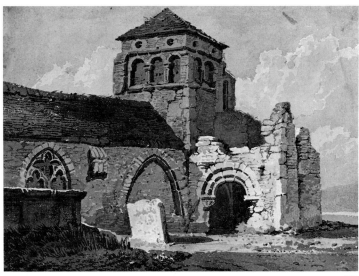

19

20
Norham Castle, Northumberland, from a distance

Sepia over graphite on cream wove with a little penwork and (?) gum, lights reserved and scraped; $7\frac{1}{2} \times 10\frac{1}{2}$ (18.9 × 26.5), sight size
Signed *S. Prout* in pen, lower right and lower left centre (the latter only ? by the artist)
Ins. *10.75* in ink and stamped *VAM* in mon., bottom right
10.1875
CONDITION: Discoloured and dirty
PROV: Purchased from Miss M. Carlton, 1875, and then 'in circulation'

The castle is seen from a distance with thatched cottages in disrepair on the left, a lone figure in the centre beneath the castle and a screen of wall and trees on the right.
 Even allowing for the condition of the drawing, this is a poor performance. Despite the two signatures, the possibility should be considered that this is a copy drawing after another closer to the *Norham* soft-ground etching (pl. 14, *Studies of Cottages & Rural Scenery*, published by Ackermann, August 1816). The etching (in reverse) places the castle in the centre, with the cottages on the left (in the sepia) cut back to the cart, and the right-hand screen of wall and trees extended and greatly elaborated. The figure, it should be said, in the etching, is equally inept. The relationship, for instance, between *On St Michael's Mount*, pl. 13 of the *Studies* and the watercolour (**18**) is very much closer.

21
Stonehenge, Wiltshire

Watercolour and bodycolour over graphite on cream wove, with dry colour and gum, lights reserved; $11\frac{1}{4} \times 18\frac{1}{4}$ (28.3 × 46.3)
Ins. *344* in ink, and bearing the stamp of the National Gallery of British Art, lower right
FA 344 .
CONDITION: Badly discoloured and faded, 'in circulation'
PROV: Acquired 1860
LIT: R. Redgrave, *Catalogue of the Pictures . . . South Kensington Museum*, 1859 (344)

A close-up view of the stone circle: 'Rain clearing off from behind the cromlech' (Redgrave).
 The subject, made famous by Constable, followed naturally on from Prout's earliest work for Britton in pursuit of the latter's specialist interest in stone monuments. Britton's 'Cromlech' volume at Devizes contains several drawings with grey-blue wash which are preparatory to this large watercolour (colour pl. II): Avebury (1982.3235), St Burian (1982.3237), or the Hurlers (1982.3238), all identified by Britton as by Prout. The wash drawings of Stonehenge itself in this volume are, however, by Britton. The parallels between the Devizes monochromes of *c.* 1805 and *Stonehenge*, which could be ten years later, have been heightened since the extreme damage that this watercolour has suffered has revealed the underdrawing, which is comparable in technique to that used for the earlier works.

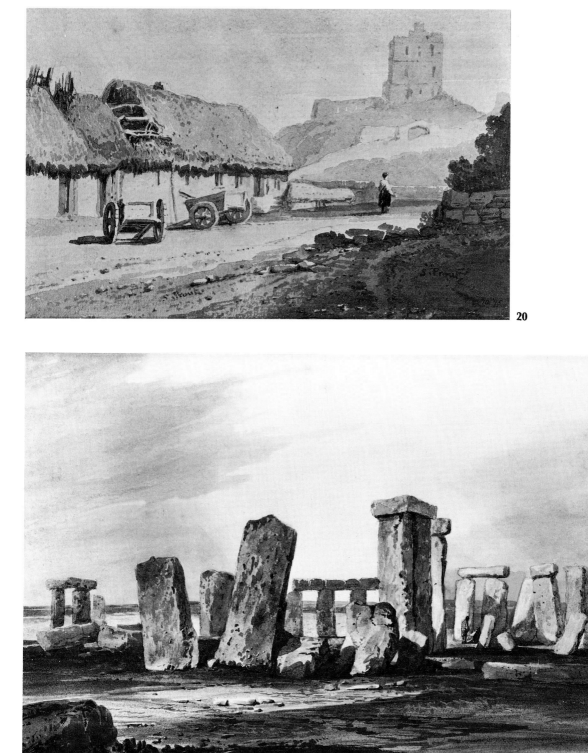

20

21

22

House by a pond with a woodcutter resting

Sepia over graphite on white wove, with gum, lights reserved, laid down and trimmed; $8\frac{3}{4} \times 12\frac{1}{2}$ (22.2×32.0)
(?) Signed *S. Prout* with brush lower left and stamped *NAL* in mon., centre bottom
D 327.1886
CONDITION: Good
PROV: Bought from E. Parsons, 1886

The woodcutter snoozes against a tree trunk on the left, with cottage and trees in the centre and pond to the right.
 This is not a typical Prout composition, in that it is so obviously an invented rather than a real scene.

22

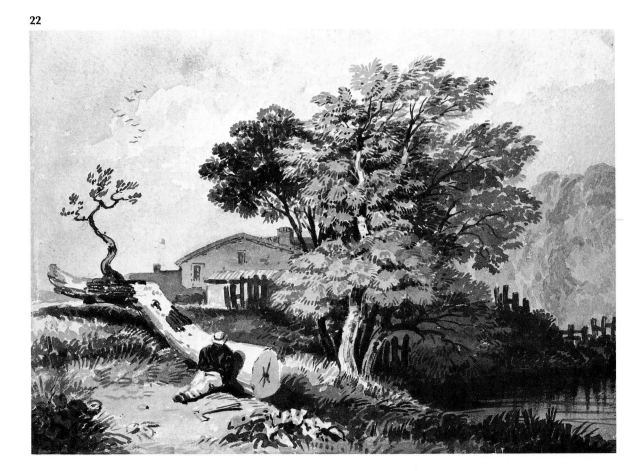

23
Tenby Castle, Pembrokeshire

Watercolour over graphite on white wove, with penwork and gum, lights reserved and scraped, laid down; $7\frac{3}{4} \times 10\frac{1}{4}$ (19.4 × 25.9)
Ins. *386* in ink and stamped *VAM* in mon., lower right
Perhaps there is a date in pen in the extreme right-hand corner of the drawing; if so 18?9
Ins. verso *Tenbigh Castle*
FA 386
CONDITION: Discoloured and faded, the original colour preserved along the edge
PROV: Bought 1858 'of Mr Evans for £2 as a school copy for distribution'. As *A castle on the shore* in the 1859 *Inventory* and as *Tenbigh Castle* – circulation, in the 1870 *Catalogue*

The castle occupies most of the left side of the picture, viewed from behind some cows, towards the sea and a headland in the distance.

Despite damage by over-exposure, this remains a strong and competent landscape, the castle well set off against the sunnier backdrop. The cows belong, although Prout rarely risks animals. However, Prout's imaginative limitations are exposed by a comparison with Cotman, for instance the latter's *Castle by water* (Ranza Castle) of *c.* 1810 (repr. in colour in A.W. Moore, *John Sell Cotman*, 1982).

Prout sold a *Tenby* 'drawing' to Palser in April 1814, for £1.11s. 6d. A *Tenby* belonging to J.W. Safe was exhibited at Wrexham, 1896 (798) – A. Graves, *A Century of Loan Exhibitions*, Vol. 2, 1913, 262.

23

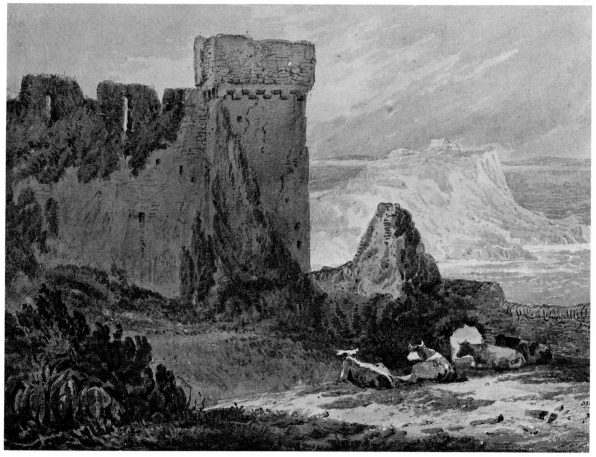

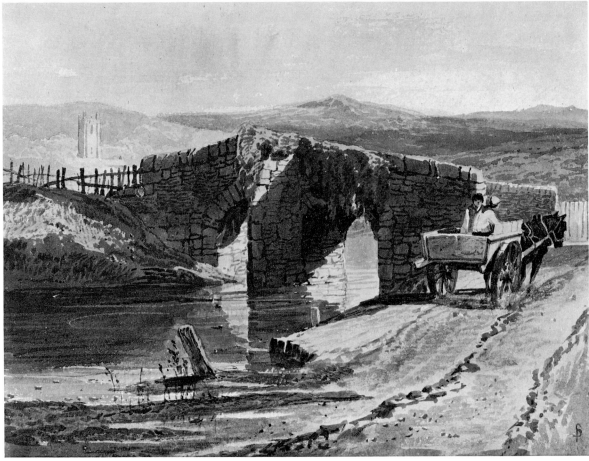

24

24
Landscape with bridge and church tower

Watercolour and bodycolour on cream wove with penwork and gum, lights reserved and scraped; $8\frac{1}{4} \times 10\frac{1}{2}$ (20.7 × 27) Ins. *S.P.* in mon. with pen, bottom right Ins. verso *at Okehampton Devon* in gr.
P 40.1968
CONDITION: Discoloured and faded with colour lifted in a spot at the left end of the bridge due to foxing. There is a small vertical ridge in the centre
PROV: Dr H.A. Powell Bequest, 1968, through the National Art Collections Fund
LIT: *Catalogue of the Herbert Powell Collection of Water-Colours and Drawings of the Early British School*, 2nd ed. 1947 (103)

Although the verso inscription is convincing, the Okehampton bridge is three-arch. The monogram signature also looks suspect, and Prout's usual practice was to restrict this form of signature to his prints. The rubbing where the cartwheels meet the ground is unhappy and the cart generally strikes an awkward note. Some treatment has given the whole an untypical appearance. Overall this is a doubtful attribution.

25
Entrance to a harbour

Watercolour on cream wove with penwork and gum, lights reserved, laid down; $8\frac{3}{4} \times 18\frac{3}{4}$ (22.3 × 47.5)
1764.1900
CONDITION: Discoloured and faded
PROV: H.S. Ashbee Bequest, 1900

One side of the harbour mouth, beginning bottom left, curves round to the right and back to dominate the centre of the composition, with the sea with distant sails and coast on the horizon.

This was once a most impressive work both as regards composition and watercolour technique. Prout is rarely so successful, when working in colour, at combining a strong foreground with delicacy of handling. The figures are also unusually well absorbed into the composition. The delicate brushstrokes used to define the wood-planking construction of the pier head is matched by the most subtle reservation of unwashed paper for the distant sails, a miniature touch masked by fading.

Some pencil sketches at the National Maritime Museum from a collection of Prout's marine drawings (put together by Isabella Anne Prout) anticipate the composition. These are of Dover and are on 1811-12 paper. A stormier version of this subject, from the sea side, is one of Prout's *Marine Sketches* published in lithograph in 1820. This watercolour might be dated *c.* 1815.

25

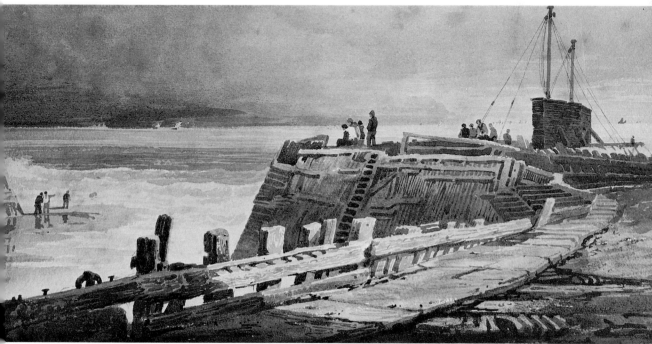

26

**Shore scene with fishermen boiling
shrimps**

Watercolour on fine white wove, with
penwork, lights reserved and scraped, laid
down; $8\frac{1}{4} \times 12\frac{1}{4}$ (21×31.2)
Signed *S. Prout* in pen, ins. *224.85* in ink
and stamped *VAM* in mon., lower right
224.1885
CONDITION: Discoloured and faded; the
edges of the watercolour have been badly
damaged by removal from a glued top
mount. Previously cut and ruled when laid
down
PROV: Bought 1885, and then in
circulation

A beached fishing boat, with a cart pulled
by four ponies alongside, occupies the
horizontal centre line of the composition,
with the sea beyond and the beach in
front.

 As in **25**, the figures are well managed
and the simplicity of the composition
contributes to the success of the design. In
this instance Prout's method from sketch to
finished watercolour can be followed, as
the much smaller drawing (7.9×16.5), on
which the watercolour is based, is in an
album put together by Prout's youngest
daughter and now at Barnstaple. The
drawing extends slightly further to the left
and includes a third boat at sea. Otherwise
Prout follows the drawing to the letter,
only reducing the number of ponies and
carts, and moving figures from the right of
the ponies into the lee of the boat. The
scraped lights, which are not indicated in
the drawing by white, are rather maladroit
and may indicate some later work. The
palette is reminiscent of Girtin and akin to
Francia.

26

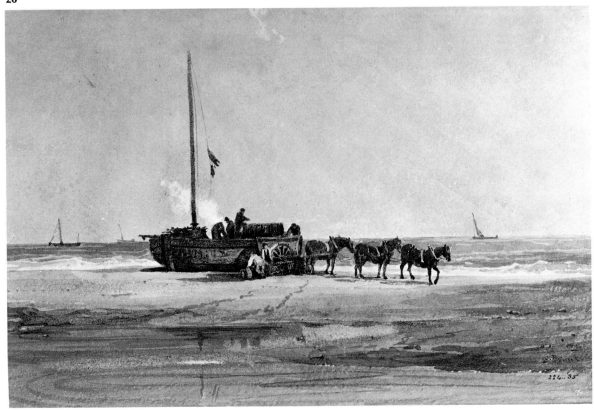

27
Castle by a rocky shore

Watercolour on fine cream wove, with penwork and gum, lights reserved and scraped; $8\frac{1}{2} \times 10\frac{1}{2}$ (21.5×26.7)
Ins. *2963.76* in ink and stamped *VAM* in mon., lower right
CONDITION: Discoloured and faded; a thin edge protected by the mount indicates the original state; fox marks
2963.1876
PROV: William Smith Bequest, 1876
LIT: Hardie, Vol. 3, pl. 6 where 27 is compared to Girtin. Hughes, *O WCS*, pl. 111

A castle is sited on a promontory to the left with a headland across the sea to the right, a choppy sea between them.

The effectiveness of this (?) imaginary coastal landscape is seriously reduced by its condition.

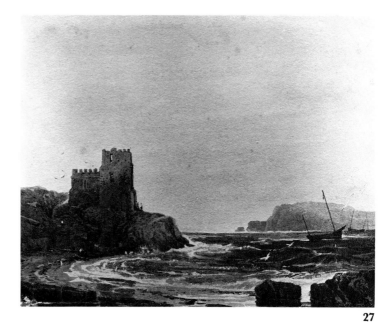

27

28
Fishing boats beached at high tide

Graphite on thin white wove with stump and rubbing, $6\frac{1}{4} \times 9\frac{1}{4}$ (15.7×23.5), sight size
E 3032.1927
CONDITION: Somewhat crumpled, with damage at bottom right, otherwise good
PROV: J.R. Holliday Bequest, 1927

A variety of boats beached with buildings and cliffs behind.

This is one of a small number of drawings that reached the Museum out of a large parcel of Prout drawings acquired by Holliday, the majority of which are in the Birmingham Museum. Generally, Prout's boats are sturdier than this, and these slimmer boats are more typical of Samuel Owen. However, there are numerous comparisons to be found amongst Prout's sketchbooks (e.g. **3**) and among a series of drawings formerly belonging to Holliday, most of the Italian Lakes and the coast from Marseilles to Genoa and Naples (**45**). Prout makes much use of the point of the pencil and the stump, and the drawing was no doubt done rapidly.

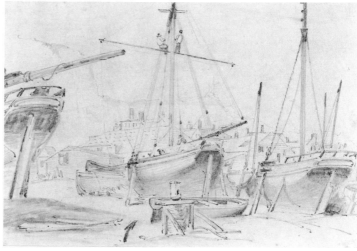

28

29

30

29
Seascape with fishing boat coming in

Sepia wash on buff wove, with white, penwork and gum, lights scraped, laid down; $7\frac{1}{2} \times 10$ (18.2×25.1)
Signed *S. Prout* in pen, lower left, and stamped *VAM* in mon.
117.1896
CONDITION: Surface rubbed
PROV: Presented by James Orrock, RI, 1896

A fishing boat is about to beach near some lobster pots.

After *Lulworth* (**32**) this is perhaps the best of the four sepias from *c.* 1815–20. It brings together the sea, boats, distant cliffs and lobster pots – favourite Prout ingredients. The amount of detailing pen is well judged. There are numerous studies of lobster pots amongst Prout's pencil sketches, e.g. Courtauld Institute (Witt 4095), and several in the National Maritime Museum.

30
Seascape with boat putting out

Sepia wash over traces of graphite on fine buff wove, with bodycolour, penwork and gum, lights reserved, laid down; $7\frac{1}{2} \times 10$ (19.1×25.6)
Signed *S. Prout* with pen, lower right
118.1896
CONDITION: A number of surface abrasions giving the sepia drawing a rather spotty look
PROV: Presented by James Orrock, RI, 1896

A heap of marine bits to the left, the boat putting out to the right, with a stormy sky.

This Cotmanish wash drawing was evidently conceived as a pair to **29**; the design is in reverse and the sky given a more dramatic treatment. There are touches of yellow as well as white.

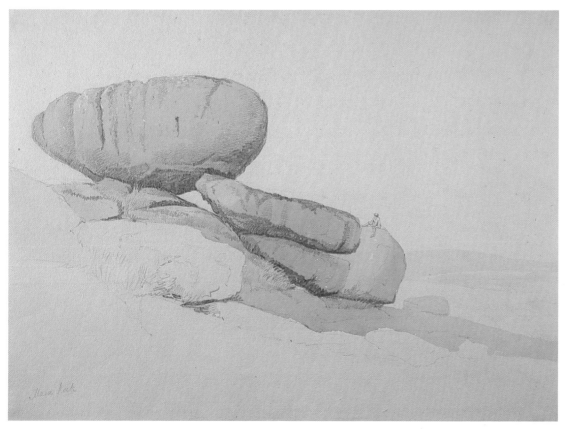

I *Maen Rock, Cornwall*
N. Devon Athenaeum, Barnstaple

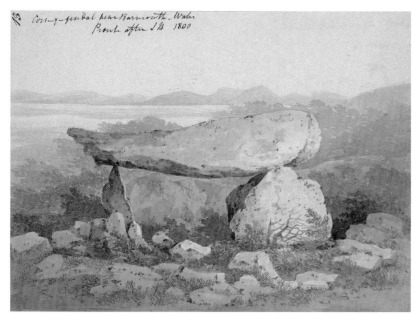

II *Cors-y-Gendel, near Barmouth, Merioneth*
Wiltshire Archaeological Society, Devizes

III *Interior of Malmesbury Abbey, Wiltshire*
Wiltshire Archaeological Society, Devizes

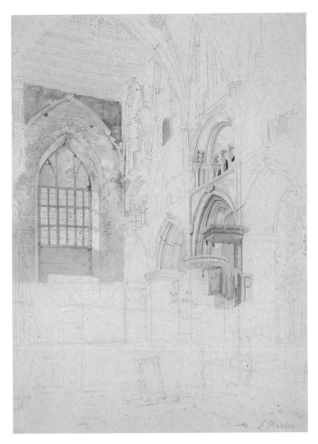

IV *Broadwater, near Worthing, Sussex*
Fitzwilliam Museum, Cambridge

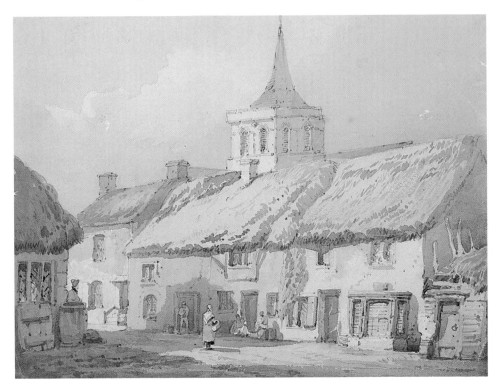

V *Teignmouth and the Hamoaze, Devon,* soft-ground etching
pub. by T. Palser in *Picturesque Delineations,* 1812
Plymouth Museum and Art Gallery

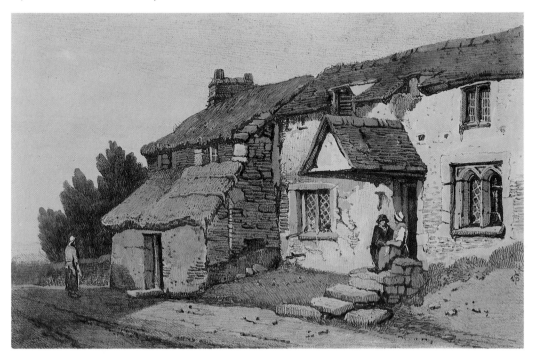

VI *Cottages near Saltash, Cornwall,* soft-ground etching coloured
by hand, pub. by T. Palser in *Prout's Village Scenery,* 1812.
Victoria & Albert Museum, London

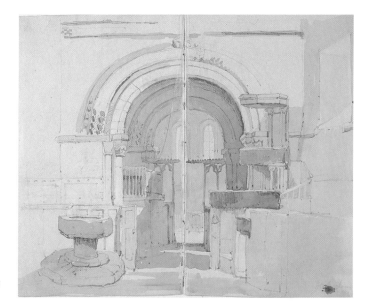

VII *Interior of Old Fincham Church, Sussex*
N. Devon Athenaeum, Barnstaple

VIII *Studies*
Birmingham City Museum and Art Gallery

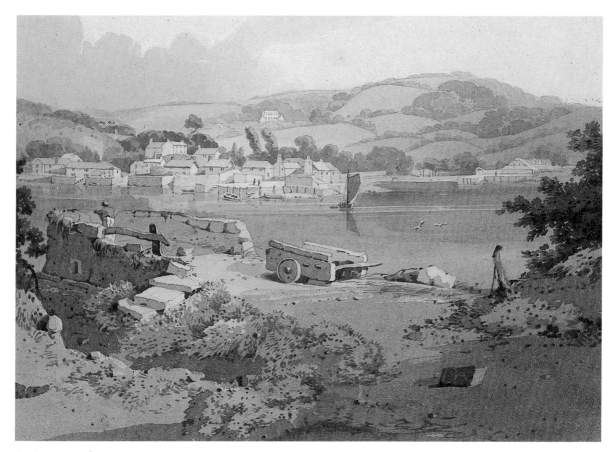

Catalogue 5 *Estuary scene*

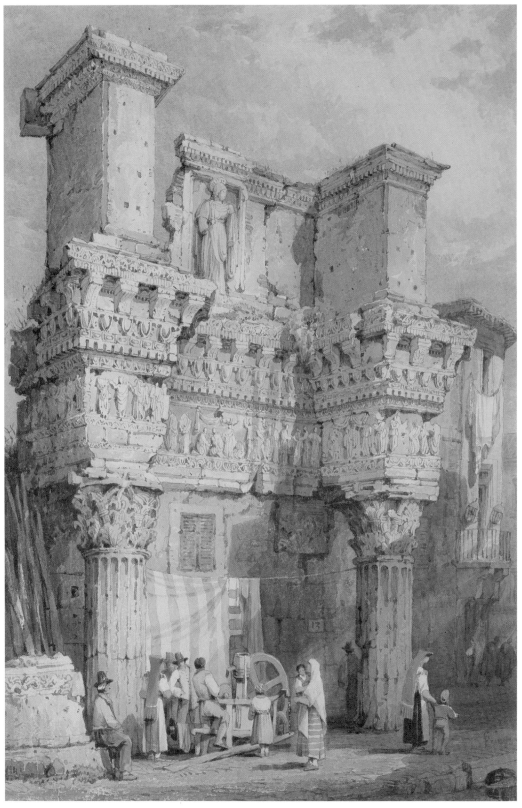

Catalogue 46 *The Forum of Nerva, Rome*

Catalogue 48 *West porch of Ulm Cathedral, Bavaria*

Catalogue 65 *The Arch of Constantine, Rome*

31
The shipwrecked mariner

Sepia wash on cream wove with penwork,
lights reserved and scraped, laid down;
$8 \times 10\frac{1}{2}$ (20.4×27.0)
E 83.1915
CONDITION: The surface is buckled and
generally rubbed
PROV: Presented by Sir H.F. Wilson
KCMG, 1915. Formerly in the collection of
Sir Charles Newton Robinson

A seaman on the left attempts to throw a
line to a group making for a single figure,
all on a rock surrounded by a stormy sea.

It is not quite clear who is saving whom.
Prout has failed to convey the sea with his
usual conviction and the dramatic note is
best struck by the strong light bursting
diagonally through the clouds from top
left.

31

32
Lulworth Cove, Dorset

Sepia wash with traces of graphite on buff-
coloured wove, with penwork and gum,
lights reserved, scraped and rubbed;
$4\frac{1}{2} \times 6\frac{1}{2}$ (11.3×16.3)
Ins: *25 in gr.*
E 3382.1922
CONDITION: Good
PROV: Presented by Douglas Eyre, 1922.
In an album with a stamped title in
capitals: *Drawings the gift of Dr. Penrose to
Henry R. Eyre*

Coastal scene with sailing boats and, in the
foreground, rocks, fishing boat, lobster pots
and fisherman mending nets.

This is a completely successful
composition from Prout's usual vocabulary
of beach staffage, with the additional
merits of his skill at depicting the sea and
coast itself. It was engraved by G. Cooke
for W.B. Cooke's *Southern Coast* (1826). The
sepia could, however, be dated to 1820 or
earlier. A slightly more distant view of the
cliffs, but almost the background of the
sepia with a different foreground, can be
seen in a drawing in the Courtauld
Institute (Witt 4052).

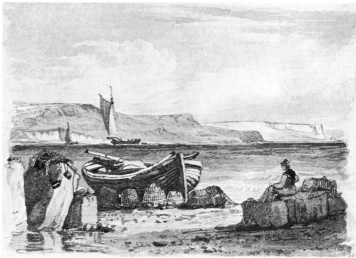

32

33
The beach at Old Folkestone, Kent

Watercolour over traces of graphite on fine white wove, with gum, lights reserved and scraped; $8\frac{1}{2} \times 13$ (21.8×32.8)
Ins. *90.79* in ink and stamped *VAM* in mon. lower right
90.1879
CONDITION: Discoloured and faded
PROV: Purchased from Mrs Maxwell, Isleworth, 1879, when described as 'about 1820'
LIT: Quigley, 1926, pl. 39

The shore line curves from left to right and back to a jetty forming a horizontal centre line with beached fishing boats and houses, the latter below the cliffs and the church. The right foreground is occupied by a fisherman working in his beached boat.

The usual loss of blue-green disguises a successful, straightforward coastal scene at which Prout was adept. The fishermen's cottages are finely handled and are reminiscent of Rowlandson.

The location is apparently inscribed on the verso of the drawing. A very similar boat appears in pl. 14 of *Easy Lessons*, published in 1820, and the date suggested on acquisition may well be right.

34
The beach, Hastings, Sussex

Watercolour and bodycolour on cream wove, with dry colour and gum, lights reserved and scraped; $17 \times 23\frac{1}{4}$ (43×59.2)
Signed *S. Prout* with pen, ins. *3023.76* in ink and stamped *VAM* in mon., all bottom right
Ins. verso *Hastings* in gr.
3023.1876
CONDITION: Discoloured and faded with vertical fold-mark in centre
PROV: William Smith Bequest, 1876

33

The eye is led from rocks and a large abandoned capstan in the left foreground via some rowing boats towards the town in the centre middle distance, from which the bay, filled with boats, curves round to the left horizon. Cliffs rise above the sands on the right.

Prout made drawings of Hastings on paper watermarked as early as 1805 (Hastings Museum) and 1811–12 (various collections) and it is argued in this book (p. 34) that he was on this part of the south coast in 1812. He is known to have been in Hastings in August 1815 and he first exhibited Hastings subjects (usually *Hastings boats*) in 1816. This large demanding piece must represent an exhibition watercolour such as Prout showed at the OWCS or even at the RA; OWCS No. 199, in 1817, is a candidate. For health reasons Prout frequently visited Hastings in later years and resided there from 1836 to 1844.

As in most of the English scenes in the Museum's collection, the effect of Prout's work can hardly be judged because of fading and discoloration. In general the blue-greens have proved fugitive and 'Prout's Brown' has become far too dominant. Although the contrast between foreground rocks and a relatively clear and light sky was once even more marked, the controlled transition from foreground to horizon which linked them has been weakened. Not all the changes of balance due to over-exposure to light, however, account for the crudeness of the foreground figures and the bodycolour used on foreground figures, reflections and rocks. Prout is unlikely to have left accidental spots of blue bodycolour on the rocks, for instance, and it is suggested that the watercolour has been 'improved' by a later hand.

34

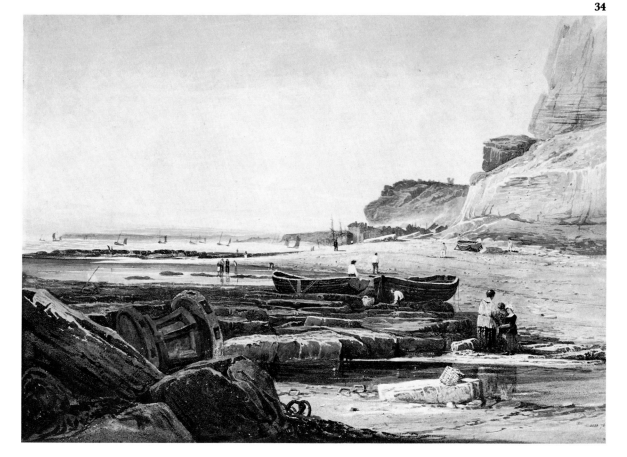

35

Blore Ray Church, Staffordshire: interior, view west

Graphite on cream wove with stump and rubbing; $10\frac{1}{2} \times 15\frac{1}{2}$ (26.3 × 39.2), sight size Ins. *Blore* in gr., bottom right and stamped *NAL* in mon.
D 2527.1908
CONDITION: Good apart from glue marks and stains at corners
PROV: Purchased from John Lane, 1908. Lane formed a collection of West Country views including a large number of drawings by Prout which he gave to the Royal Albert Memorial Museum, Exeter. This drawing and **36** was no doubt acquired by him with other Prout material but was let go, having no West Country associations

View from the centre of the chancel through the screen towards the nave and west window.

Prout exhibited a watercolour – *Blore Church, Staffordshire* – at the OWCS in 1821 (**19**) which was bought by Prout's friend Francis Chantrey for 8 guineas. There was a watercolour in Ralph Bernal's collection – *Interior of Blore Church* – (Christie's 23.4.1853, lot 267). Perhaps Prout travelled through Staffordshire towards Yorkshire and Scotland in 1818 as proposed here (pp. 39–41). Although a similar subject to *Old Fincham Church*, in a sketchbook of *c.* 1812 (colour pl. VII), Prout's handling is now robust where it was once delicate, stump and toning by rubbing with the stump or finger, replacing wash. *Blore* is quite different in feeling and intention to the purely factual recording done by Prout at Dunstable for Britton in 1805 (**1, 2**). By 1818 Prout has developed so that he can capture both the appearance of a medieval church with its fifteenth-century font and chancel furniture and the pre-Victorian restoration atmosphere of such a building in the earlier nineteenth century. Cotman was of course a master of this situation but generally introduces a slightly more formal note. Here, at least, Prout has achieved the temperature and silence of the church with only himself present, looking down the paved aisle to the patient bell ropes. The graphic technique is extremely subtle in range, from the surfaces in full light to the few small areas of dense shadow. The three-dimensional space of the small nave is absolutely defined by hatching and rubbing. This contrasts with the vigorous and rapid definition of carved stall ends and screenwork in the chancel. Most of Prout's finest continental drawings which employ the same graphic techniques are exterior views and, for some reason, Prout did not fully exploit his evident gift for interiors during the 1820s.

35

36

**Blore Ray Church, Staffordshire:
interior, view east**

Graphite on thin buff wove, with stump
and rubbing, fixed in parts; $10\frac{1}{4} \times 15\frac{1}{2}$
(26.2 × 39.6), sight size
Ins. *Blore* in gr., bottom right, and stamped
NAL in mon.
D 2528.1908
CONDITION: Several creases and some fox
marks, torn bottom left
PROV: Purchased from John Lane, 1908.
See **35**

The chancel is viewed from the nave, off-
centre to the left. The pulpit and screens
dominate the centre of the drawing, with a
font in the right foreground.

The drawing is more forceful than in the
companion view (**35**), with stronger
hatching around the pulpit and a greater
use of the stump, although the drawing
suffers from the loss of the whiter paper
and the further flattening effect of the
fixing. It is otherwise a less subtle piece of
work, for instance in the handling of the
upper part of the east window.

36

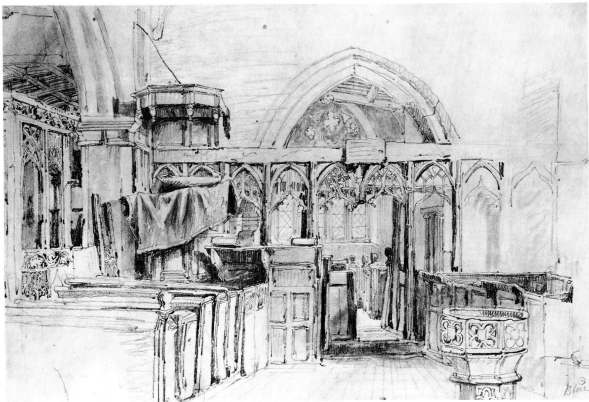

37
Drawing-Book illustrations

Graphite on white wove card: $3 \times 4\frac{1}{2}$ (7.5×11.6)
9206
CONDITION: Generally good except for glue stains at edges
PROV: Bought from Miss J. L. Gray, 1883

The six miniature drawings are identical in size and, but for the exceptions noted, also in condition. Two of them appear slightly larger and in reverse in *Easy Lessons in Landscape Drawing*, published by Ackermann in 1820. The general toning of these drawings, achieved by repeated strokes of the pencil, makes them more typical of Prout's etching than of his drawing, but there are comparisons to be found in sketchbooks and in the series of views probably made in Italy in 1824.

a Treaty House, Uxbridge, Middlesex. This is based on a pencil drawing in the Barnstaple album, only the central feature of which has been used, i.e. this is a capriccio, which may be true of many of the others in the series.
b Coastal scene with windmill.
c Remains of a quay with coast beyond.
d River landscape with a three-arch bridge. Pl. 15, *Easy Lessons*, published 1819. The drawing has been bent and broken across a horizontal line towards the bottom.
e Church.
f River landscape with six-arch bridge. Pl. 15, *Easy Lessons*, published 1819.

37

a

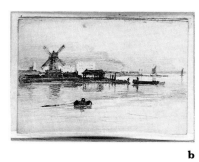

b

c

d

e

f

38
Drawing-Book illustrations

9207
See **37**

a Remains of a quay with fishing boats.
b A port seen across a bay.
c Coastal scene with sail barge. Pl. 16,
Easy Lessons, published 1819. The
discoloured paper suggests that this
particular drawing, unlike the others, has
been framed up and 'in circulation'.

d A port scene.
e Coastal scene with sail barge. Pl. 15,
Easy Lessons, published 1819.
f Village scene with church tower. This
looks slightly more tentative and less
mature than the others and can be
compared to the framed sketches in the
sketchbook volume titled *Sketches in
Cornwall* (**3**).

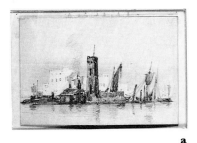

a

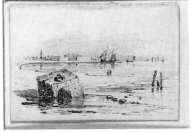

b

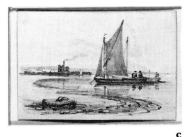

c

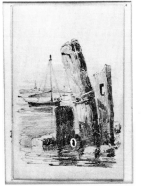

d

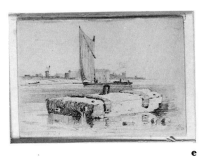

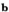

e

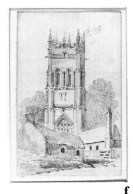

f

39

Strasbourg, Church of St-Omer with the river

Graphite on fine white wove, with stump and rubbing; $10 \times 6\frac{3}{4}$ (25.2 × 17.3)
Ins. *Strasbourg/St Omer* in gr. lower left
Circ. 84.1958
CONDITION: Discoloured and dirty round the edges, a little foxing, a loss of surface lower right
PROV: Acquired 1958

The church is viewed from below across water; on the right a group of women doing the laundry.

Contrasts between pure white and shaded areas are now subdued but the very fine control of darks and lights is still evident and, although on a relatively small scale, this is a very good example of Prout's powers of graphic description. The drawing is closely followed in the lithograph in *Illustrations of the Rhine* but has become denser and more shaded, as in contemporary lithographs made in France (e.g. in the *Voyages pittoresques*). The lithograph is dated Nov. 1822 and was included in the first part of the *Illustrations* to appear, in 1823. Prout used a different view of St-Omer for a plate in *Facsimiles of Sketches made in Flanders and Germany* (illus. Halton, pl. X), pub. 1833. Prout exhibited four Strasbourg views, including a *St Omer*, at the OWCS in 1822.

Although Prout may have visited Strasbourg on several occasions because of its situation on the Rhine, it is certain that this drawing was made on the first visit and can be dated precisely to 12–19 Sept., due to the survival of the almanack that he used for recording his movements on the tour of 1821.

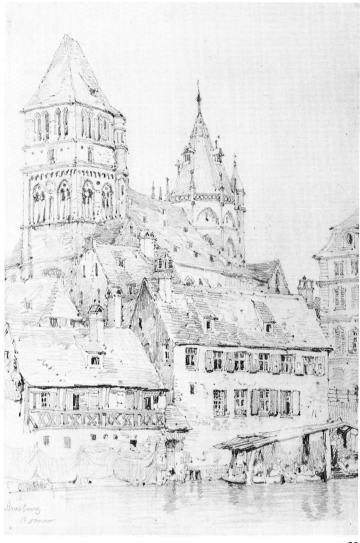

39

40

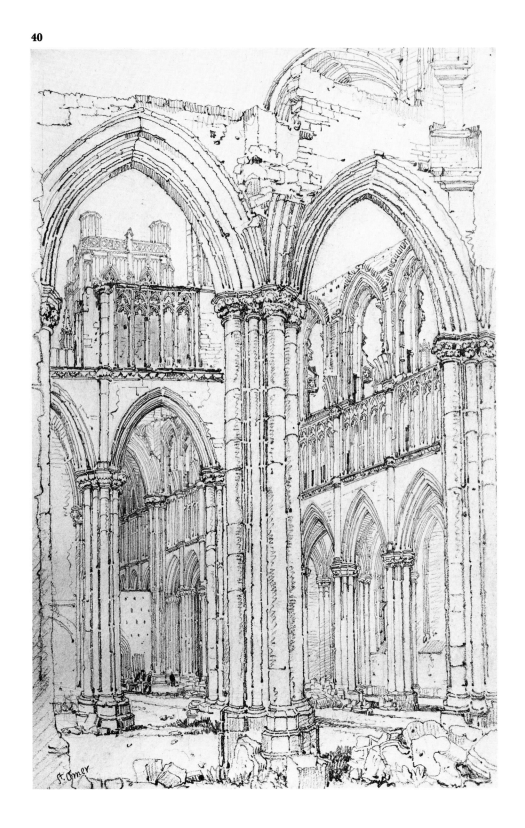

40

St-Omer, the abbey church of St Bertin: view of nave and north transept from the crossing

Hard and soft graphite on cream wove, stump with rubbing; $16\frac{1}{4} \times 10\frac{3}{4}$ (41.5×27.5), sight size
Ins. *St Omer* in pencil lower left
E 2659.1914
CONDITION: Good, but the drawing has lost some of its surface quality, ? some fixing
PROV: Bought from G. T. Phillips, 1914
LIT: Quigley, *Architectural Review*, 1926, repr.
EXH: Arts Council, 'Richard Parkes Bonington', Nottingham etc. 1965 (332)

The crossing is viewed from east of the arcade into the south transept, the screen of two arches rising almost to the top of the drawing with the openings filled with architectural details to the west.

This and **41** are stupendous examples of factual draughtsmanship and give the lie to critics who say that mannerism prevented Prout from faithfully depicting architecture (*Magazine of Fine Arts*, 1834). Ruskin could hardly have admired him if this had been so. These drawings deserve to rank with the best of Cotman's antiquarian work or with that of lesser men such as Charles Wild, Frederick Nash and Frederick Mackenzie. Although this is quite unlike a Bonington drawing in selection of subject and graphic technique, Bonington's presence with Prout at St-Omer may have stimulated the latter to these heights. Apparently Samuel Prout told his friend Dominic Colnaghi at the Bonington sale in London in July 1829 (Dubuisson and

Hughes, p. 29) that an oil by Bonington had been painted in his presence (? that repr. in colour, Peacock, pl. XI). Prout is more likely to have visited St-Omer in 1822, *en route* for the Low Countries, than in 1823 when he visited Germany, although 1823 is the traditional date for the meeting.

Ruskin's admiration for Prout, as for other artists such as T. M. Rooke, was related to their ability to chronicle European monuments which he saw as under attack either from demolition or from restoration. Prout captures men in the act of carting away blocks of stone from the ruins of the abbey church, very little of which survives today. De Jolimont in his *Monumens … de Rouen* (1822) commented on the comparative lack of interest that his countrymen expressed for their architectural heritage, and it was the English, with their well-established antiquarian tradition, who pioneered the study of Norman buildings and, to a lesser extent, of French cathedrals. Nodier and Taylor's *Voyages pittoresques* (1820-78) marked an important step forward, and English artists, including Prout, contributed substantially to the illustrations. These do not amount to an architectural record to compare with John Sell Cotman's *Architectural Antiquities of Normandy* (1822). This was partly because Nodier and Taylor's enterprise was imaginative as well as factual, attempting, like Bonington's costume pieces, to evoke the atmosphere of the period in which the monuments were built and to summon up the shades of the original inhabitants. Prout's concerns are firmly rooted in the present.

41

St-Omer, the Abbey Church of St Bertin: view of east end from the crossing

Graphite on fine cream wove with stump and rubbing; 16 × 11 (40.7 × 28), sight size
Ins. *St Omer* in pencil lower left
E 2660.1914
CONDITION: Has lost some surface quality, (?) by pressing and (?) some fixing
PROV: Bought from G. T. Phillips, 1914
LIT: Quigley, *Architectural Review*, 1926, repr.

The east end, with a backdrop of dark trees, is viewed from the east end of the nave, from almost beneath the crossing.

This drawing does not have quite the range of its companion, where a harder pencil was used for the upper part of the west tower, but the introduction of the back-screen of trees in black with the intensity of crayon, gives this view an admirably weighted foil to the complex of Gothic details. Although the artist has given very careful attention to light and shade where it will add to our understanding of the structure, for instance in correctly reading the screened passageway or triforium at the east end, his primary method is to emphasize the horizontal against the vertical elements and to emphasize the capitals and string courses. There are traces of uninterrupted ruled lines in this and its companion, but if a ruler has been used it is done with subtlety; the line is broken as usual and the pencil breaks off both to left and to right and not in a repetitive or mechanical way.

How exactly did Prout set out these drawings and capture such a wealth of architectural detail? Did he use any mechanical aids? There is no direct evidence that he did so himself, although he recommends their use to others.

Cotman, who was given a Graphic Telescope by Sir Henry Englefield in 1817, and drew with it in Normandy, wrote that the instrument was 'used by all ye artists I find!' ... An early reference to it appears in Samuel Prout's *Rudiments of Landscape* of 1813. Having mentioned the value of the 'camera lucida' to the amateur, he adds: 'A similar invention, or rather an improvement thereof, has been made by Mr. Cornelius Varley, who has added the power of a reflecting telescope to this most ingenious instrument, by which views of objects at a considerable distance may be drawn, which affords a vast scope for the study of landscape composition. This instrument will be found particularly useful to the military profession, as it enables the artist to draw a fortification, or other regular building, with exactness even at the distance of some miles.' (M. Pidgley, *Exhibition of Drawings and Watercolours by Cornelius Varley*, Colnaghi & Co., 1973.)

It is difficult to imagine any glass or telescope that would have produced such dramatic close-up viewpoints. The close-up position chosen by Prout for his stool gives his St-Omer drawings more the effect of Girtin's *Peterborough Cathedral* (Ashmolean Museum) or of Turner's *Interior of Tintern Abbey* (Victoria & Albert Museum, 1683.1871) than of Cotman. Despite their quality as entirely convincing architectural records, these drawings pose problems if translated into a ground plan.

41

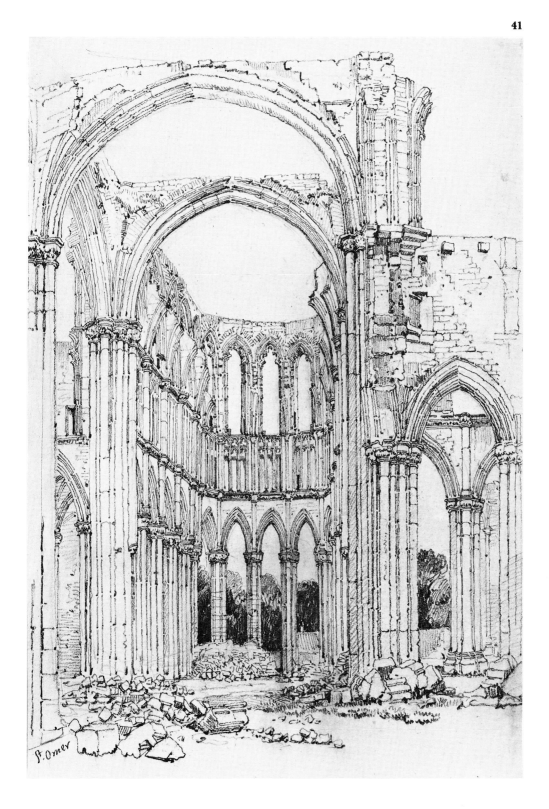

St. Omer

42

Ulm Cathedral, Würtemberg, view of the west front

Graphite on cream wove with stump and rubbing; $11 \times 16\frac{1}{2}$ (27×41.5)
Ins. *Ulm* in gr. lower right, and some colour notes
E 2661.1914
CONDITION: Some of the original surface quality has been lost (?) through pressing
PROV: Bought from G.T. Phillips, 1914, with **40, 41, 53**

The cathedral is seen from the far side of the Münsterplatz with an octagonal fountain to the left and a row of half-timbered houses leading towards the cathedral on the right.

Prout was in Ulm in 1823 during a tour which also took him to Würzburg, Nuremberg, Regensburg, Munich and Augsburg. He made at least six on-site drawings on the smaller scale of $10\frac{1}{2} \times 7$ in. Prout published some of the fruits of his stay in Ulm as soon as he returned to London, through the OWCS exhibition of 1824. He also included a lithograph among his *Views in Germany*, a supplement to the *Illustrations of the Rhine* published in 1826. Ulm features in the 1833 *Flanders and Germany* and in later publications such as the 1834 *Interiors and Exteriors* and the 1844 *Sketches at Home and Abroad*. Prout made a number of Ulm watercolours, particularly in the 1820s and 1840s, but only one, sold to Ackermann for 15 guineas in 1825, is called *Cathedral at Ulm*. Prout replaced the dilapidated houses shown here on the right in his views from the west portal, see **48**.

This drawing is one of Prout's finest, and brilliantly expresses the lace-like screen façade of the cathedral, the isolation of the fountain in the square and the lowly nature of the houses on the right. No other artist was attempting such factual reporting in this part of Europe at the time.

42

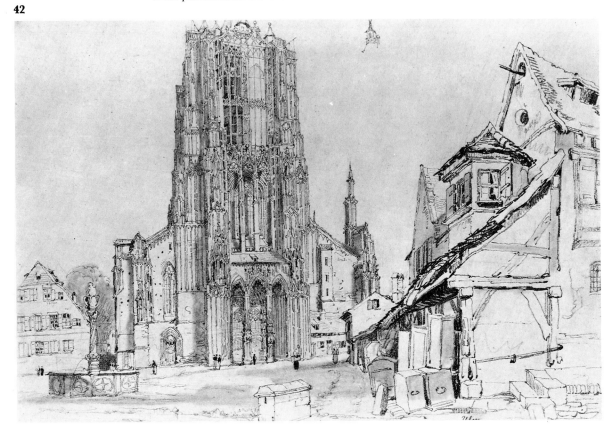

43
Lavey, near St Moritz, Switzerland

Graphite and white on fine grey wove,
with stump and rubbing; laid down;
$14\frac{3}{4} \times 10\frac{1}{4}$ (37.5 × 26)
Ins. *Lavey/nr: St Maurice* in pencil, lower
left and stamped *NAL* in mon., lower right
D 128.1890
CONDITION: Vertical crease down centre,
otherwise good
PROV: Bought 1890 for £4

View down the village street, flanked with
houses, of the mountains beyond.

 This drawing most probably dates from
August/September 1824 when Prout passed
through on his way to Italy. It was from
such drawings that he would make other
drawings and watercolours for sale. This is
extremely close to J.T. Willmore's steel
engraving titled *Swiss Cottage, Lavey*,
published by Jennings in the first of the
Landscape Annuals: that for 1830 which, like
its successor, was entirely illustrated by
Prout. The text by Thomas Roscoe reads
as if he had not personally visited 'the
small sequestered hamlet of Lavey' and
was relying on the artist when saying: 'Yet,
although we entirely acquit the rustic
architect of any variety of design, a Swiss
cottage is an exceedingly picturesque
object' (p. 64).

43

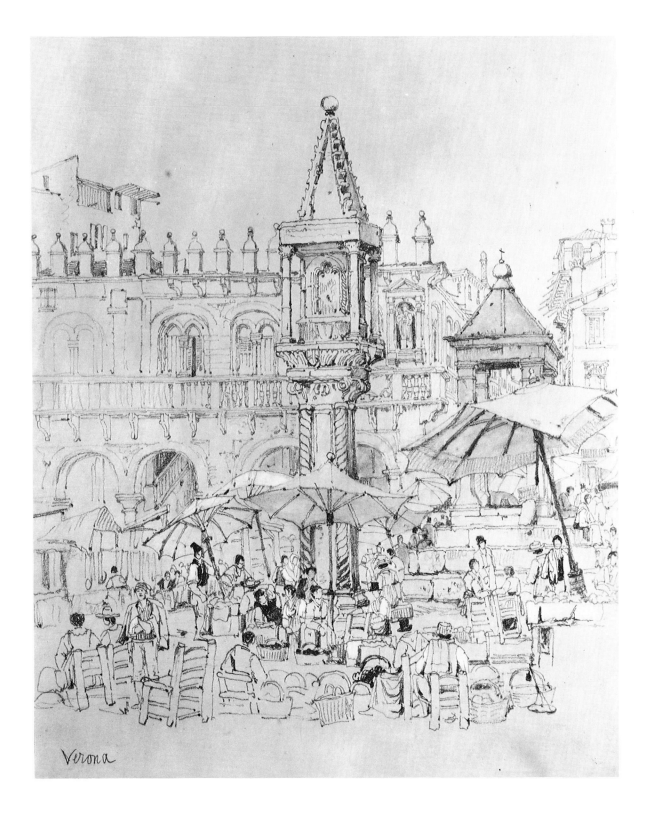

Verona

44
Verona, the Piazza delle Erbe

Graphite and white on fine cream wove
(watermarked 1815), with stump and
rubbing; 14 × 10 (35.5 × 25.5), sight size
Ins. *Verona* in gr., lower left
E 956.1936
CONDITION: A curving crease from centre
left to bottom right. The drawing has lost
some of its surface quality (?) through
treatment
PROV: Presented by Dr H.A. Powell,
1936, through the National Art Collections
Fund

Umbrellas and sturdy wooden chairs
surround the Colonna Antica and the
Capitello to which the Casa di Mercati
acts as a backdrop.

The size of this enchanting drawing is
not typical of Prout's on-site sketches.
There were 15 drawings measuring 15 ×
10½ in the 1852 sale and, assuming that
they were made on the tour of 1824, Prout
must have stayed in Verona for several
days. Two of the 1852 drawings (bought
by Popham) were called *Market Scenes at
Verona*. A fine *San Zeno, Verona* (Courtauld
Institute Coll., Witt 3278) is on buff-tinted
paper.

44 is also somewhat unusual for Prout
for its concentration on a central group of
figures; they are generally more incidental.
Carefully introduced figures are a
characteristic of Prout's best drawings and

watercolours, and Ruskin saw a touch of
genius in this quarter. He might well have
remarked on the brilliant use that Prout
made of the umbrellas, a feature much
reduced in a small and more stolid
performance in watercolour based upon the
sketch (Sotheby's, 18.12.1980 Lot 197).
The drawing would be hard to match for
its brilliant instant quality, despite the fact
that it has required much architectural
description. Prout has applied extreme
economy, making his characteristic accents
with the point of the pencil and the stump
to add a three-dimensional quality to
arcades and umbrellas; an order of
precedence is clearly established.

A direct comparison can be made
between this drawing and one made not
long afterwards by Bonington (Peacock, p.
62). Bonington takes the view in the other
direction. His graphic style is much busier
and no doubt he achieved his object more
speedily than did Prout.

Prout fully exploited his visit to Verona,
exhibiting 16 pictures, many of them as *At
Verona*, at the OWCS between 1827 and
1846. Only the Scaliger Tombs and the
Amphitheatre are more specifically
designated, and the former was certainly
Prout's most distinctive Veronese subject
which he supplied to the Annuals (*Forget-
me-Not*, 1826/7) and used in his own
lithographed *Sketches in France, Switzerland
and Italy* (1839).

45
**Casamice, Isola d'Ischia
(Casamicciola), near Naples**

Graphite on fine grey wove; $10\frac{1}{2} \times 15$
(26.5×38.0)
Ins. *Casamici in Ischia*, lower right
E 3031.1927
CONDITION: Good
PROV: J.R. Holliday Bequest, 1927

A series of rocky headlands stretch across
the centre of the paper from right to left.

The hesitant drawing is reminiscent of
Prout's early sketchbook of the Cornish
coastline (**3**). It comes from the large
collection acquired by Holliday and
distributed after his death to Birmingham,
the Fitzwilliam Museum, Cambridge and
the Laing Art Gallery, Newcastle, as well
as to the Victoria & Albert Museum. The
majority of them are in the Birmingham
collection, which has five other Ischia
drawings, all but one on grey tinted paper
(930′27, P 75/76/80/91′79). The odd one
out, on white paper, is watermarked 1805.
They belong with others made between
Gaeta and Sorrento. Not all of them are as
slight as **45**; a few are fully realized
through use of the stump and rubbing. The
Holliday drawings cover other parts of
Italy – Rome, the Italian Lakes and Genoa
– all apparently made on the 1824 tour.
Prout never exploited these southern
Italian landscapes, probably because he
was ousted from the *Landscape Annual* by
Harding (see p. 79).

45

46

Rome, the Forum of Nerva (Temple of Pallas)

Watercolour and bodycolour on white wove, with penwork, dry colour and gum, lights reserved and scraped; 16½ × 11 (41.8 × 27.7), sight size
Signed *S. Prout* (SP in mon.) with pen, ins. *3056.76* in ink and stamped *VAM* in mon., lower right; stamped again middle left 3056.1876
(see colour plate between pp. 120 and 121)
CONDITION: Some discoloration but relatively unfaded; the paper wrinkled bottom left.
PROV: William Smith Bequest, 1876. A previous mount was ins. *Wm Smith, 9 Southwick Street, Cambridge Square, London. Graphic 1860. Presented by E. Evans Esq.*
LIT: W. Gaunt, *Rome, Past and Present*, 1926, pl. CV

The monument is seen from close up, with a group of figures including a knife-grinder in the centre foreground.

Prout visited Rome at least twice during his tour in 1824, the most likely date for the relevant site drawing. He may have returned to Rome sometime between 1824 and 1829, but if so this is not recorded. This particular subject was exhibited by him at the OWCS in 1826 (a 6-guinea watercolour sold to Charles Wild) and again in 1827 (another at the same price to G. Hibbert) when he also sent a watercolour to the RA. The size of the Birmingham version (P 304′53) – 26 × 19 in – might suggest it as a candidate for the RA. This is larger as a composition as well as in scale but (?) due to some treatment has an unsatisfactory, slightly anaemic appearance when compared with **46**, the smaller but stronger and more vivacious London picture. The Birmingham version relies on a busy street scene and the well-managed curve of the street beyond the Roman monument which is the focus of the picture. The London version concentrates all its interest upon the Temple of Pallas itself and is a splendid example of Prout's talent at conveying the multicoloured surface of ancient stone with the stains and growths of time.

Prout never made up his mind as to which of the two titles to prefer and there was a drawing for each in the 1852 sale similar in size to **46** and to his standard on-site sketches.

Neither the OWCS catalogues nor Prout's account books specify size and so all of the following watercolours exhibited at the OWCS may be possibles: 1832 (7 guineas, W.B. Roberts); 1841 (9 guineas, Price Edwards); 1844 (15 guineas, Thos. Avison); 1849 (10 guineas, W.B. Morgan). Prout supplied S. & J. Fuller with a 9-guinea version in 1845 and two cheaper ones in 1850.

Charles Heath bought a *Temple of Pallas, Rome* for 13 guineas from the artist in 1830, apparently getting drawing and reproduction rights together, this being a version used by J.B. Allen for the steel engraving that appeared as a framed title to the *Landscape Annual* for 1831; Heath was supervising the engraving. The engraved view does not obscure the lower part of the Roman monument with a contemporary infill as in **46**. In this respect, and as regards the arrangement of figures, the engraving of 1830 is close to the lithograph in *Sketches in France, Switzerland and Italy*, published in 1839 (Halton, pl. LVIII) and repub. in photolithograph by Sprague & Co. in *European Sketches by Samuel Prout*, n.d.

Two watercolour versions in recent sales represent free variations on the theme – Christie's, 22.2. 1977 (79) and Sotheby's, 13.11.1980 (89). In these Prout removes parts of the structure and re-erects them as his fancy takes him. Such capricci are candidates for watercolours titled *At Rome*.

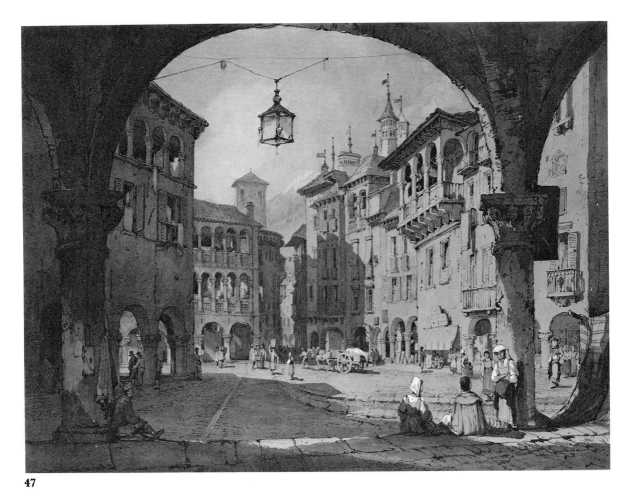

47

47
Domodossola, Piedmont

Watercolour and bodycolour on cream
wove, with dry colour, penwork and gum,
lights reserved; $18 \times 23\frac{3}{4}$
(45.5×6.04)
104. 1896
CONDITION: Discoloured particularly in
the sky and faded so as to overemphasize
blue shadows and white highlights
PROV: Bought at the Hargitt Sale,
24.2.1896 (361); Agnew label on the back
of the frame

An irregular piazza is viewed from beneath
an arcade.
　　Prout arrived in Domodossola on 7
September, towards the beginning of his
first Italian tour in 1824. There are only
two drawings in the 1852 sale catalogue,

one of which, *Domod'ossola, Street Scene*, must
be that lent by Ruskin to the 1879
exhibition and illustrated in autotype in
one edition of the catalogue. This drawing,
now at Brantwood (761), is the basis for all
the other versions, which include W.
Wallis's steel engraving in the *Landscape
Annual* for 1830 and Prout's lithograph for
his *Sketches made in France, Switzerland and
Italy*, published in 1839 (Halton, pl. LI).
The latter omits the framing arcade and is
the duller as a result. A watercolour, $9 \times$
13 in (Sotheby's 7.7.1983, lot 187) exactly
reproduces the engraved view in which the
horse and cart has moved forward a yard
or two. This feature is not in the site
drawing, which is unusually full of local
inhabitants. The most obvious differences
between the watercolour under discussion
and all other versions, is the inclusion of

the hanging lamp as an incident in an otherwise large expanse of unbroken sky, and the signboard fixed behind the right-hand column. There are various minor variations in the buildings, particularly those on the extreme right of the composition.

The measurements of the Museum's version agree with those of a watercolour sold by Joseph Arden at Christie's (24.4.1879, Lot 820) and bought by Agnew's for £110. 5s. This very large and striking watercolour seems too grand, even for the modestly priced Prout, to fit the 1838 and 1845 OWCS pictures, both sold for only 8 guineas to W.C. Marshall and John Dent respectively. The same is true for the 12-guinea picture bought by Prout's friend Francis Broderip at the OWCS in 1826, the earliest appearance of this subject. One can understand the impact that Prout made in the mid-1820s in the London exhibition room if *Domodossola* represents a painting of this time. Even in its damaged state this watercolour is extremely bold, quite apart from its novelty as a subject, the shadows being thrown in with particular force. Prout is also on top form with his figures.

48
Ulm Cathedral, Würtemberg: view from the west porch

Watercolour and bodycolour on cream wove, with penwork, laid down; $21\frac{1}{2} \times 16\frac{1}{2}$ (54.6×41.6)
P 12. 1953
(see colour plate between pp. 120 and 121)
CONDITION: Some discoloration and fading
PROV: Bequeathed by Miss M.A.B. Paton, 1953, in memory of her brother A.A. Paton, CB

Half-timbered houses and a church behind, are viewed from beneath the triple portal of the cathedral.

This is a delightful example of Prout's novel recipe of mixing Europe old and new. The spatial setting is intriguing and the framing of the church spire with the central arch is a clever device sensitively brought off. The local inhabitants are among the artist's most successful, in particular the group at the foot of the

central pier and the soldiers in shadow beyond. The gentleman in the tricorn hat has travelled to or from Würzburg – Manchester, Whitworth, D 23.1924 (fig. 34). This watercolour is a classic example of Prout's use of the reed pen, grey for the back screen of houses and church, and brown for the stonework of the porch itself. The structure of the Gothic portal is not allowed to be too repetitive and Prout breaks it down with blue-grey brush strokes of diagonal lighting and by taking a triangular bite out of a shadow area on the left. **48** is slightly larger than the *Porch at Ulm* in the Manchester City Art Gallery collection (1890.19) and both are considerably larger than the $10\frac{1}{2} \times 7$ in drawing also at Manchester which is the same size as the six Ulm drawings in the 1852 sale. The Manchester watercolour is more ponderous than **48** and lacks such well-contrived staffage; in general it is less close to the spirit of the site drawing which has a relatively slim and elegant central porch with only a single Madonna-and-Child statue showing. Both watercolours inflate the architecture and increase the statuary and inflation has gone furthest in the Manchester picture. A reduced version in reverse is the lithographed pl. 21 in *Sketches at Home and Abroad*, 1844.

Prout exhibited 12 *Ulms* at the OWCS between 1824 and 1850, eight of which could be, but only one of which is actually called *Porch at Ulm Cathedral* (bought for 5 guineas by the Hon. Col. Stanhope in 1824). The artist sold a *Porch at Ulm* to G. Haldimand for £2. 12s. 6d in 1826 and a *Porch Ulm* together with a number of other 3-guinea watercolours to Ackermann in 1842. However, because the memory of 1823 still seems strong in **48**, a date in the 1820s is to be preferred and other possibles are worth mentioning: *At Ulm* (Ackermann, 5 guineas, 1824); *Cathedral at Ulm* (Ackermann, 15 guineas, 1825); *At Ulm* (Sir Alexander Hume, 12 guineas, OWCS, 1827). Another watercolour of this subject is in the Ferens Art Gallery, Kingston-upon-Hull (W 77).

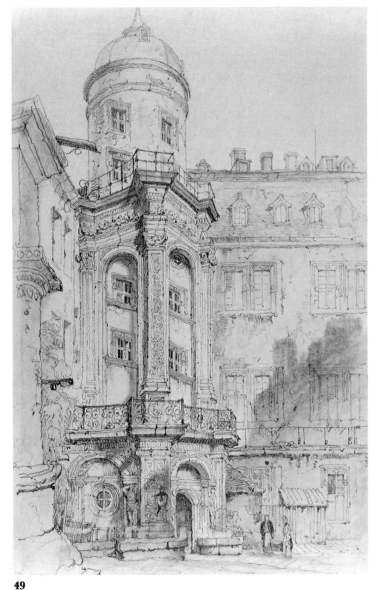

49

49
Dresden, palace courtyard

Graphite, stump and rubbing on fine grey
wove; $11\frac{3}{4} \times 8\frac{1}{2}$ (30×21.5)
Ins. *Dresden* in pencil lower right
Circ. 9.1927
CONDITION: The sheet is uneven as a
result of being stuck down at the edges
PROV: Acquired 1927

A turreted entrance in the corner of a
courtyard.

 With the possible exception of the
pioneering Capt. Batty, Prout was breaking
new ground as an English professional
artist when he organized a tour to Saxony
and Bohemia in 1829. This particular
drawing, smaller in scale than those others
recorded by the 1852 sale which are
$16\frac{1}{2} \times 11\frac{1}{2}$ in, was not apparently exploited
for use as a lithograph or watercolour or
for reproduction in steel engraving; it is less
successful than some of his finest
continental drawings but this is to be
hyper-critical. Prout was on his own in the
sense that he was breaking new ground
topographically and to some extent
technically. The rarity of slighter sketches
(other than for staffage) of continental
subjects suggests that this type of on-site
drawing, taken to a high level of
completeness, represents his usual method
of working on tour, at least in places that
he perhaps felt he might never see again.
Such a drawing requires a commitment to
a subject which implies time spent in
selection and, thereafter, a dedicated
concentration more difficult for Prout than
for others, given his susceptibility to illness.

50
Prague, portal of the Týn Church

Graphite and white on grey-green wove paper with stump and rubbing; $16\frac{1}{4} \times 10\frac{1}{2}$ (41×26.7)
Ins. *Prague* in gr. over *Bamberg* erased, lower right
Circ. 576.1923
CONDITION: Paper discoloured and damaged at corners where once stuck down with glue, the surface generally flattened and the white highlights damaged by some treatment
PROV: Acquired 1923

The porch is viewed close up and slightly from the left, due to the narrowness of the street in which it is set.

The artist featured Prague, an obviously 'new' subject to a British audience, by including five views in his lithographed *Facsimiles* published in 1833; pl. 44, *Thein Church* (Halton, pl. XLIX), is an equally oblique view taken from the other side. He however failed to establish Prague as a successful subject at the OWCS, his *Thein Church, Prague*, at 7 guineas, being returned unsold in 1839. His only success was with *Porch the Stein (sic) Church of Prague* at 15 guineas in 1846. A watercolour based on **50** is illus. by Hughes, *OWCS*, pl. VI (British Museum).

Prout was in Prague in early September 1829, having been held up for a few days in Bamberg (see p. 55). He made at least 17 drawings while he was there, among which was *Entrance porch to an old church* (1852 sale, lot 349) which may be **50**. Other 1829 drawings of the same size and also on tinted paper are: Birmingham Museum 7'05 (*Facsimiles*, pl. 43, Hotel de Ville, Prague); Fitzwilliam Museum, Cambridge, 1416; British Museum, 1889-5-26-17 (*Facsimiles*, pl. 44, Thein Church); and 1915-3-13-42, (*View along the bridge*, illus. f. p. 62 in *Notes* . . . (23) when belonging to S.G. Prout); Plymouth City Museum and Art Gallery, 161.14 (*The Bridge, Prague*, seen from below).

50

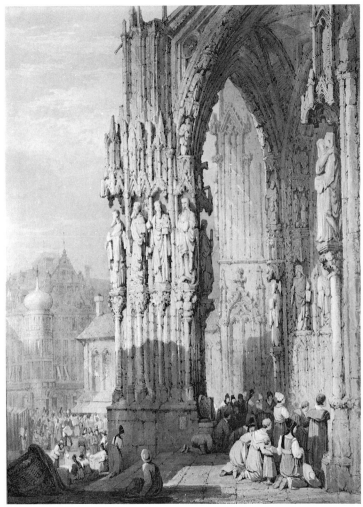

51

51

Regensburg Cathedral, Bavaria: view from the west porch

Watercolour and bodycolour on cream wove, with penwork, dry colour and gum, lights scraped; $25\frac{3}{4} \times 18\frac{3}{4}$ (65.5×47.7)
Signed *S. Prout* with pen, lower left, ins. *1040.78* in ink and stamped *VAM* in mon., lower right
1040.1873
CONDITION: Discoloured (particularly in the sky) and faded
PROV: Richard Ellison Bequest, 1873
EXH: Nottingham Museum, 'Thomas Shotter Boys', 1974 (140); Munich, Haus der Kunst, *Zwei Jahrhunderte Englische Malerei*, 1979/80
LIT: A. Dayot, *La Peinture Anglaise*, 1908,294; H.M. Cundall, *A History of British Watercolour Painting*, repr. colour pl. 28; Quigley, *Architectural Review*, 1926,4; Hughes, *OWCS*, pl. VIII; Williams, fig. 281; Hardie, Vol. 3, 10 and pl. 7. Other versions include: A.A. Allen lent to Exeter Museum Exh., 1932 ($16\frac{3}{4} \times 11\frac{1}{2}$ in); Eton College (12×9 in); Christie's, 30.6. 1981 (90); Sotheby's, 16. 7. 1981 (141), (24×18 in); Christie's 18.3.1980, lot 264 ($10\frac{1}{8} \times 7\frac{1}{8}$ in), Haldimand Sale. Mrs Haldimand sold a version at Christie's, 21.6.1861

The view is taken from the top of the steps leading into the cathedral parallel with the façade, with a glimpse of the adjoining square at a lower level.

A large version (26×21 in) is in the Manchester City Art Gallery (Gresham 1917.267) and, being of the same dimensions as **51**, invites comparison with it. The disposal of figures, shadows and lights is more or less the same in both but the London version is less thinly painted while the penwork and figures are more carefully worked. The Manchester version is in fact very thinly painted, the grain of the paper being visible over most of the surface. The London version is distinguished like *Domodossola* (**47**) for having boldly thrown shadows which create a strong spatial as well as abstract picturesque effect. Casting the shadow over the foreground figures is a particularly successful tactic and prevents the figures from receiving the degree of attention which they frequently do not deserve.

51 is based directly on a drawing ($17 \times$

11½ in on white wove) in an album of 'copy sketches' put together by the artist for Lord Lansdowne in 1825.

Prout's watercolours of this subject provoked an unusual amount of critical comment. The *Art Union* in 1844 (p. 172) remarked:

> This artist has so entirely appropriated to himself the rich and ragged Gothic of such edifices as this that we feel no other brush – or chisel, we may safely say – could do justice to the colourless sandstone. The main objects in the composition are the vast columns of the porch, around which are niched the venerable fathers of the Church.

In 1849 the subject caught the attention of both the *Athenaeum* (p. 496) and the *Art Journal* (p. 177). The former said of it:

> it contains as good an idea of the specific and original style of the artist that we have known from his hand for many a year past. In none of his drawings here exhibited is there any symptom of diminution of force and vigour peculiarly his own.

The latter said:

> This is an attractive subject; it has already been exhibited by the artist, but we think the former work has not so much of the colour of the grave reality we see here. In the upper part of the drawing there is a great denial of colour, and hence the variety in the drapery of the figures below acquires greater power.

Prout visited Regensburg during his ambitious 1823 tour which also included Ulm, Munich, Nuremberg, Bamberg and Würzburg. Prout realized that the deep, richly carved Gothic portal offered great picturesque possibilities, whether at Regensburg, Chartres, Ulm or Amiens. Either Shotter Boys accepted that Prout had unerringly chosen the best viewpoint at Regensburg, or he simply plagiarized him; his 1835 lithograph (*Architecture pittoresque*, pl. 21) is a shortened version of the *Facsimiles*, pl. 23 (Halton, pl. XXXV) (see J. Roundell, *Thomas Shotter Boys*, 1974, where they are juxtaposed). A watercolour, presumed to be the source for the Boys lithograph, with a Prout signature, was reattributed to Boys in the Newall sale at Christie's – 13.12.1979 (11). By 1833 Prout had already exhibited the subject three times at the OWCS: 1824 (8 guineas to Francis Chantrey); 1826 (15 guineas to Lady Ridley); 1828 (18 guineas to J. Brydges). Outside the OWCS he sold versions in 1837 (Colonel Rawdon), 1842 (3 guineas to Ackermann) and 1845 (9 guineas to S. & J. Fuller), and inside the OWCS in 1844 (20 guineas to the Bishop of Lichfield) and 1848 (26 guineas to F.A. Fellfoot).

Among many other imprecisely described 'Ratisbons' is an 'upright' sold in 1844 to Fuller (£13. 5s.) and an *At Ratisbonne* sold to Ellison for 18 guineas in 1832. The Museum watercolour ought of course to be this last, a rare instance when the wealth of information in the account books can be married up to a particular watercolour.

52
At Würzburg, Franconia (Bavaria)

Watercolour and bodycolour on white
wove, with penwork, lights scraped;
26 × 19 (66 × 48), sight size
Signed *S. Prout* with pen, ins. *1041.73* in ink
and stamped *VAM* in mon. lower right
1041.1873
CONDITION: Discoloured and faded
PROV: Presented by Richard Ellison, 1873
LIT: S. Redgrave, *A Descriptive Catalogue of
the Historical Collection of Water-Colour
Paintings in the South Kensington Museum,*
1876; *The Portfolio,* 1892, repr. f. p. 164

A corner of the palace with a polygonal
turret occupies the right, with a column
(fountain) supporting a small statue in the
foreground on the left; a street scene
behind is closed off by the west wall of a
church.

Following his tour to central Germany in
1823, Prout immediately made two
Würzburg watercolours for Lord Stafford in
1824, and briefly thereafter Würzburg was
one of his most successful subjects. F.
Broderip bought a watercolour for 15
guineas in 1826. At the OWCS, also in
1826, Lady Charlotte Stopford paid 20
guineas and in 1831 E. Parratt £35, a very
high price for a Prout even at the height of
his career. It was in the following year,
1832, that Richard Ellison bought an *At
Würzburg* for 18 guineas which presumably
is **52**. Würzburg is not mentioned in the
account books again until 1851 when Prout
sold an *Interior* to Gambart. Redgrave gives
a succinct description of the watercolour
technique: 'Drawn in with sepia and
painted in contrasts of warm and cool
colour. The figures gay with bright tints.'

This watercolour can be used to
demonstrate Prout's working method and
especially how he exploited the sketches

that he made on site. **52** is composed from
two site drawings (17 × 11½ in on white
wove) known from 'copy sketches' made in
1825 by the artist (private coll.). These
sketches were used straightforwardly for the
making of some watercolours e.g.
Manchester, Whitworth Art Gallery D
23.1924 (fig. 34) and Wolverhampton Art
Gallery W129. These provide the street
view leading down towards the façade of a
church (which Prout in **52** reduces from a
twin-towered west front to a simple gabled
end with a distinctly English flavour) and
the polygonal corner turret with caryatid
herms. The fountain in the Whitworth
watercolour is shifted from the right to the
centre and the picturesque group of
bonneted ladies is wisely moved with it.
These ladies do not appear in the drawing.
A different adaptation of the
Wolverhampton composition, which is very
similar to the right half of **52**, is also in the
Whitworth Art Gallery (D 12.1910).
Another version which takes the same
angle of view as the Wolverhampton
picture, but which introduces the
Kiliansdom in the background, is in the
Courtauld Institute collection (9.76).

The grandest of Prout's Würzburg
compositions is also in the Whitworth (D
21.1904) (fig. 33). This highly elaborate
and large (22 × 29 in) exhibition piece,
which shows the view across the
Kürscherhof towards the Marienkapelle and
the Falkenhaus, is also partly an invention;
neither the fountain on the left nor the
domed corner turret on the right can be
found in the site drawing which is also in
the Whitworth (D 6.1905).

Prout has concentrated as many
Würzburg sights as possible in the one
picture. Hence the appropriate vagueness
of many of the titles that he gives to his
works and which is here suggested for **52**.

52

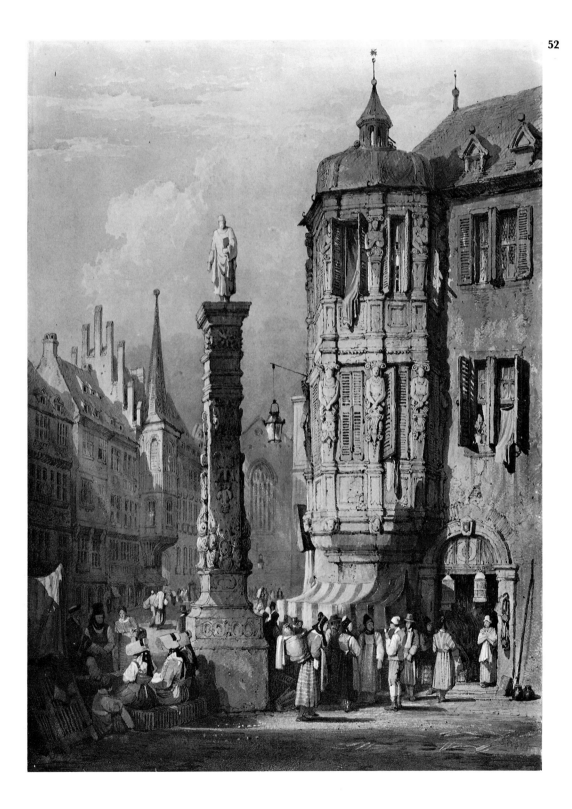

53

53
Amiens Cathedral, Picardy: view from a side portal of the west front

Graphite and white on buff-tinted wove paper, with stump and rubbing and a toning brown wash; $15\frac{3}{4} \times 10$ (40×25.5), sight size
Ins. *Amiens* in gr., lower right
E 2658.1914
CONDITION: Damage at the corners where once glued down, some foxing. The toning wash has been removed in odd patches and there are losses to graphite in the uncovered areas. This damage can also be found on buff tinted drawings at Plymouth and Exeter, e.g. Exeter 30.1940.2, a drawing of Bamberg
PROV: Bought from G.T. Phillips, 1914 together with **40**, **41**

The view is taken from just within the doors with most of the picture area taken up by the trumeau dividing the doorway and the richly decorated carved inner side of the deeply projecting porch.

This is likely to be lot 195, one of three Amiens drawings in the 1852 sale, titled *Cathedral Porch, Amiens*, measuring 16 × $10\frac{1}{2}$ in. A smaller drawing in the $10\frac{1}{2} \times 7$ in format was lent by S.G. Prout to Ruskin's 1879 Fine Art Society exhibition (later J.C. Robinson and now Fitzwilliam Museum, Cambridge, 738/20) and is reproduced to scale in autotype in the illustrated edition f. p. 28. The style of these two drawings can be distinguished from that of the 1820s. Prout is using a softer pencil, draws more rapidly, more strongly and with less concern to record, on site, a careful gradation of tones.

The Cambridge drawing caused one of Ruskin's purple passages on Prout:

Take the little view in Amiens, No. 7, showing the west front of the cathedral in the distance. That front is enriched with complex ranks of arcade and pinnacle, which it would take days to outline perfectly, and which, seen at the distance assumed in this drawing, gather into a mystery which no fineness of hand could imitatively follow. But all this has been abstracted into a few steady lines, with an intelligence of choice and precision of notation which build the cathedral as if it stood there, and in such accurate likeness that it could be recognized at a glance from every other mass of Gothic in Europe.

There is not space here to continue Ruskin's analysis, which deciphers in Prout's drawing 'the general facts respecting the valley of the Somme', why the rivers look as they do (a geological point), and 'the state of peasant life assembled in the fellowship of a city ... All this can be enough told in a few rightly laid pencil lines, and more it is needless to tell of so lowly provincial life.'

Prout could have travelled via Amiens on one of his tours to Germany or Italy in the 1820s, but a more likely moment would be in 1833 when he is recorded in Calais and Paris, or in 1834 when he was on the Loire and in Paris, a tour cut short by illness. He may also have visited the Loire in 1833. He sold only watercolours in 1834 and 1844 although he loaned five Amiens views, including a *Porch Amiens – Interior*, via Hullmandel to Baron Taylor in 1835. Amiens was more the province of Charles Wild and the cathedral specialists. The drawing style is analogous to the vigorous lithographs in the *Facsimiles of Sketches made in Flanders and Germany*, published in 1833. It is perhaps relevant that these are larger images than the earlier *Illustrations of the Rhine*.

54

Martigny, Switzerland (An Alpine village)

Watercolour and bodycolour over traces of graphite on cream wove, with penwork and gum, lights scraped and rubbed;
$13\frac{1}{4} \times 9$ (33.8×23.1)
Signed *S. Prout* (*SP* in mon.) with pen, lower right
1754.1900
CONDITION: Good
PROV: H.S. Ashbee Bequest, 1900

Gabled houses, with balconies and villagers in the foreground, are set before a background of mountains with a castle on a peak.

The identification of such Alpine subjects is an inexact science, see for instance **43**, a drawing inscribed *Lavey/nr: St Maurice* which is a closely comparable scene. The identification proposed here relies on the engraving by J.T. Willmore after Prout in the *Landscape Annual* for 1830 which most probably reverses a drawing upon which this watercolour is loosely based. Prout's topographical views are sometimes composite, the most extreme examples virtually capricci.

Prout's only recorded tour to the Alps was in 1824 and he is likely to have passed through Martigny on his way from Lausanne (24 August) to Domodossola (7 September). There is only one drawing mentioned in the 1852 sale, but three watercolours, e.g. *Cottages at the Foot of the Mountain, Martigny*. Ruskin lent a watercolour – *Martigny Village* – to his 1879 Prout/Hunt exhibition. *At Martigny* was the title of an exhibit at the OWCS in 1835 sold to Maj. Gen. Sir Charles Greville for 5 guineas and a *Post House Martigny*, priced at 8 guineas and sent to the 1846 exhibition, was returned to the artist unsold. There is nothing to pin this watercolour to either date.

The watercolour is typical for the contrast between foreground and background and between the front screen, distinctly defined with reed pen, and the hazier backdrop. The mountains which Prout observes acutely in his tour sketches are here generalized away. The foreground is treated with more broken lights and is in this sense more picturesque than usual. Although the drawing is undistinguished, the relatively good condition of this watercolour makes it attractive.

54

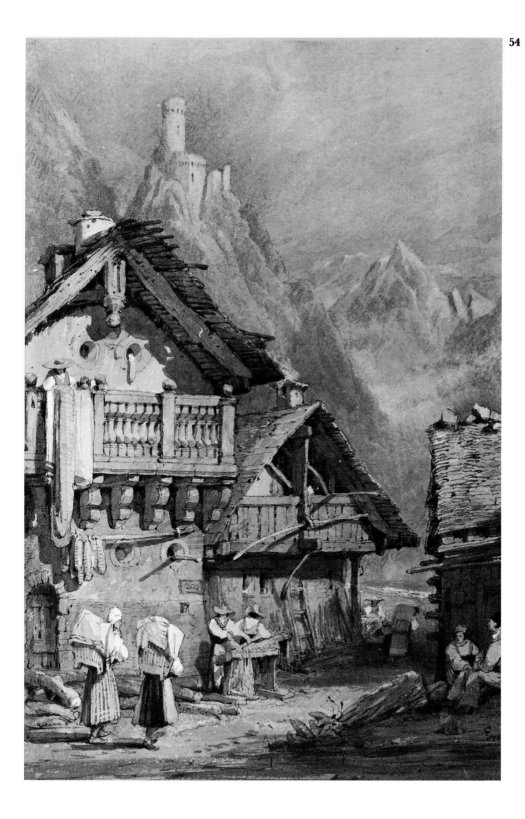

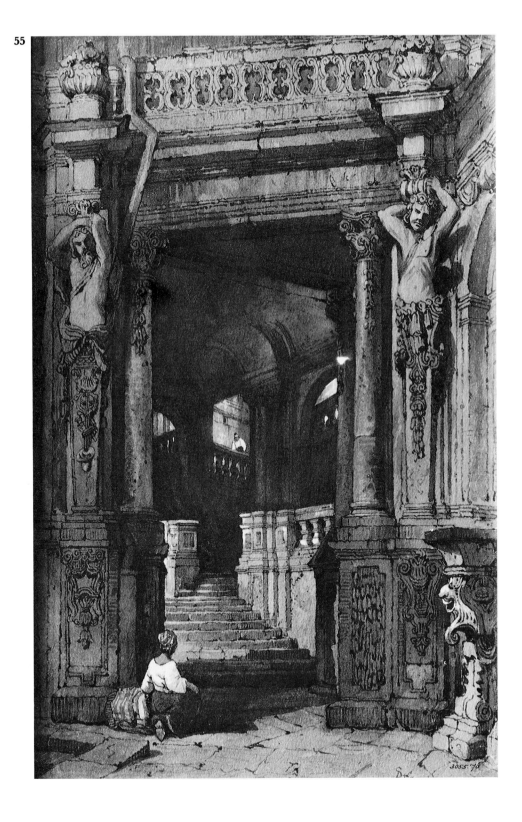

55

55

**Dresden, Zwinger Palace, Bavaria:
entrance to the Wallpavillon**

Watercolour and bodycolour on fine white
wove, with penwork and gum, lights
scraped; $13 \times 8\frac{3}{4}$ (33×22)
Signed *S. Prout* (the *SP* in mon.) in pen,
ins. *3055.76* in ink and stamped *VAM* in
mon., lower right
3055. 1876
CONDITION: Some discoloration and
fading emphasizing the blue gouache
shadows, white highlights and figures, and
some damage at the right corners
PROV: William Smith Bequest, 1876
LIT: Hughes, *OWCS*, repr.

A grand staircase broken into several
flights is viewed from just outside the
portal, which is 'supported' by two male
caryatids.

Prout made the somewhat larger
drawing on which this watercolour is based
(Courtauld Institute, Witt 3277 –
presumably lot 366 in the 1852 sale) on a
tour which took him as far as Prague (see
p. 55) in the summer of 1829. The drawing
was repeated to the same scale for the
lithograph included among five Dresden
views in *Facsimiles of Sketches made in
Flanders and Germany* which Prout published
for himself in 1833 (Halton, pl. XLII). He
had in the interval supplied drawings to
three separate publishers for reproduction
as steel engravings in the Annuals. This
view, engraved by W. Wallis, was
published by Longman in 1832 for the
Keepsake as *Interior of the Zwinger Palace*, and

The over-prominent blue shadows are
the most obvious indication that the
appearance of the watercolour has changed
since it was painted in (?) the 1830s. The
surface is now rather dull and lifeless and
the figures, highlighted in white, are more
insistent for attention than they once were.
In particular, the carefully controlled
gradations from yellow-brown stone to
shadow have lost their range. By
comparison with other similar subjects,
Prout has made sparing use of the reed
pen.

the same plate was also published by
Moon, Boys and Graves. The Museum's
watercolour is closest in detail to Wallis's
steel engraving, in which the Saxon woman
still kneels patiently at the threshold with
her basket, lunch for her husband, perhaps,
who looks with interest from the staircase
within. Engraving and lithograph agree in
placing another figure on the stair. The
only figure in the on-site drawing is the
man, who is placed almost in the centre of
the composition.

The drawing, which is particularly fine,
establishes the general balance of lighting
with rubbed shadows; these are
strengthened in the lithograph and put in
with even more emphasis in the
watercolour, where shadows assume a
special pictorial importance. Prout's
characteristic broken-line technique can be
followed from drawing to lithograph to
watercolour, for instance up and round the
window on the extreme right.

There are seven $16\frac{1}{2} \times 11\frac{1}{2}$ in Dresden
drawings in the 1852 sale so that both **55**
and **49** (a drawing) are uncharacteristically
small; the watercolour is a reduced version
of the subject. A watercolour nearly twice
as large and with additional figures
belonged to Prout's friend Sir William
Boxall, the portrait painter (Christie's, 10.
7. 1984, Lot 236). This might be a
candidate for *Part of the Zwinger Palace
Dresden*, bought by W.B. Roberts in the
OWCS for 18 guineas in 1831, this being
the highest price that the artist received for
any of his Dresden pictures, including any
whose description does not specify another
view. In fact, only one of the 29 Dresden
works mentioned in OWCS catalogues or
in Prout's account books is called *Porch of
Zwinger Palace* – OWCS 1835, bought by
Mr Houghton for 8 guineas – which might
be **55**. Prout continued to sell *Dresdens* and
Zwinger Palaces until the end of his career;
Ruskin père bought a 10-guinea *Dresden* at
the OWCS in 1836 and Decimus Burton a
12-guinea *At Dresden* in 1850. S. & J.
Fuller bought a *Zwinger Palace Dresden* for 9
guineas in 1845 which was of the same
dimensions as the Boxall watercolour.

56

Venice, the Ca d'Oro on the Grand Canal

Watercolour and bodycolour on cream wove, with penwork and dry colour, lights reserved and scraped; $17 \times 11\frac{3}{4}$ (43×30), sight size
Signed *S. Prout* (*SP* in mon.) with pen on column left, ins. *1165.86* in ink lower right 1165.1886
CONDITION: Discoloured and faded, white highlights have turned to brown particularly in the water, a tear bottom right
PROV: H. E. Dixon Bequest, 1886
LIT: *Watercolours in the Dixon Bequest*, 1923, pl. XI; S. Brinton, 'Venice, Past and Present', *The Studio*, special no., 1925, repr.; Quigley, *Architectural Review*, 1926, repr.
EXH: London, Wildenstein, 'Venice in Peril', 1972/3 (27). Venice, Museo Correr, 'Mito e imagine de Venezia nell' eta romantica', 1983/4 (182).

Prout made at least two drawings of the subject (1852 sale) but did not, surprisingly, make them into exhibition watercolours. The formula of viewing the principal object through or beneath an arcade was a favourite one that he used also for **47**. Here he borrows the foreground column from the Doge's Palace, an allusion that the purchaser would no doubt catch. In fact Prout has transplanted the column direct from a *St Mark's, Venice* seen from the Doge's Palace (Finden's *Byron*, Vol. 3, 1834, pl. 21), based on a site drawing (private coll.) made from within the arcade.

Prout's first Venetian exhibits, following the 1824 tour, were novelties and it is worth recalling that Turner and Bonington's Venetian views were exhibited slightly later; Bonington was encouraged by Prout to go to Venice in 1826 (Grundy & Roe, *Nettlefold Collection*, I, p. 16). Thomas Uwins says that he had thought of doing Venetian subjects until he bumped into Prout in 1824 and at once gave up the idea! (Uwins, *Memoir*, 287).

Later critics weigh Prout's Venice in the balance with the Venice of Turner, Bonington, Harding, Stanfield, Roberts, Callow, Holland … For Ruskin, who had the opportunity of seeing Venice through other men's spectacles, Prout's Venice was especially evocative:

> I had not the least idea of the beauty and accuracy of those sketches of Venice, – so touchingly accurate are they, that my wife, who looks back to Venice with great regret, actually and fairly burst into tears over them, and I was obliged to take them away from her. *I*, who in many cases like the sketches better than the places, pursued my walk through Venice with intense pleasure: especially because you have been so scrupulous and fondly *faithful*: and so often rendered the character of peculiar features, of which, I believe few persons except myself could understand the precision – (Letter of May 1849 – *Works*, XXXVIII, 343).

Prout ought to have published a book of sketches on Venice, and the lithographs which were included in his *Sketches made in France, Switzerland and Italy* in 1839 hardly fulfil the potential of the sketches that provoked Ruskin's admiration and Effie's tears. The steel engravings after Prout in the first two volumes of the *Landscape Annual* for 1830 and 1831, *Sketches from Venetian History* published by John Murray in 1831/2 and Finden's *Illustrations of the Life and Works of Lord Byron* of 1833, do not fill the gap either.

56

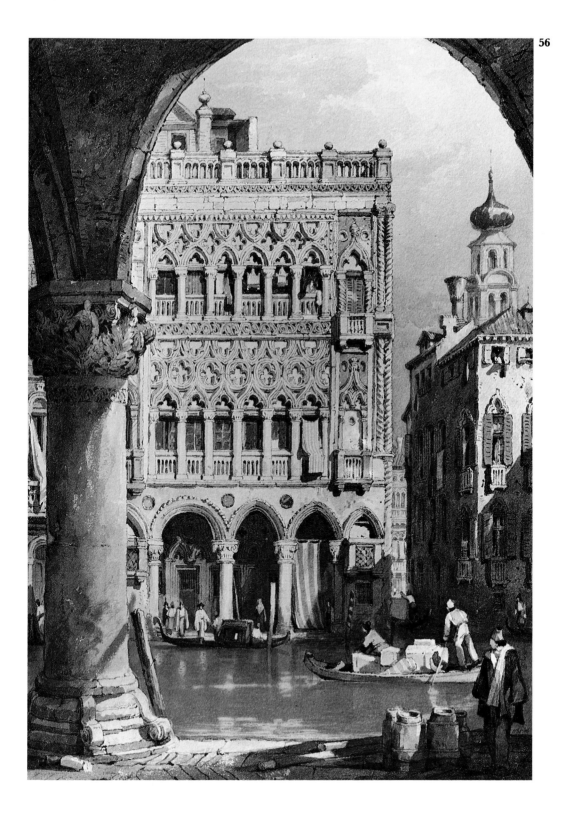

57 f.33v.

57
Sketchbook – sketches in Northumberland and Cornwall

55 leaves on white wove, 'not' Whatman watermarked 1823, bound in brown paper cover with red leather spine and corners; folios $3\frac{1}{2} \times 6\frac{3}{4}$ (9.1 × 17)
Graphite
Signed *Samuel Prout* inside back cover and ins, with a poem (? by Prout) on two folios up to and including the back cover
E 709.1923
CONDITION: Good, some foxing
PROV: Bought from Ernest Brown & Phillips, 19 April 1923
LIT: *Accessions*, 1923

The sketchbook contains coastal landscapes, farm animals, boats and figure studies. From f. 31 the sketchbook has been used starting from the back.

Drawings with ins. in folio order: *Bathing over/Torquay Devon/Nov. 8; Lindesfarne Abbey Holy Island Castle/Northumberland; Thirlwall Castle/Northumberland; Mylor Church May 21.36; Hermitage Duncomb; at Bripper near Cambourne/Cornwall; Mylor.*

Drawings on at least six folios are by another hand. A drawing of rocks (f. 10) is initialled *RP*, perhaps Rebecca Prout, Samuel's eldest daughter. This is a small book, for the most part containing fine slight landscapes and figures in a staccato style punctuated by the pencil's resting-points.

Some drawings, and the hand in some of the inscriptions, are very similar to those in E 706.1923, which came from the same source and is ins. *JS Prout, Penzance 1835*! (**71**).

58 f.41v **58** f.33

58
Sketchbook – coastal scenes

65 leaves of white wove watermarked R.
Tassell, 1830, bound in calf with clasp;
folios $3\frac{1}{4} \times 4\frac{1}{2}$ (8.5 × 11.5)
Graphite, and one watercolour (f. 41v.)
Signed *Samuel Prout* with pen on inside of
front cover
E 710.1923
CONDITION: A well-used and travelled
pocket sketchbook, the covers cut and clasp
broken, dirty inside covers, some loose
pages
PROV: Bought from Ernest Brown &
Phillips, 19 April 1923
LIT: *Accessions*, 1923

This miniature sketchbook contains mostly
coastal subjects – ships, boats, fishermen
and women, studies of children.
 The sketchbook contains one or two
surprises, including the skull (illus.) in
watercolour (f. 41v.), which should be
compared for technique and palette to the
Avon/Wye landscapes to which wash has
been added in **60**. The study of a
fisherwoman on f. 33 is charming (illus.),
ditto the study of plants on f. 37. Among
the more complete studies are a *St Michael's
Mount* (f. 7) and a village street (f. 28). The
St Michael's Mount on f. 18 is fully toned, as
is the untypical (?) inn on f. 34 which is
worked up and squared off to resemble a
darkly shadowed print.

59 f.3.

59

Sketchbook – sketches in South Wales, figure studies, coastal subjects

36 leaves of white wove watermarked Whatman 1833, bound in marbled paper with purple leather spine and corners; folios $4\frac{3}{4} \times 7\frac{1}{2}$ (11.8 × 19.2)
Graphite, two pages with wash
Signed *Samuel Prout* on inside of both covers
Ins. inside front cover include: *Mrs Blakemore – bottom of the Lyn*. Ins. inside back cover: *Bring J. Hopkinson Book & Pencils*
E 708.1923
CONDITION: Good, some foxing, one folio cut out
PROV: Bought from Ernest Brown & Phillips, 19 April 1923
Sketchbook originally supplied by George Davey, stationer and bookseller, 1 Broad Street, Bristol
LIT: *Accessions*, 1923

Drawings with ins. in folio order: *Telian's Well 540/Llandaff. Decr 26.39; Caerphilly* (illus.)*; Caerphilly; Jan 13.35; 2 centre/top centre; Stoke Vicarage Feby 23d. 35.*

The sketchbook itself is a pair to **60**. Three folios have sketches made in South Wales, one of which is ins. *Dec 26.39*. Two others are ins. *Jan.* and *Feb.35*. There are several animal and boat studies and numerous figures. Most of the drawings are very brief and done with a smooth unaccented line. The landscapes are generally free and rapidly sketched and in this respect are comparable to two later sketchbooks used on the Continent (Barnstaple). There are two fully worked 'pictures' of courtyards.

60

Sketchbook – sketches on the Avon and Wye and at Oxford

36 leaves of white wove watermarked Whatman 1833, bound in marbled paper cover with purple leather spine and corners; folios $4\frac{3}{4} \times 7\frac{1}{2}$ (11.8 × 19.2) Graphite, two with added watercolour Signed *Samuel Prout* with pen inside the back cover where ins. *Jany 2/Sent 9 Drawings to Mrs Parry; Mrs Brennand. 6 Tickets 259–264*
E 707.1923
CONDITION: Fair, some marks and foxing, some scribbles
PROV: Bought from Ernest Brown & Phillips, 19 April 1923
LIT: *Accessions*, 1923

Drawings with ins. in folio order: *Common Salt in Water . . .* (a medicinal recipe for an inhalant continues); *Elixir of C Vitriol . . .; Facing of the stones apparently pealed off/Oriel corbel of 1s mouldg; Magdalen; Magdalen/Over*

the dons; Maudlin; (another inhalant recipe); *Maudlin;* (Notes giving 12 stages in the creation of a drawing); *Dec. 6. 3 months/ P.N: C. College 10.17.6; 5 sheets of Imperial Litho Paper . . .; Scene for the Stage/23 Feet wide. 15 feet high . . . Distant View – wood.*

The sketchbook itself is a pair to **59** and was also supplied by George Davey, Stationer, Bristol. Several sketches are of the Avon and/or Wye river valley landscape (illus.) e.g. Durdham Down and the Avon (identified by Christopher Titterington). A few pages are given over to 'bits' of Oxford. Prout made a visit to Oxford in September 1840.

The remaining sketches are of shipping, figures, groups, a windmill, rocks, a portrait of a young woman (f. 33v.) and a theatre plan (f. 36). The river valley landscapes (2) are attractively washed in. Prout's style in **60** and **59** is akin to that of Harding and Müller in the 1830s. Müller was in close touch with John Skinner Prout at this time. (See **71**.)

61

61
Fishing boats beached

Graphite on white wove with stump and rubbing, fixed; $6\frac{1}{2} \times 4$ (16.7×10.3), sight size

E 3029.1927

CONDITION: Stain marks at corners where formerly glued down. The drawing has suffered from inexpert fixing and (?) treatment

PROV: J.R. Holliday Bequest, 1927

Prout made hundreds of drawings of this sort, from the *c.* 1810 pencils, with or without a monochrome wash, to the pen-and-ink drawings, often on a tinted paper, perhaps mostly dating from the Hastings years (1836–44). This may date from the latter period. It formerly belonged with the large parcel of Prout drawings acquired by Holliday and distributed to more than one museum after his death, the lion's share falling to his native city of Birmingham. The technique used for this drawing was developed by the artist shortly before he began his sequence of elaborate foreign tours in the 1820s, to which belong his best-known drawings. This and **62** employ the stump and finger to control the lights and darks and give form to the whole. The foreign drawings are generally tighter; here Prout's line is relatively free and slack.

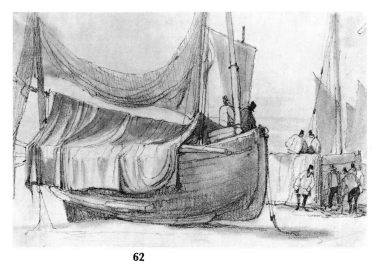

62

62
Fishing boats beached

Graphite on white wove (traces of a watermark) with stump and rubbing, fixed; $4\frac{1}{4} \times 6\frac{1}{2}$ (10.8×16.4), sight size

E 3030. 1927

CONDITION etc.: see **61**

Several fishing boats on the shore with seamen taking down sails.

63
Venice, the Palazzo Contarini-Fasan on the Grand Canal

Watercolour and bodycolour on white wove, with penwork, lights reserved and scraped, laid down; 17×12 (43.4×30.2) Signed *S. Prout* (*SP* in mon.) with pen, centre right

1732.1900

CONDITION: Some discoloration of the paper and damage at corners where formerly glued down, fracture lower right
PROV: H.S. Ashbee Bequest, 1900
LIT: *The Studio*, Winter No. 1922/3 (repr. in colour); Quigley, *Architectural Review*, 1926, repr.; Hughes, *OWCS*, VI, repr.
EXHIB: J. Mayne, 'British Watercolours 1750–1850' (71), 1966/7, Loan Exhib. to the USA from the Victoria & Albert Museum; London, Wildenstein, 'Venice in Peril', 1972/3; Louisville, Speed Mus., 'Ruskin and Venice', 1978; Venice, Museo Correr, 'Mito e imagine de Venezia nell'eta romantica', 1983/4

The fifteenth-century palazzo (in the centre of the group of buildings) is viewed obliquely from the canal, the near part of which is largely occupied by a barge, with a campanile in the distance.

This is much lighter and fresher than most Prout watercolours, an effect partly due to some treatment. Incident is introduced through a carefully judged arrangement of drapes and the strong 'picturesque' silhouette of shadow cast by the buildings opposite. The chalky light on the further buildings is typical, as are the blue shadows.

There are several versions including: Christie's, July 1822; Harrogate Sale, 1924; G.P. Cooper, Nottingham, 1927; Salford Art Gallery, acquired 1951; Christie's, 18.11.1980 (167); Manchester City Art Gallery (1917.74) ex James Blair. There are no exhibited watercolours or drawings in the 1852 and 1880 sales under this title.

Christie's, 1980, is an identical view except that the canal is given more prominence by siting a large barge in the centre foreground and by extending the view of the canal in the distance by including buildings on the other side. It gives more interest to the skyline and throws the eye forward, having cast the right foreground building into shadow. The London and Manchester versions are identical and as close as two watercolours can be without there being some mechanical process at work. They are identical in size, architectural detail, sky, lighting and figures. Prout made numerous versions of many subjects but not replicas, an unnecessarily time-consuming activity.

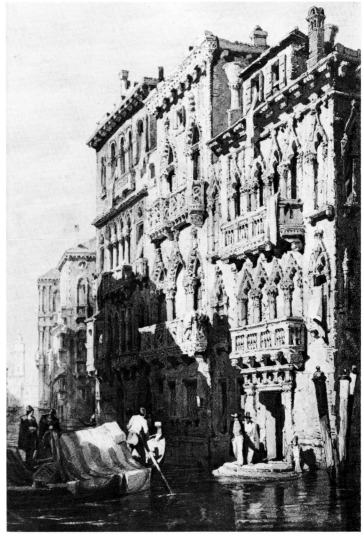

63

There can be no doubt about the London version and therefore suspicion falls on the Manchester version, which is signed with the unusual (for a watercolour) *SP* monogram. Samuel Gillespie Prout was certainly capable of imitating his father's work very closely, but he would not have introduced his father's signature. For example, a highly mistakable *Scaliger Tombs, Verona* (Sotheby's, 18.4.1968, lot 47) is distinguished by the signature *S.G. Prout.*

This is the composition for which Prout borrowed a drawing from John Ruskin. Ruskin's drawing (illus., *Works*, III, f.p.

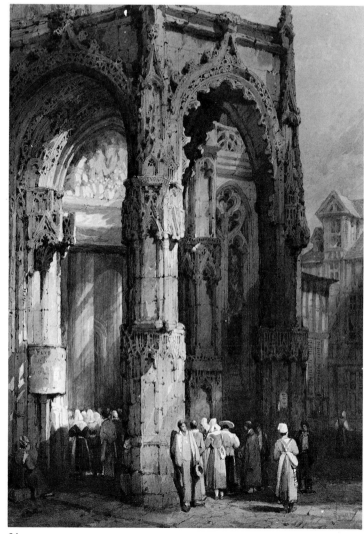

64

212) was made in 1841 and the loan was
recalled in 1876 (*Works*, XXVIII, 756).
Ruskin took the view from further back;
Prout chose to heighten the dramatic effect
by adopting a favourite close-up position.
According to Ruskin, Prout was short-
sighted! A comparison between drawing
and watercolour also reveals the
importance that shadows play in Prout's
most effective compositions; only the
shadows under the eaves are taken from
the Ruskin drawing. The comparison
provides evidence for Prout's 'capricious'
approach; he omits completely one of the
palazzo's neighbours! Ruskin says that this
view was widely known through a
chromolithograph (*Works*, XXVIII,
756).

64

**Rouen, Church of St Vincent, entrance
porch**

Watercolour and bodycolour on cream
wove with penwork, lights reserved,
14 × 9¾ (35.8 × 24.9), sight size
Signed *S Prout* (*SP* in mon.) with pen and
ins. *1160.86* in ink, lower right
1160.86
CONDITION: Good, some discoloration
PROV: H.E. Dixon Bequest, 1886

The polygonal porch is viewed at an angle
with some characteristic half-timbered
Rouen houses to the right.
 This is a light and airy painting only
spoilt by the dull horizontally arranged
figures in the foreground. The white used
to highlight the carved tympanum is not
entirely successful. The interior of the
church, glimpsed through the porch, is
enlivened with diagonal shafts of light.
This watercolour is a reduction of the
original composition which can be seen in
a pen-and-ink drawing on tracing paper
(Fitzwilliam Mus., Cambridge, PD 2773).
Surprisingly, Prout made another drawing
from almost the same spot (Plymouth
Mus., 164.14 – lot 193 in the 1852 sale).
 The composition is essentially the same
as a watercolour that has been called *The
Porch, Rheims* (Yale Center for British Art,
B 1975.4.1360) illus. in J. Bayard, *Works of
Splendour and Imagination: the Exhibition
Watercolour 1770–1870*, 1981 (50). This is in
fact an excerpt from a view of St Maclou,

Rouen, e.g. Sotheby's, 13.11.1980 (171), which was a close neighbour of St Vincent.

Prout sold only two watercolours identified as of St Vincent: *St Vincent, Rouen* at the OWCS in 1822 (107) and a *Porch of St Vincent's, Rouen* in 1849 (bought by Miss Robertson for 12 guineas). **64** could be the latter.

Shortly after Prout first exhibited the subject, a lithograph by Villeneuve was published (1823), to be used in the second volume, *Ancienne Normandie* (1825), of the *Voyages pittoresques*.

65
Rome, the Arch of Constantine from the south-east

Watercolour and bodycolour on cream wove, with penwork, lights reserved; $14\frac{1}{4} \times 10\frac{1}{4}$ (36.0 × 26.2)
Ins. *1473.69* in ink and stamped *VAM* in mon., lower left, ins. *71* in ink and stamped *NAL*, lower right
1473. 1869
(see colour plate between pp. 120 and 121)
CONDITION: Good except for some surface abrasions and horizontal fracture below centre
PROV: Rev C.H. Townshend Bequest, 1869; (?) OWCS, 1850
LIT: S. Redgrave, *A Descriptive Catalogue of the Historical Coll. of Water-Colour Paintings in the South Kensington Mus.*, 1876, repr; Quigley, *Architectural Review*, 1926, repr.; Hughes, *Early English Watercolours*, ed. 1950, repr.; Hughes, *OWCS*, repr.

The triumphal arch is viewed close up at a narrow angle from the east side which features the relief of *Sol*.

Prout did not sell or exhibit a watercolour of this subject until 1827, so it is possible that his site drawing was made later than his only recorded visit to Rome in 1824. He exhibited a 15-guinea picture at the OWCS in 1827 which was bought by Wyattville. Stylistically this seems too early for the larger version of the subject in Exeter Museum (76.1950.2) which is set further back than **65** and provides a more generous setting for the fourth-century monument. Such a watercolour would have been a striking object in the London exhibition room, entirely novel except to those whose memories went back to the days of Alexandre Ducros and gouache

reproductions of classical monuments made for eighteenth-century grand tourists. **65** remains a fresh and attractive picture, with the monument articulated by Prout's skilful reed pen set off against the sky. This exemplifies Prout's intuitive feel for the right amount of detail and the use of shadow in what appears to be a strictly topographical landscape. The foreground shadow gives a substantial base to the mass of stonework and in the Exeter version is also used to link the Arch to the more extensive landscape to the right. For the engraved vignette by J.B. Allen in the 1830 *Landscape Annual*, the shadow falls only on the free-standing columns. A watercolour measuring $13\frac{3}{4} \times 8\frac{3}{4}$ in (priv. coll., photograph in the Witt Library, Courtauld Institute) is close enough to this engraving to be the watercolour that the supervising engraver, Charles Heath, bought from Prout in 1829. **65** is presumably the 8-guinea picture bought by Townshend at the OWCS in 1850, and demonstrates the very high quality that Prout could achieve right to the end of his career. There is no evidence that he sent in other than recent work to the annual exhibitions. *At Dresden* (OWCS, No. 251) is another example of a late work of high quality – see Chapter V, n. 4.

Prout painted at least three other *Arches of Constantine*, a 15-guinea picture at the OWCS in 1843, and two sold elsewhere in 1843 and 1844. J.C. Grundy bought a watercolour of this title at the 1852 sale.

Some later 'sightings' include: Christie's, 11.4.1891 (35) sold by Sir H.A. Hunt and (?) the same as that lent to the 1888 Glasgow exhibition by John Hunt (1194); Agnew's, Aug.–Sept. 1946, described in the Museum's files as 'a ? small replica'. E. Morris, *English Drawings and Watercolours*, Liverpool, Walker Art Gallery, 1968, 42, notes the capriccio element in a version in the Liverpool Coll. (1074).

66

Rome, interior view of the Coliseum

Watercolour and bodycolour on cream wove with penwork and gum, lights reserved, scraped and rubbed; $9\frac{1}{4} \times 13\frac{1}{2}$ (22.7×33.8)

Ins. in ink *634*, lower right and bearing the stamp of the National Gallery of British Art in mon., lower left

F A 634

CONDITION: Some discoloration

PROV: Bought from the Rev. E.P. Neale, 1864

The Coliseum curves from left to right, the direction of a religious procession which fills the lower foreground.

This is not a very successful performance and is not accepted by Lambourne as by Prout himself (p. 300). Although it sticks closely to the site drawing, to which it merely adds figures, the watercolour has somehow lost the effect of the concave space which is fully expressed in the drawing (illus. in Ruskin's *Notes* . . . between pp. 34/5), which is fully toned by rubbing. The figures are not a good

addition to the composition but do reflect one of Prout's strongest impressions of Rome, as expressed in a letter home written in December 1824 (see p. 54). The backdrop of the Coliseum is more convincing, particularly in the lighting from left to right.

Prout's only recorded visit to Rome was in 1824, when he was there on two separate occasions, and unless other evidence exists, site drawings should be dated to that year, e.g. the very fine external view of the Coliseum at Yale (B 1975.3.973) which is no doubt that in the 1852 sale. The drawing relevant to the watercolour was lent by S.G. Prout to Ruskin's exhibition at the Fine Art Society in 1879, to be put into the sale that followed shortly afterwards in 1880 (lot 112). The only two watercolours mentioned in Prout's account books are *Interior, the Coliseum* sold to Charles Heath the engraver for 10 guineas in 1829 and *In the Coliseum* sold to the publishers S. & J. Fuller for £3. 10s. 6d in 1850. Possibly neither of these relate to **67**, but the later date is the more probable.

DOUBTFUL ATTRIBUTIONS

67

Cottage (said to be) at Torbryan, Devon

Watercolour on cream wove, with penwork and gum, lights reserved, laid down; $7 \times 10\frac{1}{4}$ (17.5×26), sight size

E 1059.1918

CONDITION: Discoloured (sky), generally dirty with some surface rubbing

PROV: Presented by Arthur Myers Smith, 1918

A cottage with lean-to viewed end on, sheets hanging out to dry.

Despite the similarity of provenance and colouring between this and **13**, it is a doubtful attribution and more probably a contemporary copy after a watercolour or etching.

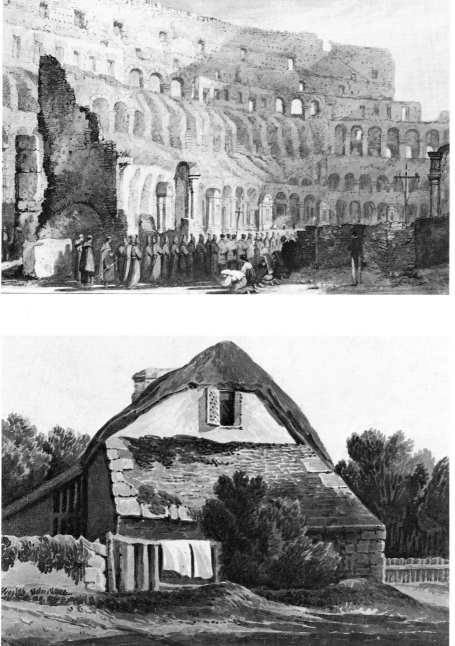

66

67

68

69

68
Woodland scene

Watercolour and bodycolour on white wove, with penwork and (?) gum, lights reserved and scraped, laid down: $9\frac{1}{2} \times 6\frac{1}{2}$ (24.2 × 16.4)
Ins. *S. Prout* in pen lower left, *186.90* in ink, lower right, and stamped *VAM* in mon.
Ins. verso *JP* in mon. (Dr John Percy)
Ins. on mount *S. Prout. Forest Scene/Early Drawing/No 10*
186.1890
CONDITION: Discoloration and fading, a rubbed area on the right-hand tree
PROV: Purchased at Dr Percy's sale, 1890 (lot 989)

A track leads into the woodland, with a figure below the horizontal centre on the right.

After about 1810 Prout made very few pure landscapes, as opposed to cottage scenery or seascapes. The rare exceptions are small drawings without colour. In his later work his urban landscapes are varied only by rivers, e.g. *Illustrations of the Rhine* published from 1822. The use of a strong blue for the shadows as here is a relatively late feature of Prout's watercolour style, although the landscape otherwise looks early. The figure is particularly unhappy. All in all, this landscape should be doubted.

69
Cottage at Halstead, Essex

Watercolour over traces of graphite on cream wove, some dry colour in the foreground, lights reserved; $6\frac{1}{4} \times 9\frac{1}{4}$ (23.7 × 15.3)
Stamped *NAL* in mon.

Ins. rev: *Halsted, Essex.* Stamped with *JP* mon.

D 125.1890

CONDITION: Discoloured and faded.

PROV: Purchased from Dr John Percy who, according to the ins. on mount bought it 'at Barron Grahame's Sale, Sotheby's March 15. 1878. Lot 122. Very early drawing...'

Close-up view of a cottage with figures at door and a tree behind.

This watercolour should not be attributed to Prout and is therefore an example of a student's copy probably based on a published etching.

70
Nantes Cathedral, from the Loire

Watercolour over graphite on white wove, with penwork, ruled edges; $2\frac{1}{4} \times 1\frac{3}{4}$ (6×4.5)

Ins. verso *Nantes* in gr.

E 1146.1948

CONDITION: Some discoloration and foxing

PROV: H.H. Harrod Bequest, 1948

70

The cathedral is seen from the south-west from below, across the river harbour.

The cathedral is typical in its handling if compared to the buildings in the background of larger watercolours. The foreground boats, however, which look Eastern Mediterranean, are not typical. Five equally miniature watercolours ($1\frac{1}{4} \times 2\frac{1}{2}$ in) are in the Hastings Museum (W 203) but they are of subjects known in versions on a larger scale. There are no other recorded Nantes views and his only known tour to Brittany was his last tour abroad, in 1846. In fact there is no good reason to associate this watercolour with Prout, since the composition is taken directly from Turner, the title page vignette of *Turner's Annual Tour 1833: Wanderings by the Loire*! The squat, tight feeling of this copy can be contrasted with the more vertical, spacious, and light-filled atmosphere of Turner's watercolour (Ashmolean Mus., Oxford) illus. in colour in *Turner en France*, Paris, Centre Culturel du Marais, 1981 (58), fig. 455. Prout was an acknowledged admirer of Turner but did not make copies of his work as far as is known.

Sketchbook Attributed to John Skinner Prout

71
Sketchbook – Cornwall, South Wales, Avon

22 leaves of white wove, watermarked Turners 1829, bound in marbled covers with purple leather spine and corners; folios $5\frac{1}{2} \times 9$ (13.4×23.4)
Signed and ins. *JS Prout/Penzance/1835* inside front cover and *JSP* and *SP* (both in mon.) on f. 1
E 706.1923
CONDITION: Good
PROV: Bought from Ernest Brown & Phillips, 19 April 1923
LIT: *Accessions*, 1923

The sketchbook is of a set with **59** and **60** except that it is a size larger. It includes studies of boats, cliffs, figures and landscapes (illus.). The identified landscapes are: Avon; St John's Mill, Helston; Mylor Church (illus.); Oystermouth; St Michael's Mount; Old Place House and the Pier at Swansea. Some place names and the names of (?) clients, Miss Armstrong and Miss Freshfield are also noted.

Some drawings are worryingly similar to those in three other sketchbooks from the same source and attributed to Samuel Prout, J.S. Prout's uncle, largely on the basis of his autograph signature inside the covers (see **57**, **59**, **60**). The similarities are sufficiently close to suggest the possibility that the nephew borrowed sketchbooks during the 1830s. There is no mention of John Skinner Prout in the documentation connected with Samuel Prout, although it is generally assumed that the one was a pupil of the other.

71 f.13

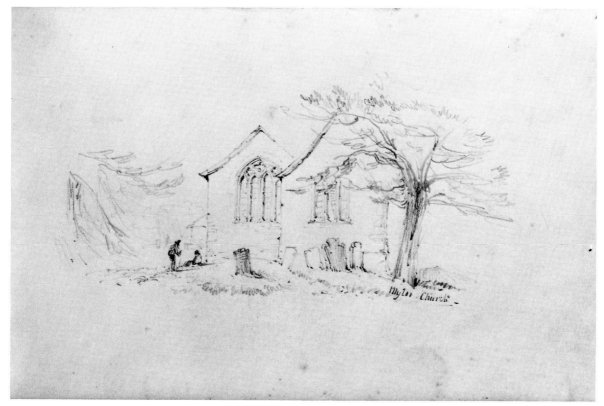

71 f.13

Tour in northern England and Scotland 15 July – 27 August 1814

Prout travelled from London to Leeds by coach as an outside passenger.

Kirkstall: 'The monks always made choice of highly romantic spots for the foundation of their abbeys, surrounded with scenery ... embosoming themselves in the retirements of nature to pass their religious and secluded lives ... a large mass of ruins are without any form, yet so beautifully mantled with ivy and shaded by overtopping trees that the whole is picturesque in every point of view.'

Durham: left **Leeds** 5 a.m., arrived **Durham** 7.30 p.m.: 'Smiling morning ... was in good spirits with my work 'till the afternoon ... constant cold rain. With paper soaked to a sponge I persevered under my umbrella to finish my work at this place to make another stage to the N.'

Finchale Priory: 'A romantic spot where I found work to pay me for my walk.'

Lumley Chester-le-Street: 'The stone houses and red tiled roofs are so exceedingly unpicturesque that every house is passed without a second look.'

Saturday, 23 July
Newcastle: 'Very unwell with a bilious headache and very feverish all day. Without a letter from Brixton, my disappointment was excessive and, with the severe pain I was in, compelled me to retire to bed where in a few hours I lost the pain, but could scarce walk from languor and disquietude.'

Sunday, 24 July
'Very weary from a fidgetty feverishness ... morning heard Mr. Fuller ... evening again heard Mr. Fuller. Nothing gave me more than momentary ease, being again disappointed at the post, and full of horrible fears ... returned early to my bed room, but could not sleep, being in a burning fever.'

Monday, 25 July
'Rose early and attempted to sketch the castle ... Stop'd at **Tynemouth** to make sketches of the ruined monastery situated on a high promontory commanding an exten-

sive view of the water and headlands with the entrance into [?], where the bars of sand and rocks cause an incessant roar of broken waters.'

Tuesday, 26 July
Walks back to **Newcastle**: 'Scarce anything like good habitations are seen on this hot dry road but the poor hovels, in rows, of the coal miners; steam engines smoaking on each side with their mighty works and immense accumulation of small coal – some of the heaps have taken fire and blazed a city of flames. The trees, what there are, are most miserable and of short growth, most of the hedges displaying but leafless rotten trunks.'

27 July
Newcastle – Morpeth: 'Newcastle is a well built town, with wide clean streets, many public buildings and institutions, but there is a want of country scenery in the neighbourhood, the banks of the river being occupied with manufactures and coal wharfs.'

Thursday, 28 July
'Arrive at **Alnwick** an hour before the mail which brought me the long prayed for letter from Brixton, cheering me with the best news, and putting a stop to the dreadful anxiety in which I have been living ... the Duke's architect for the tower-house conduit, etc., manifests a wretched want of judgement and feeling for harmony. On the battlements of the towers are figures of warriors, they have an extraordinary effect, perhaps not improving the grandeur of the noble pile.'

Friday, 29 July
'All the day till the evening a distressing headache kept me in bed, but the head getting better and the evening clearing up fine I determined to walk to **Warkworth**.'

Saturday, 30 July
'The evening was beautifully serene, the moon shone full, lighting up the [Warkworth] castle walls and sparkling on the sea.

The dark woods were reflected in deeper shades in the river winding round the banks and retiring into indistinctiveness, while the hanging grey clouds and the streaked red twilight were reflected in this water-mirror, heightening by sudden contrast the blackness of the forest's shades. A few small boats slept on the undisturbed water, suspended as it were between the heavens above and the heavens below. As I sat on the banks the village females were passing backwards and forwards by the winding path through the woods, fetching water from a well. Their cheerful laugh echoed on the river, and was the only sound that broke the still silence of the evening ... [Castle] much in ruins, and very much in want of ivy.'

Sunday, 31 July
Morning: 'The [church] service being mouthed over by a double chin clergyman who could scarce articulate the words, something like a consciousness of which made his delivery impetuous.' The presence of some richer parishioners who lived some way away was explained by the fact that a parish meeting was held after the service, 'thereby serving themselves at the same time in quieting a little conscience.'

Evening: 'Very delightful but solitary saunter on the sand. Beyond the banks 'tis quite retired, and seldom marked with human footsteps. The gulls are lords of the domain, looking out on every wave for their rightful prey. When the tide is ebbing or flowing on a sandy shore, the constant dashing of the waves seems always to lull the mind to melancholy feelings, if reflection is indulged, or to awaken it to enthusiasm – either sitting on a rock and looking at nothing on the expanse of sea or with a favourite author reading aloud in raptures.'

Monday, 1 August
Visits a hermitage **near Warksworth**: 'This religious cell is almost covered from the eye by ancient trees, and is quite the abode of silent retirement, when the world would soon be forgotten and the [?] of the heart grow unchecked. Devotion loves retirement, but the habit of constant retirement lays a dead hand on the best part of man. In such a cell I could be a hermit too for a few weeks perhaps, but too soon for their laws I should be looking for the faces of my friends. Fortunately this morning I

met with hospitality from a farmer's wife who refreshed me with farmer's fare – bread and cheese and beer and to my astonishment in this land of rocks and dreariness found some v. pretty females, inhabitants of this lonely mansion.'

Tuesday, 2 August
Hot and oppressive weather between showers.

Wednesday, 3 August
'Bad headache, v. bad indeed. I attempted to stir abroad, but could only keep up while a bed was prepared in another room, my lodging room being the best tap room. In agony and most miserable depression of spirits I continued all day, with sickness, pain and fever.... Found the letter from my dear Betsey which had been misdirected, and though very acceptable served sadly to make me feel misery more acutely.'

Thursday, 4 August
(Free from headache): 'Walked to **Bambrugh** [Bamburgh] for breakfast and to save 8 miles – walked back Bambrugh sands 5 miles to **Holy Island** retreat of St. Cuthbert ... whose history says more of the amazing superstition of the age than can be paralleled.'

Friday, 5 August
Holy Island: 'An unlucky rush of wind blew my paint water and colours over my morning's labour; for a few moments my disappointment was almost frantic, a misery few people can sympathize in. My next sketch found wings, and to my astonishment mounted the walls of the church and sailed over the monastery, and remained to my great distress sky high for some time. Fortunately the storm whirled it round a house, where my chase soon ended without any accident to the drawing.'

Saturday, 6 August
To **Berwick** across the sands: 'Fearing my shoes would be soaked to paper, after 2 miles I took off stockings etc and hung them on my folio to dry as I journey along, no doubt being a laughable figure, dressed out with so many wet trappings ... Berwick gave me a letter from home, but is a poor field for an article.'

Sunday, 7 August
'A day of rain cold and wind ... I heard three Scotch ministers. The peculiarity of

their forms of worship was very new to me ... A more wretched set of psalm singing clerks cannot be, their praises were miserable sounds to my ears. Sent a letter to my Betsey.'

Monday, 8 August
Berwick - Coldstream - Twyzell Castle - Norham: 'I most sorrowed in being obliged to make memorandum only under my umbrella at **Norham,** a very picturesque village with a ruined castle grouping in the best composition imaginable, all I think that could be wished for at a village scene, but the rain fell in incessant torrents and I could only catch the slightest sketches ... I was disappointed to see the inside [? of the church] metamorphosed into everything that is neat and meeting-like, perhaps best so.'

Kelso: The Tweed 'sweeping round the town in uncommon beauty, for the Tweed is in most parts beautiful rather than romantic'.

Tuesday, 9 August
'At work early, and in the afternoon walked over to **Jedburgh** ... the broken irregularity of this stream [the Jed] under deep foliage, occasionally emerging to sweep a bank of pebbles and again flowing under its umbrageous shade, has a feature of romantic character such as I have not met with on the Tweed ... The cottages are hovels, with their Scotch chimneys, and picturesque wretchedness; they are thatched and unadorned with whitewash ... Nothing to the eye destroys so much the beauty of a river, with its varied accompaniments of stones and broken banks, as a regular 3 arched bridge as plain as possible.'

Wednesday, 10 August
'The lasses go stockingless, and not the longest petticoats to cover their large legs.'

Thursday, 11 August
Jedburgh - Melrose

Friday, 12 August
Dryburgh: 'I sketched a fragment of the Abbey, so embosomed in trees as almost to be hid in gloom. Gardens, pleasure grounds, and garden houses are formed about the remains, which have not much beauty of architecture. The Tweed flows round it and the banks are very pleasing, principally planted by the Earl of Buchan, whose

modern home is adjoining the Abbey, and on the estate his Lordship is occupied many months in the year active to render the beauty of the spot complete, with a taste that wants some correction, though not bad. Instead of planting fruit trees against the walls, ivy would be better as in some parts of the ruin it seems to thrive very well. His lordship's politeness cannot be forgotten ...' The grave of one of the Earl's domestics: 'Twas a large block cut in the shape of a coffin, one side recorded the name etc, and on the other was sculptured, the size of life, a likeness of the old servant in his coffin, shrouded, with the feet bare. It is admirably done, but almost excites too powerful a feeling – still I never felt myself so much among the dead.'

Sunday, 14 August
'Attended the Kirk but the very excellent minister was so very Scotch that it became painful to hear him in being obliged to strain the attention in connecting his words and sentences ... The lasses which were half naked yesterday appeared at Kirk today decent, well clothed and clean. The Scotch are very exact in appearing every service at the Kirk, but I think them rather inattentive congregations.'

Monday, 15 August
Sketching under an umbrella 'until limbs wet' at **Melrose.**

Tuesday, 16 August
Confined in bed at **Melrose** with a 'violent, rheumatic headache'.

Wednesday, 17 August
'The conflict for sketches between health and weather very singular. Today was much better, but it rained incessant, and could only catch memorandums under my umbrella ... I observed every sign in the village of the smallest shops, however four very conspicuous – to say that they deal with all four parts of the globe.'

Thursday, 18 August
Melrose - Edinburgh on the Jedburgh Fly: 'Appears very like the representations of Irish accomodation, being v. dirty, v. ragged and patched with boards, with a raw Scotch dirty lad for coachman.'

Friday, 19 August
Edinburgh: 'The new town is regular and delightfully situated, clean and very respect-

able. The Old Town has all the features of antiquity, and some of the streets a great deal of peculiarity, the houses very high, very ancient, but very [?] picturesque.'

Saturday, 20 August
Walks seven miles to **Roslyn** [Roslin] with a sore heel. Finds the chapel exquisite but has not the time to draw it as this would have taken days. Describes the castle: 'which is only interesting from its romantic situation, on the summit of a wooded hill, the hills closing into narrow dells, folding into each other with many turnings, the river between them in some places broken into cascades by immense masses of rock heaped on each other in the wildest manner, while in other parts the chasm is deep and the stream silent, beautifully overshadowed by hanging rocks and ancient trees'.

Sunday, 21 August
'A wet day. Heard Mr. Peddie twice with much pleasure.'

Tuesday, 23 August
'Called at the E. of Buchan's house and hurried through the pictures etc; also delivered a letter to Lord S. whose manners were peculiarly the gentleman.'

Saturday, 27 August
London: 'Safe home and very thankful – by 10 o'clock.'

Checklist of publications by Samuel Prout

PUBLICATIONS WITH SOFT-GROUND ETCHINGS

1812 *Picturesque Delineations in the Counties of Devon and Cornwall*, imitated from the original studies. 24 plates, $21\frac{1}{2} \times 15$ in. Pub. T. Palser, Feb. 1811–Feb. 1812

1813 *Prout's Village Scenery*. 11 plates, $11 \times 17\frac{1}{4}$ in. Pub. T. Palser
Rudiments of Landscape in Progressive Studies, in imitation of chalk, Indian ink, and colours. 64 plates, some with aquatint, $11 \times 14\frac{1}{2}$ in. 16 pages of text. Pub. R. Ackermann. Reissued with new title page in 1814. (Abbey, 170 & 171)

1815 (?) a Palser publication of 'Cottage Scenery'. (?) no. of plates, 12×17 in. Pub. T. Palser, Oct. 1815.
Picturesque Sketches of Rustic Scenery. 54 plates. Pub. R. Ackermann. (?) same as *Picturesque Studies of Cottages* . . .

1816 *Picturesque Studies of Cottages, Old Houses, Castles, Bridges, Ruins etc.* in the manner of chalk. 16 plates, with aquatint, $14\frac{1}{2} \times 10\frac{1}{4}$ in. (?) same as:
Studies of Cottages and Rural Scenery, drawn and etched in imitation of chalk. 16 plates, $14\frac{1}{2} \times 10\frac{1}{4}$ in. Pub. R. Ackermann.
Studies of Boats and Coast Scenery for Landscape and Marine Painters, drawn and etched in imitation of chalk. 16 plates, $12\frac{1}{2} \times 9\frac{1}{2}$ in. Pub. R. Ackermann.
Progressive Fragments drawn and etched in a broad and simple manner, with a comprehensive explanation of the principles of perspective for the use of young students. 24 plates, $11\frac{1}{4} \times 7\frac{1}{2}$ in. Pub. R. Ackermann. Also issued with title page dated 1817.

1817 *Sketches of the Thames Estuary and on the South Coast*. 23 plates. Pub. T. Palser (?) originally in 1814.

1819 *Samuel Prout's New Drawing-Book containing 12 views in the West of England*, drawn and etched in imitation of chalk. 12 plates, 15×11 in. Pub. R. Ackermann. The same as:
A Series of Views of Rural Cottages in the West of England (Abbey 172), where the plates are arranged in a different order.

1820 *A Series of Easy Lessons in Landscape Drawing* contained in 40 plates arranged progressively, from the first principles in the chalk manner to the finished landscape colours. 40 plates, some with aquatint, $5\frac{1}{2} \times 8\frac{1}{2}$ in. Pub. R. Ackermann. Feb. 1819–Nov. 1819 (Abbey 173).

1821 *Samuel Prout's Views in the North of England: A Series of Views of Rural Sketches in the North of England*, drawn and etched in imitation of chalk. 12 plates, 15×12 in. Pub. R. Ackermann, 1821. This has been described as in lithograph but is identical with the *West of England*, where the plate mark is faint and sometimes trimmed. A faint plate mark can be found hidden by the spine in the *North of England* whose plates are otherwise trimmed.

PUBLICATIONS WITH LITHOGRAPHS

1820 *Marine Sketches* drawn on stone. 16 plates (at least), 10×12 in. Pub. by Rowney & Forster as *Lithographic Drawing Book*(s).

1821 *Picturesque Buildings in Normandy* sketched from nature and drawn on stone. 8 plates, $10\frac{1}{2} \times 14$ in. Pub. by Rodwell and Martin. Feb.–July 1821. Printed by Charles Hullmandel.

1823 *Studies from Nature*. (?) no. of plates, $15\frac{1}{4} \times 11\frac{1}{2}$ in. Pub. by Rodwell and Martin in parts, Jan. 1823. Printed by C. Hullmandel lithog.
(?) a Rowney and Forster publication of 'Continental Views' (?) no. of plates, $17\frac{1}{2} \times 13$ in (St Maclou, Rouen).

1824 *Illustrations of the Rhine* drawn from nature and on stone, 25 plates (+vignette by Hullmandel), $16 \times 12\frac{1}{2}$ in. Pub. by R. Ackermann/Rodwell and Martin/J. Dickinson, 1822-4. Printed by C. Hullmandel. (See Abbey 219 for the complex publication history.) A later ed. with added tint was pub. by E. Gambart in 1853.

1826 *Views in Germany in continuation of Views on the Rhine* drawn from nature and on stone. 5 plates, $16 \times 12\frac{1}{2}$ in. Pub. J. Dickinson as a Supplement to *Illustrations of the Rhine*. Printed by C. Hullmandel.

1829 Edward Hull, *Six Drawings after Prout*. 6 plates, small folio. Pub. by G. Engelmann in Paris and Mulhouse.

1833 *Facsimiles of Sketches made in Flanders and Germany* and drawn on stone by Samuel Prout F.S.A., Painter in Water Colours in Ordinary to Her Majesty the Queen. 50 tinted plates, 22×15 in. Published by the artist (repub. rights later sold to Charles Tilt) n.d. Printed by C. Hullmandel.

1834 *Interior and Exteriors* drawn from nature on stone. 26 tinted lithographs, $15 \times 10\frac{1}{2}$ in Pub. by Ackermann & Co. Repub. 1844 by A.M. Nattali. Printed by C. Hullmandel.

1838 *Hints on Light and Shadow, Composition etc.*, as applicable to Landscape Painting. 20 tinted lithographs, 15×17 in. with text. Pub. by Ackermann & Co. Repub. 1848 with two additional plates (Abbey, 176).

1839 *Sketches in France, Switzerland and Italy*. 26 tinted lithographs, 22×15 in. Pub. by Hodgson & Graves. Printed by C. Hullmandel. (Abbey, 34).

c. **1840** *Bits for Beginners by Samuel Prout*. (?) No. of plates, $8\frac{1}{4} \times 12\frac{1}{2}$ in. Pub. by Ackermann & Co. Printed by Hullmandel & Co. n.d.

Elementary Drawing Book of Landscape and Buildings. 24 plates (drawings on zinc), 1839, $11 \times 7\frac{1}{2}$ in. Pub. by Charles Tilt, n.d. Printed by J.R. Jobbins.

1841 *Prout's Microcosm: The Artist's Sketchbook of Groups of Figures, Shipping and other Picturesque Objects*. 24 tinted lithographs, $15 \times 10\frac{3}{4}$ in. Pub. by Tilt & Bogue. Printed by C. Hullmandel.

1844 *Sketches at Home and Abroad: Hints on the Acquirement of Freedom of Execution and Breadth of Effect* to which are added simple instructions on the proper uses and application of colour. 48 tinted lithographs (+two vignettes), $15 \times 10\frac{1}{2}$ in. Pub. by A.M. Nattali (an enlarged ed. of 1834 *Interiors*) and printed by Hullmandel & Walton.

BOOKS WHOLLY OR LARGELY ILLUSTRATED WITH STEEL ENGRAVINGS AFTER PROUT

1811 *Relics of Antiquity, or Remains of Ancient Structures in Great Britain*. Pub. W. Clarke, 1811 with 31/47 engravings after Prout dated 1810/11.

1821 Thomas Hodson & John Dougall, *The Cabinet of Arts*. Pub. 1821 by R. Ackermann. 2nd ed. with *c.* 15 plates after or by Prout; engravings, aquatints and lithographs (Abbey, 146).

1829 *The Landscape Annual for 1830:* The Tourist in Switzerland and Italy. 26 plates. Pub. by Robert Jennings, 1829, with text by Thomas Roscoe.

1830 *The Landscape Annual for 1831:* The Tourist in Italy. 26 plates. Pub. by Robert Jennings, 1830, with text by Thomas Roscoe.

1830 *The Continental Annual for 1832*. 13 plates. Pub. by Smith & Elder, with text by William Kennedy.

n.d. *The Continental Tourist:* Views of Cities and Scenery in Italy, France and Switzerland: Vol I. 18 plates after Prout and 26 after J.D. Harding. Pub. by Peter Jackson, Late Fisher Son & Co., with text by Thomas Roscoe (English) and Alexander Sosson (French).

The Continental Tourist: Vol. II. 23 engravings after Prout and 21 after Harding.

The Continental Tourist: Vol. III. 15 engravings after Prout, 3 after W.H. Bartlett, 26 after Harding. Prout's views had already been published in the *Landscape Annuals*, etc.

Exhibited works by Samuel Prout

Note: A few obvious spelling errors have been corrected in accordance with Prout's account books; otherwise the entries are as they appear in the original catalogues.

Royal Academy

Artist's Address: 10, Water Street, Bridewell Precinct
1803 (653) Bennet's cottage on the Tamer, near Plymouth

Artist's address: 21, Wilderness Row, Goswell Street
1804 (662) St Keynes' Well, Cornwall
1805 (479) Oakhampton Castle, Devonshire
(481) Farleigh Castle, Somersetshire
(493) The grand porch to Malmesbury Abbey church, Wiltshire

Artist's Address: 55, Poland Street
1808 (541) View on Dartmoor, Devon
(560) Arthur's Castle at Tintagel, Cornwall
1809 (253) The birthplace of Sir J. Reynolds – Plympton, Devon
1810 (180) Tavistock, Devon

Artist's Address: 7, Brixton Place, Stockwell
1812 (436) Berry Castle mill, Devon
(500) Freshwater, Isle of Wight
(510) Tavistock Abbey, Devon
(514) Tremarton, Devon
1813 (684) Zeal, Devon
(712) A calm
(726) St Michael's Mount, Cornwall
(777) View near Leskeard, Cornwall
(782) View of Leskeard, Cornwall
(786) St Ives, Cornwall
(787) Freshwater Bay, Isle of Wight

Artist's Address: 4, Brixton Place, Stockwell
1814 (557) Margam, South Wales
(558) View on the Dart at Totness, Devon
(620) Hulks at Plymouth
(651) View of Monmouth
1817 (594) A Wreck at Cromer
1826 (268) The Ducal Palace, Venice
1827 (553) Temple of Pallas, Rome
(558) Hotel de Ville, Ghent

British Institution

Artist's Address: 55, Poland Street
1809 (261) The Water-mill and Manor House near Plymouth, 4′10″ × 5′7″
1810 (292) Sketch of the fire at Billingsgate 1′9″ × 1′10″
(317) A sea shore, near Teignmouth 1′9″ × 1′10″

Artist's Address: 7, Brixton Place, Stockwell
1811 (299) East Indiaman and Dutch Boats 4′6″ × 5′4″

1816 (159) Melrose Abbey 6′6″ × 8′6″
1817 (109) Holy Island 2′2″ × 2′9″
1818 (35) View near Dulwich 1′10″ × 2′3″
(190) Tynemouth Priory 1′10″ × 2′3″

Associated Artists in Water-Colours

Artist's Address: 55, Poland Street (Member)
1810 (14) Shoreland House, Isle of Sheppey
(18) Radford Mill, Devon
(2) Cottages on Dartmoor, Devon
(3) Cottages at Plympton
(73) Shipping from the Greenland Dock, on the Thames
(82) Cottages at Bishop's Teignton, Devon
(200) Cheezewring and Hurlers, Cornwall
(223) Frigates at Deptford
(260) Cottages near Plymouth, Devon
(265) View near Landrake, Cornwall

Artist's Address: 7, Brixton Place, Stockwell
1811 (38) Beach at Deal
(71) Glastonbury, Somersetshire
(106) Ogwell Mill House, Devon
(137) Wreck of an Indiaman, Plymouth Sound
(152) Vessels at Deptford
(181) Study of Vessels
(189) Study of a Brig
(208) Study of Shipping
(259) Ship Breaking
(276) Cottage near Tunbridge, Kent
(285) Deal Beach
(289) Cottage near Totness, Devon
(295) Plymouth Harbour, Devon
(307) Mill, Exeter, Devon
(309) Plymouth Harbour
(314) Chasse-Marées
1812 (12) Torbrian, Devonshire
(19) Exeter
(50) Sandwich, Kent
(51) Tamerton Mill, Devon

Bond Street

1814 Pembroke
Llantwit
Interior, Monnow Church near Plymouth
Interior, Ewenny Priory
1815 11 Drawings

Society of Painters in Water-Colours (Old Water-Colour Society)

Note: Numbers in brackets after entries show price paid in guineas.
Artist's Address: Brixton Place, Stockwell

1815	(177)	Part of Durham Bridge	
	(184)	Jedburgh Abbey	
	(272)	The Wreck	
	(289)	Kelso Abbey	
	(300)	Calm	(4) W. Fawkes
	(308)	Jedburgh Abbey	
	(349)	Near Plymouth	(4) Ld Buckinghamshire
1816	(119)	Old Shoreham Church	(6)
	(128)	Hastings, Boats (oil)	(8)
	(130)	Willow, near Dulwich (oil)	(8)
	(201)	Worthing Sands	(10)
	(234)	Study at Worthing	(4)
	(236)	Holy Island	(4)
	(249)	Hastings, Boats	(4) Mr Henderson

Artist's Address: 4, Brixton Place

1817	(12)	Cromer	
	(188)	Study at Worthing	
	(196)	View near Exeter	
	(199)	Hastings	
	(200)	Fishing Boats	
	(229)	Beachey Head	
	(257)	Greenlanders	(8) Mr Ward
1818	(6)	Melrose Abbey	
	(222)	Mounts Bay	(6) W. Fawkes
	(264)	Ballast Barges	(8) W. Fawkes
	(274)	Fisherman's Cottage	
	(328)	Scene on the Lara	(9)
	(335)	A Storm	(4) Hon Mrs B. Cochrane
	(359)	Sunset	
1819	(8)	Brig in Distress at Bamborough Castle	
	(16)	Scene near Worthing	
	(123)	Dover Backwater	
	(269)	Fishing Boat	(6) J. Vine
	(277)	Cerne Abbey, Dorset	(8) Ld Grey
	(278)	Dismasted Indiaman	(12) J. Allnutt
	(295)	Fordington, Dorset	
	(317)	Fishing Boats on Shore	(6) Dr Williams

Member

1820	(5)	Fishing Boats	
	(11)	A Water-Mill, Devon	(6) Thomas Griffith
	(13)	Old Pier, Dover	
	(15)	On the Seine at Duclair	(5) E. Tattersall
	(16)	At Fécamp, Normandy	(5) J. Allnutt
	(22)	Dismasted Indiaman	(6) W. Fawkes
	(24)	Near Yvetot, Normandy	
	(28)	Scene on the Seine, near Rouen	
	(250)	Croix de Pierre, Rouen	(12) T. Griffith
	(261)	St. Maclou, Rouen	(12) Mr Webster

(273)	Six Sketches in Normandy, at Lillebonne, Montivilliers, Fécamp, and Rouen		
(282)	Wreckers under Plymouth Citadel	(10)	E. Tattersall
(291)	Dismasted Indiaman on Shore	(12)	Mr Webster
(297)	Harfleur, Normandy – a Sketch	(6)	Watts Russell
(299)	Etretat on the Coast of Normandy	(7)	J.C. Warner
(347)	Backwater, Dover		
(372)	Hastings Fishing Boats		
1821 (1)	Montivilliers, Normandy	(12)	G. Giles
(6)	At Rouen, Normandy	(12)	G. Giles
(9)	Men of War	(12)	G. Giles
(16)	An Old House at Truro, Cornwall	(8)	Mr Bacon
(19)	Blore Church, Staffordshire	(8)	F.L. Chantrey
(34)	Place de la Pucelle, where Joan of Arc was burnt, at Rouen	(25)	Mr Warner
(62)	Pont de l'arche on the Seine	(6)	J. Taylor
(65)	On the Seine at Rouen	(5)	J. Allnutt
(70)	At Granville, Normandy – a Sketch	(1½)	J. Taylor
(74)	At Aymville, Normandy – a Sketch	(1½)	Mr Utterson
(98)	A Shipwreck	(8)	W. Fawkes
(110)	Ruins of Howden Church, Yorkshire, 24 × 21 in		T. Griffith
(116)	Part of the Palais de Justice, Rouen – a Sketch	(2½)	
(121)	A Sea Shore	(8)	
(123)	Part of the Place de la Pucelle, – a Sketch	(2)	
(124)	Croyland Abbey, Lincolnshire	(7)	Mr Godwin
(137)	A Man of War ashore	(£25)	T. Griffith
(159)	Walm Gate, York		
(166)	Prison de St Lo	(2)	Mr Salvin
1822 (3)	At Lahnstein on the Rhine – a Sketch	(1½)	Sir W.W. Wynne
(4)	Metz	(12)	J.G. Lambton, M.P.
(5)	At Strasbourg – a Sketch	(1½)	G. Hibbert
(7)	Boats returning from a Wreck	(12)	Hon Mrs Grey
(39)	Palais du Prince – Liege	(10)	J.G. Lambton
(41)	Fishing Boats	(8)	J.G. Lambton
(42)	Strasbourg	(15)	J.G. Lambton
(46)	Mayence	(15)	J. Taylor
(50)	On the Lid, Devon	(2)	J. Taylor
(54)	Crypt of Kirkstall Abbey	(2)	G. Hibbert
(80)	St Omer, Strasbourg – a Sketch	(2)	Revd W. Long
(85)	Strasbourg	(35)	B. Oakley
(92)	At Andernach on the Rhine – a Sketch	(2½)	G. Hibbert
(101)	Part of the Cathedral, Rouen	(6)	G. Hibbert
(106)	Merchantmen setting Sail	(10)	T. Griffith
(107)	St Vincent, Rouen	(6)	Ld Gower
(117)	Rheinfels, from St Goarshausen on the Rhine	(5)	J. Webster
(118)	Cat, from St Goar on the Rhine [Katz]	(5)	J. Newman
(139)	An Indiaman Ashore	(25)	T. Griffith
(140)	Scarborough Castle	(2½)	H. Brooke
1823 (3)	Oberwesel on the Rhine		
(26)	At Ghent	(10)	Ld Lansdowne
(28)	Maline, Flanders	(40)	Watts Russell
(47)	Marine Subject	(3)	J. Webster
(52)	Antwerp		

(81)	Receiving Ships, Portsmouth	(25)	Ld Stafford
(88)	St Jacques, Antwerp. The Church in which Rubens is buried	(2½)	Ld Gower
(90)	At Tournay, Flanders	(2½)	Ld Gower
(98)	St Etienne, Fecamp, Normandy	(10)	Mr Broderip
(113)	Castle at Heidelberg	(10)	C.H. Turner
(127)	Abbeville	(15)	Gen Grey
(134)	At Andernach on the Rhine	(2)	Ld Gower
(136)	Hotel au Corbeau, Strasbourg	(10)	Sir Abraham Hume
(142)	Rouen Cathedral, destroyed by Fire 1822	(15)	Gen Grey
(156)	At Rouen	(2)	Revd W. Long
(157)	Hotel de Ville, Louvain	(40)	G. Haldimand
(162)	Hotel de Ville, Ghent		
(191)	At Andernach on the Rhine	(2)	Revd W. Long
(217)	At Ypres, Flanders	(8)	Lady Stafford
(237)	Marine Subject		
(248)	At Cologne, on the Rhine	(5)	B. Windus
(276)	At Lahnstein on the Rhine		
(291)	At Brussels		
(299)	Notre Dame at Huy, on the Meuse		
1824 (26)	Beguinage, Brussells	(2)	E. Tattersall
(38)	Chateau de Martinsburg, Mayence	(6)	Duke of Norfolk
(46)	View in Mayence	(6)	G. Hibbert
(64)	Mayence on the Rhine	(25)	E. Tolcher
(88)	Well at Nuremburg	(2)	E.V. Utterson
(90)	Cologne on the Rhine	(25)	Mr Arrowsmith
(98)	Hotel de Ville, Cologne	(12)	C. Turner
(103)	Porch of the Cathedral at Ulm	(5)	Hon Col Stanhope
(105)	Marine	(10)	Mr Arrowsmith
(108)	At Ratisbonne	(2)	G. Hibbert
(133)	Cathedral Well at Ratisbonne	(3)	E. Swinburne
(136)	Augsburg – Bavaria	(15)	Mr Arrowsmith
(142)	At Nuremburg – Bavaria	(12)	C. Turner
(145)	Fishing Boats	(5)	— Watt
(149)	At Strasbourg	(15)	Lady de Grey
(150)	Marine View	(5)	— Ferguson
(158)	Utrecht	(15)	Mr Arrowsmith
(189)	At Basle	(25)	C. Turner
(196)	Church of the Holy Ghost – Nuremburg	(15)	C. Turner
(198)	Hotel de Ville, Ghent	(12)	C. Turner
(202)	Well at Strasbourg	(2½)	Mrs Lechmere
(203)	Hotel de Ville, Cologne	(5)	Hon Col Stanhope
(207)	Indiaman dismasted	?(50)	J.S. Buckinghamshire
(222)	Munich, Bavaria	(50)	Duke of Norfolk
(235)	Porch of Harfleur Church, Normandy [? Honfleur]	(4)	M.W. Ridley
(277)	At Frankfort	(8)	F. Chantrey
(278)	South Porch of Rouen Cathedral	(12)	C. Turner
(279)	Porch of Ratisbonne Cathedral	(10)	F. Chantrey
1825 (40)	Ponte di Rialto, Venice	(50)	Hon G. Liddell
(57)	Ponte di Rialto, Venice	(12)	Sir Abm Hume
(108)	Portico di Ottavia – the Fish Market at Rome	(12)	G. Hibbert
(110)	Ponte della Canonica – Venice	(20)	Ld Brownlow
(148)	Church at Arque, near Dieppe	(3)	F. Chantrey
(151)	Place St Antoine, Padua	(20)	G. Hibbert

	(156) At Ratisbonne	(3)	— Giles
	(164) At Lahnstein on the Rhine	(2½)	C.H. Turner
	(191) At Braubach on the Rhine	(2½)	Lady Stafford
	(192) At Geneva	(10)	Sir W.W. Wynne
	(227) Maison de Ville, Louvain	(15)	R. Ackermann
	(244) At Nuremburg, Bavaria	(15)	Hon. G. Liddell
1826	(17) Antwerp	(30)	— Ellison
	(24) Domo D'Ossola	(12)	F. Broderip
	(53) Milan	(50)	Ld Surrey
	(67) At Wurzburg, Bavaria	(20)	Lady Charlotte Stopford
	(81) Temple of Nerva, Rome	(4)	C. Wild
	(114) Porch of Ratisbonne Cathedral	(15)	Lady Ridley
	(180) Swiss Cottages, near St Maurice	(15)	— Clive
	(224) Palais du Prince, Liege	(8)	T. Griffith
	(233) At Venice	(12)	Sir W.W. Wynne
	(237) Receiving Ships at Portsmouth	(30)	
	(243) The Campanile at Venice	(20)	Ld Brownlow
	(249) At Nuremberg, Bavaria	(15)	Ld Northwick
1827	(25) Arch of Constantine, Rome	(15)	J. Wyattville
	(26) Ponte di Rialto, Venice (Premium picture)	(60)	Lady de Grey
	(31) Como	(18)	J. Braithwaite
	(32) At Ulm	(12)	Sir Abm Hume
	(34) Nuremberg, Bavaria	?(50)	C. Holford
	(48) Vicenza		
	(66) Leaning Towers at Bologna	(6)	J. Braithwaite
	(67) Bridge of Sighs, Venice	(20)	C. Turner
	(78) Part of the Amphitheatre at Verona	(6)	J. Braithwaite
	(105) Portico di Ottavia, Rome	(6)	— Prior
	(141) Church of St. Maclou, Rouen	(18)	G. Hibbert
	(159) Fountain at Basle	(18)	G. Hibbert
	(171) Temple of Jupiter Tonans, Rome	(10)	
	(172) At Verona	(20)	J. Braithwaite
	(260) Ponte Rialto, at Venice	(40)	G. Morant
	(359) At Venice		
1828	(21) Campanile, Ducal Palace, Bridge of Sighs, Prison, etc., at Venice	(50)	F.G. Moon
	(24) Rue Grosse-Horloge – Rouen	(18)	C. Turner
	(37) Mausolée de Mastin 2d famille d'Escaille, Verona	(18)	Sir W.W. Wynne
	(60) Piazza Basilica, Vicenza	(4)	F. Broderip
	(69) Piazetta – Venice	(8)	F. Broderip
	(97) The Rezzonico, Two Foscari, and Balbi Places, at Venice	(40)	Duke of Devonshire
	(106) Petrarch's House at Arqua, near Padua	(6)	Ld Farnborough
	(117) Bayeux, Normandy	(4)	C. Mathews
	(130) Rue St Jean, Caen	(40)	J. Brydges
	(158) Part of the Church of St Mark, etc., at Venice	(20)	C. Mathews
	(148) Rue St Amand, Lisieux, Normandy	(18)	Ld Brownlow
	(178) Porch of the Church of Louviers, Normandy	(8)	J. Bridges
	(179) Part of the Church of St Pierre at Caen	(20)	Revd M. Mansfield
	(180) Mausolée de Can François de l'Escaile, Verona	(6)	Sir W.W. Wynne
	(237) Porch of Ratisbonne Cathedral	(18)	J. Bridges
	(319) Porch of the Cathedral of Lausanne	(4)	Hon G. Agar Ellis
1829	(48) Abbeville	(10)	F. Broderip

(49)	At Venice	(8)	Duchess of Bedford	
(70)	Milan	(8)	Lady Chetwynd	
(7)	On the Grand Canal at Venice	(50)	W.H. Harriott	
(79)	At Verona	(8)	— Parrott	
(138)	At Caen, Normandy	(8)	D. Colnaghi	
(140)	A Sketch	(4)	W. Prior	
(153)	'As the tall ship, whose lofty prore	(35)	James Watt	

(153) 'As the tall ship, whose lofty prore
Shall stem the billows more,
Deserted by her gallant band,
Amid the breakers lies astrand.' (*Lady of the Lake*)

(245)	Church of Louviers	(20)	C.H. Turner
(255)	At Nuremberg, Bavaria	(30)	Duke of Bedford
(316)	Place de la Pucelle at Rouen, where Joan of Arc was burnt	(10)	Revd E.C. Hawtrey

1830
(13)	Part of the Ancient Palace at Bamberg	(8)	S. Angell
(35)	Church of Notre Dame, Dresden	(20)	Ld Stormont
(58)	The Ducal Palace, Venice	(60)	— Morrison
(111)	Part of the Cathedral at Abbeville	(10)	Lady Chetwynd
(152)	At Brigg	(8)	C. Porcher
(189)	At Nuremberg, Bavaria	(15)	R. Bernall
(209)	At Bamberg, Bavaria	(10)	R. Bernall
(210)	Fountain at Ulm	(10)	W.H. Harriott

1831
(2)	St Mark's Place, Venice	(20)	Ld Stormont
(27)	Interior of a Church	(5)	— Stewart
(28)	Part of the Zwinger Palace, Dresden	(18)	W.B. Roberts
(32)	At Lisieux, Normandy	(6)	E. Tusten
(33)	Morning Prayers	(5)	T. Griffith
(56)	At Venice	(8)	W.B. Roberts
(83)	Fishing Boats	(5)	Mr Hixon
(84)	Porch at Rouen	(8)	W.B. Roberts
(107)	At Verona	(20)	Mrs Whitbread
(110)	An Indiaman Ashore	(8)	W.B. Roberts
(139)	Wurzburg, Bavaria	(35)	E. Parratt
(174)	Part of St Mark's Church, Venice	(6)	G. Morant
(185)	Fish Market, Rome	(6)	Duke of Devonshire
(198)	Evening Prayers	(5)	T. Griffith
(199)	Rome	(6)	Duke of Devonshire
(226)	At Rouen	(6)	Lt Gen Hall
(228)	Beauvais	(18)	W.B. Roberts
(249)	The Palace and Prison, Venice	(18)	Duke of Devonshire
(258)	At Coblenz on the Rhine	(15)	F. Squibb
(264)	Ruben's House, Antwerp	(8)	— Shaw
(285)	Porch at Louviers, Normandy	(6)	F. Broderip
(303)	Greek Church and College, Venice	(6)	Mr Austin
(306)	Church of St Pierre, Caen	(6)	W.H. Harriott
(328)	The Rialto, Venice	(12)	— Birch
(405)	At Venice	(4)	W.B. Roberts
(420)	At Mayence, on the Rhine	(8)	W.B. Roberts

1832
(10)	Lord Byron's Residence on the Grand Canal, Venice	(10)	R. Bernal
(23)	At Venice	(6)	F.G. Harding
(24)	At Ulm	(6)	Revd C. Terrot
(27)	St Etienne, Beauvais	(5)	W.B. Roberts
(42)	Near Caen	(5)	D. Colnaghi
(45)	Piazetta, Venice	(50)	F.G. Harding
(48)	At Rouen	(5)	W.B. Roberts

	(60)	At Ratisbonne	(15) R. Ellison
	(80)	Tomb of Can François de l'Escaille, Verona	(6) W.B. Roberts
	(88)	At Wurzburg	(18) R. Ellison
	(99)	Zwinger Palace	(8) W.B. Roberts
	(161)	Ponte dei Sospiri, Venice	(20) Ld Brownlow
	(178)	Porch at Wurzburg	(6) W.B. Roberts
	(187)	Portico di Ottavia, Rome	(7) Mr Hixon
	(199)	Temple of Pallas, Rome	(7) W.B. Roberts
	(211)	St Spiridion, Venice	(8) W.B. Roberts
	(214)	La Madonna della Salute, Venice	(20)
	(220)	On the Moselle	(8) Revd C. Terrot
	(384)	St Lo	(5) Mr Hixon
	(396)	At Venice	(6) F.G. Harding
	(405)	At Cologne	(6) J.V. Thompson
	(408)	Pisa	(6) Mr Hixon
1833	(4)	Place Pucelle, Rouen	(6) J.I. Ireland
	(76)	Bridge at Prague	(6) Ld Tankerville
	(97)	On the Rhine	(5) T.L. Brown
	(102)	At Verona	(8) R. Bernal
	(110)	On the Rhine	(8) J.V. Thompson
	(132)	Porch at Bamberg	(6) W.B. Roberts
	(142)	S.M. della Salute, Venice	(6) H. White
	(189)	Mausolée de Mastin II, Famille de l'Escaille, Verona	(15) Mrs Tustin
	(199)	At Caen in Normandy	(6) J. Fielden
	(203)	Montivilliers	(6) Lady Cawdor
	(274)	At Evreux, Normandy	(5) W.B. Roberts
	(315)	La Chiesa dei S. Miracoli, Venice	(6) W.B. Roberts
	(355)	Well at Evreux, Normandy	(5) W.B. Roberts
	(384)	On the Rhine	(8) — Hodgson
1834	(28)	At Milan	C.H. Turner
	(50)	At Rome	— Jolly
	(62)	Part of the Cathedral at Rouen	(18) B. Austen
	(91)	Venice	(6) W.H. Harriott
	(92)	Vicenza	(10) B. Austen
	(116)	At Abbeville	(6) Miss Wharton
	(119)	At Amiens	(5) Sir W. Pilkington
	(137)	At Venice	(10) B. Austen
	(195)	At Geneva	(9)
	(197)	On the Grand Canal, Venice	(5) — Cubitt
	(198)	A Shipwreck	(10) C.H. Turner
	(263)	Porch of the Cathedral at Chartres	(25) Ackermann & Co
	(272)	Columns of the Lower Ages at Venice	(7) Fitzjames Watt
	(278)	On the Grand Canal, Venice	(6) Revd J. Clowes
	(322)	At Lisieux	(9) — Ruskin
	(330)	At Caen	(5)
	(357)	At Rouen	(5) W.H. Harriott
	(368)	At Lahnstein on the Rhine	(6) W.H. Harriott
	(370)	La Halle au Blé, at Tours	(7) Miss Langston
	(377)	At Leudersdorf, on the Rhine	(5) W.H. Harriott
	(389)	Part of the Palais de Justice, at Rouen	(6) Hon Miss Cust
1835	(27)	On the Grand Canal, Venice	(50) F.G. Moon
	(47)	At Verona	(6) R. Ferguson
	(54)	Street View at Antwerp	(15) S. Dickens
	(61)	St Pierre at Caen	(15) Fitzjames Watt
	(77)	Part of the Zwinger Palace, Dresden	(8) Mr Houghton

(84) Croix de Pierre, Rouen	(8)	Mr H. Harrison
(91) At Chartres	(6)	Mr Houghton
(95) On the Rhine	(15)	H. Hopley White
(110) Church at Venice	(5)	Mr Hixon
(116) At Verona	(6)	R. Ferguson
(121) Lisieux	(6)	Mr Jolly
(130) Interior	(5)	J. Henderson
(174) At Martigny	(5)	Maj Gen Sir Chas Greville
(198) On the Rhine	(6)	T.C. Clifton
(212) At Orleans	(8)	J.J. Ruskin
(285) On the Rhine	(6)	Sir Willoughby Gordon
(289) St Jacque, at Antwerp, the Church in which Rubens lies buried	(6)	J. Henderson
(295) At Venice	(6)	D. Colnaghi
(309) An Interior	(5)	R. Hopley White
1836 (35) At Nuremberg	(7)	Sir Willoughby Gordon
(63) Temple of the Sibyls at Tivoli	(8)	J. Hewett
(81) At Venice	(8)	J. Hewett
(97) Abbeville	(10)	J. Hewett
(136) An Interior	(7)	J. Hewett
(161) A la Barbe blanc at Tours	(6)	Duchess of Kent
(174) At Venice	(7)	Messrs Fuller
(202) An Interior	(7)	D. Colnaghi
(209) At Venice	(6)	J. Bodley
(226) Market Place at Tours	(7)	Lady Rolle
(283) At Venice	(6)	J.T. Simes
(317) Dresden	(10)	J. Ruskin
(340) Louvain	(10)	J. Hewett
1837 (28) Antwerp	(12)	John Hewett
(50) Lavey, near St Maurice	(12)	Hon & Revd H. Legge
(71) At Padua	(6)	— Tyrrell
(72) Bridge of Sighs, Venice	(12)	John Hewett
(160) At Nuremberg, Bavaria	(8)	John Hewett
(186) At Evreux, Normandy	(8)	John Hewett
(189) An Interior	(6)	
(194) St Symphorien, at Tours	(8)	
(197) Part of the Interior of the Cathedral at Chartres	(7)	D. Colnaghi
(222) At Verona	(6)	H. Cary
(284) At Nuremberg	(6)	Lady Rolle
(297) At Chartres	(6)	
(299) On the Rhine	(6)	Lady Rolle
(337) Entrance to the Bridge at Prague	(7)	—Vaughn
(361) Chapel at Amboise	(7)	F.G. Parry
1838 (33) La Chiesa dei S. Miracoli, Venezia	(10)	
(101) Piazzetta del Molo, Venezia (Premium picture)	(60)	E.E. Tustin
(123) Part of the Amphitheatre at Verona	(8)	Samuel Angell
(130) At Bamberg, Bavaria	(6)	— Wilkinson
(133) Street View at Baccharach, on the Rhine	(8)	W.C. Marshall
(134) At Evreux, Normandy	(6)	Sir Richard Hunter
(138) At Domo d'Ossola	(8)	W.C. Marshall
(157) Well at Lahnstein, on the Rhine	(8)	Price Edwards
(175) La Halle au Blé, Tours	(8)	D. Colnaghi
(188) Ducal Palace, Venice	(12)	Her Majesty
(194) Part of the Castle at Blois	(10)	J. Ruskin

(202)	Church at Louviers, Normandy	(12)	Revd C. Terrot
(219)	On the Rhine at Nieder Lahnstein	(6)	John Wilson
(20)	Rialto, et., Venice	(12)	D. Colnaghi
(284)	At Frankfort, on the Maine	(6)	J. Ruskin
(311)	At Verona	(8)	Lady Rolle
(315)	At Venice	(12)	Marchioness Conyngham
(325)	St Etienne, Beauvais, Picardy	(12)	J. Martin
(334)	At Rouen, Normandy	(8)	Lady Rolle
1839 (21)	Entrance to the Cathedral, Abbeville	(8)	Price Edwards
(54)	On the Rhine, at Welmich	(8)	
(77)	Croix de Pierre, Rouen	(8)	Marquess of Conyngham for Her Majesty
(99)	On the Rhine at Kapelle	(6)	
(131)	Part of the Zwinger Palace, Dresden	(6)	
(138)	Thein Church, Prague	(6)	
(140)	Abbeville	(14)	Ld Liverpool
(147)	Rue de la Pucelle D'Orleans, Rouen	(8)	— Thompson
(155)	Palais de Justice, Rouen	(8)	
(159)	After the Storm	(5)	J.H. Maw
(179)	Hotel de Ville, Louvain	(14)	Miss Lockwood
(221)	At Ypres, Flanders	(10)	
(230)	Zwinger Palace, Dresden	(10)	
(268)	At Nuremberg, Bavaria	(8)	Price Edwards
(286)	At Orleans	(8)	— Hobson
(305)	Hotel de Ville, Ghent	(10)	Lady Rolle
(309)	Casa Nani, Venice	(14)	Sir Richd Hunter
(321)	At Venice	(14)	
1840 (9)	At Cologne, on the Rhine	(8)	Sir John Swinburne
(60)	S.M. Dei Frari, Venice	(8)	
(70)	Beguinage, Brussels	(8)	
(111)	Prague, Bohemia	(40)	Sir John Cam Hobhouse
(120)	At Mayence, on the Rhine	(8)	Revd W.F. Webber
(151)	At Ratisbonne	(9)	
(159)	At Venice	(8)	Sir Rd Fitzwilliam
(204)	On the Rhine	(5)	James Martin
(213)	Godesberg	(5)	E. Willes
(239)	Dome at Frankfort	(9)	J. Walker
(249)	Piazetta, Venice	(12)	Chas. Russell
(253)	At Coblentz, on the Rhine	(5)	John Martin
(260)	At Treves	(5)	E. Willes
(266)	S. Maria della Salute, Venice		
(274)	Stadt-haus, Wiesbaden	(8)	J.J. Ruskin
(285)	Strasbourg	(14)	Revd L. Vernon Harcourt
(292)	Antwerp	(14)	Jos. Walker
(303)	At Nuremberg	(8)	Thompson Hankey
(324)	Fountain at Ulm	(8)	
1841 (12)	Part of the Cathedral, Rouen	(14)	D.J. Robertson
(31)	Port of Como	(12)	
(47)	Hotel de Ville, Cologne	(12)	J. Beaumont Swete
(59)	Notre Dame, from Place de la Calende, Rouen	(8)	W. Mason
(66)	At Baccharach on the Rhine	(5)	
(68)	La Croix de Pierre, Rouen	(5)	Sir John Buxton
(78)	L'Eglise Notre Dame, Dresden	(12)	C.W. Packe

(108)	L'Eglise St Pierre, Caen	(14)	J. Hewett
(123)	Liviana, near St Maurice, Switzerland	(8)	
(154)	Temple of Nerva, Rome	(9)	Price Edwards
(177)	Nieder Lahnstein on the Rhine	(8)	
(179)	At Brigg, Switzerland	(8)	
(197)	On the Rhine	(5)	Ld Uxbridge
(202)	An Interior	(9)	
(221)	St Spiridion, Venice	(8)	
(259)	At Coblentz, on the Rhine	(8)	
(264)	At Ulm, Bavaria	(5)	P. Hardwick
(268)	Part of the Castle of Heidelberg	(8)	B. Denton
(286)	Hotel de Ville, Utrecht	(8)	J.C. Hickenshaw
(289)	La Grosse Horloge, Rouen	(9)	Dr Chambers
1842 (2)	Hotel de Ville, Brussels	(4)	C.H. Turner
(63)	Hotel de Ville, Cologne	(8)	Lt Col Batty
(74)	At Ulm, Bavaria	(8)	Henry Wilkinson
(119)	Abbeville	(14)	Hon Mrs Vernon Harcourt
(128)	Augsburg, Bavaria	(20)	Jas Cole (Art Union)
(147)	At Bamberg, Bavaria	(12)	Revd H.H. Milman (Art Union)
(155)	Porch of the Church at Louviers, Normandy	(12)	Miss Burdett Coutts
(163)	Ferrara	(8)	Ld Brownlow
(185)	At Geneva	(8)	Miss Hicks Beach
(204)	At Cologne	(15)	Thos Hutton
(214)	Petrarch's House, at Arqua	(5)	Her Majesty
(221)	Nuremberg, Bavaria	(20)	Thos Hutton
1843 (15)	Il Fondaco dei Turchi, Venice		
(26)	At Nuremberg, Bavaria	(20)	Revd W. Edge (Art Union)
(38)	At Ulm, Bavaria	(20)	T. Griffith (Art Union)
(62)	Munich	(60)	Miss Burdett Coutts
(83)	San Francesco della Vigna, Venice		
(92)	At St Maurice, Switzerland	(8)	J.J. Ruskin
(95)	At Ghent	(15)	Graves & Co
(136)	Arch of Constantine, Rome	(15)	Henry J. Limes
(146)	Portico di Ottavia, Rome	(15)	Capt Hobhouse
(171)	Church of Symphorien, Tours	(8)	Graves & Co
(207)	Place de la Pucelle, Rouen, where Joan of Arc was burnt	(8)	Hon Mrs Vernon Harcourt
(236)	Part of the Cathedral at Huy, on the Meuse	(8)	Graves & Co
(347)	Entrance to the Giant Stairs, Venice	(9)	Mrs W. Wilson
(357)	At Verona	(8)	C.H. Turner
(361)	At Lisieux, Normandy	(12)	W.S. Blackstone (Art Union)
1844 (9)	West Porch of the Cathedral at Ratisbonne	(20)	Bishop of Lichfield
(60)	Liege	(12)	Hon Mrs Vernon Harcourt
(66)	On the Lahn	(12)	Sir John Hobhouse Bart.
(95)	Croix de Pierre, Rouen	(8)	Revd H.A. Soames
(129)	Interior at Caen, Normandy	(8)	
(138)	An Interior	(8)	
(194)	Albert Durer's House, Nuremberg	(8)	Vernon Wentworth
(207)	Colonnades of the Ducal Palace, Venice	(2)	Miss Coombe (Art Union)
(255)	A la Barbe Blanc, Tours	(8)	

	(277)	Rue Notre Dame, Caen	(8)	Alex. Allen
	(294)	Interior, at Chartres, France	(8)	Miss Richardson
	(301)	Temple of Pallas, Rome	(15)	Thos. Avison
	(315)	From the Terrace of the Zwinger Palace, Dresden	(15)	Lady Sykes
1845	(22)	Street View at Nuremberg, Bavaria	(25)	C.H. Packe
	(30)	Café de la Place, Rouen	(25)	Henry Wilkinson
	(53)	Palais de Justice, Rouen	(6)	John Dent
	(67)	Hotel de Ville, St Quentin, France – From a Sketch by J. Ruskin, Jun., Esq.	(25)	John Ruskin
	(71)	On the Moselle	(6)	Sir John Lowther
	(136)	Ancient Tombs at Verona	(15)	Miss Colville
	(145)	Part of a Palace at Dresden	(15)	W.J. Broderip
	(181)	On the Bridge at Prague	(10)	W.J. Broderip
	(189)	Church of St Jacque, Antwerp, in which Rubens was buried	(10)	S.M. Peto
	(231)	La Grosse Horloge, Rouen	(25)	Col Pennant
	(233)	St Mark's Place, Venice	(8)	
	(240)	Interior at Blois	(6)	J.C. Shape
	(255)	Stone Pulpit attached to the Cathedral at St Lo, Normandy	(8)	W.J. Broderip
	(265)	The Parson's Window at Nuremberg, Bavaria	(10)	Ld Brownlow
	(281)	Part of the Cathedral at Abbeville, Picardy	(12)	S.M. Peto
	(287)	Interior at Venice	(6)	G.C. Loftus
	(322)	At Abbeville, Picardy	(8)	John Vance
	(333)	Domo Dossola	(8)	John Dent
	(344)	Interior at Rouen	(6)	W. Forsyth
1846	(5)	Church of St Pierre, Caen, Normandy	(25)	Revd H.A. Soames
	(56)	Tours, France	(18)	Geo. Pownall
	(121)	At Prague	(18)	S.C. Grundy
	(196)	Hotel de Ville, Louvain, Flanders	(25)	Hon Mrs Seymour Bathurst
	(224)	Hotel de Ville, D'Audenarde, Flanders	(40)	J. Wild
	(242)	At Verona	(15)	Lady H. Campbell
	(250)	Part of the Stein Church, Prague	(15)	Mrs Halsey (Art Union)
	(294)	Post-House, Martigny, Switzerland	(8)	
	(306)	At Treves	(8)	S.J. Simes
	(314)	Church at Tours, France	(14)	H.G. Simes
1847	(28)	Strasbourg	(25)	Thos. Ashton
	(51)	Croix de Pierre, Rouen	(18)	John Gregg
	(58)	The Lady Chapel, St Pierre, Caen	(18)	S.J. Simes
	(89)	Augsburg, Bavaria	(60)	Col Douglas Pennant
	(137)	Church of St Maclou, Rouen	(25)	W.J. Broderip
	(168)	At Nuremberg	(30)	Thos. Burgoyne
	(183)	Milan Cathedral	(30)	Francis Fuller
	(207)	An Interior	(8)	Thos. Fairbairn
	(277)	North Isle of the Church at Ville d'Eau	(12)	Miss Hicks Beach
	(292)	The Headman's House at Bruges	(8)	R. Ellison
1848	(25)	Distant View of the Bridge of Sighs, Venice	(25)	W. Duckworth
	(33)	The Lady Chapel in the Church of St Jacque, Dieppe	(25)	W. Duckworth
	(40)	Part of the Castle of Heidelberg	(8)	
	(54)	At Ober Lahnstein, on the Rhine	(6)	E. Blore
	(73)	At Sion, Switzerland	(12)	P. Hardwick
	(83)	Washing Scene at Nuremberg	(30)	C.F. Chiffings
	(93)	A Market Place at Strasbourg	(30)	J. Wild

Year	No.	Title	Price	Buyer
	(136)	At Nieder Lahnstein, on the Rhine	(6)	D. Burton
	(185)	Sibyls Temple, Tivoli	(10)	S.T. Simes
	(187)	Part of the Choir at Chartres	(12)	S. Toller
	(212)	The Cloisters at St Paul's, Rome	(10)	Lady de Waldegrave
	(229)	At Mechlin	(6)	J.P.Grundy
	(274)	Part of the Ducal Palace, Venice	(8)	G. Pownall
	(315)	Palais du Prince, Liege	(8)	R. Alexander
	(323)	A la barbe blanc, at Tours	(6)	G. Forbes
	(342)	La Bourse, Antwerp	(8)	R. Lloyd
1849	(9)	Behind the Choir of St Pierre, Caen	(25)	Richard Cumming
	(10)	Rue St Jean, Caen	(10)	Miss M.A. Arkwright
	(25)	At Lavey, Switzerland	(10)	R. Stephenson
	(37)	Temples of Jupiter Tonans and Concorde, Rome	(10)	Eveleigh Winthrop
	(56)	Porch of Ratisbonne Cathedral	(25)	F. Astley Fellfoot
	(66)	At Ulm, Wurtemburg	(8)	Lady Buxton
	(76)	Interior at Mechlin, Flanders	(8)	
	(83)	Interior of a Church	(8)	Revd H. Lloyd
	(113)	Desecrated Chapel of St Jacque, Orleans	(10)	L.W. Collmann (Art Union)
	(190)	Cathedral of Beauvais	(10)	Chas. Dickens
	(229)	St Etienne, Beauvais	(6)	Bishop of Lichfield
	(238)	Temple of Pallas, Rome	(10)	W.B. Morgan
	(262)	Notre Dame, Caen	(6)	S.P. De Gex
	(287)	Part of the Cathedral, Cologne	(8)	W. Winthrop
	(290)	Interior at Dieppe	(12)	(?) Nilkens
	(316)	Porch of St Vincent's, Rouen	(12)	Miss Robertson
	(345)	Porch of Louviers, Normandy	(6)	J.A. Beaumont
	(352)	At Lisieux, Normandy	(6)	Miss Cockredge
	(365)	Gothic Window at Cologne	(6)	J.A. Beaumont
1850	(10)	Palais Ducal et petite Place sur le Môle, Venice	(30)	C.W. Packe
	(52)	Pont de Rialto, Venice	(30)	Mrs Packe Reading
	(94)	The Protestant Church at Ulm, Bavaria	(25)	C.W. Whitmore
	(98)	Part of the Church of St Mark, Venice	(8)	
	(251)	At Dresden	(12)	Decimus Burton
	(263)	The Sibyls Temple, Tivoli	(12)	J.L. Grundy
	(308)	At Ulm	(8)	Joseph Goff
	(338)	Arch of Constantine, Rome	(8)	Revd C.H. Townshend
	(346)	Fountain at Ulm	(8)	C.S. Whitmore
	(379)	At Mayence, on the Rhine	(10)	C.S. Whitmore
1851	(38)	At Mayence, on the Rhine	(10)	Edward Sugden
	(45)	At Falaise, Normandy	(8)	Sold
	(61)	Malines, Flanders	(45)	Sold
	(79)	St Pierre, Caen	(30)	Sold
	(112)	Augsburg, Bavaria	(30)	Sold
	(152)	Basle	(8)	Mr Vokins
	(205)	La Halle au Blé, Tours	(8)	— Brown
	(301)	Schaffhausen, on the Rhine	(8)	
	(319)	At Cologne, on the Rhine	(8)	Bishop of Lichfield

Original sources and sketchbooks

BARNSTAPLE, NORTH DEVON
ATHENAEUM

Collection of letters mostly in connection
with the publication by subscription of the
Facsimiles of Sketches ..., 1833

Goldsmith's Almanack for 1821 (Diary of
the 1821 Rhine tour)

Address book (including a note dated
1843)

Account books for 1809-16, 1824-31,
1832-50

Account book 1833-4 (in connection with
the *Facsimiles*)

Account book 1839-44 (relating to the
family budget while in Hastings)

Sketchbook (dismembered) watermarked
Fellows 1812, 19 folios 18 × 11 cm (Sussex
coast)

Sketchbook watermarked Whatman 1813,
11.6 × 18.4 cm (? Hastings)
ins. inside front cover *Hastings August 26th
1815*
ins. inside back cover *S. Prout 1826*

Sketchbook watermarked Whatman Mills
1835
11.4 × 18.4 cm

Sketchbook (Loire, Alps, Italian Lakes,
Venice)

Sketchbook (Dovedale)

Album of Sketches arranged by Isabella
Anne Prout.

PLYMOUTH CITY MUSEUM

Partial transcriptions of letters

Partial transcription of tour journal (1814)
from Leeds to Edinburgh

Note of 1824-5 passport

BRITISH MUSEUM DEPARTMENT OF
MANUSCRIPTS

BL Add. 42, 523. Correspondence etc. of
Samuel Prout and Samuel Gillespie Prout
1810-1911.
Presented by G.C. Williamson through the
NACF

BL Add. 45, 883. Letters to J.H. Maw

ROYAL WATERCOLOUR SOCIETY,
BANKSIDE, LONDON

J.J. Jenkins Papers: letters to Jenkins from
S.G. Prout; letters to John Hewett from
Samuel Prout

OWCS annotated catalogues for 1815-51

NATIONAL MARITIME MUSEUM

Sketchbook watermarked Whatman 1811,
27 × 26.2, 8 folios (? South coast *c.* 1812,
boats etc.). PR 51/370

Dismembered album of maritime subjects
arranged by Isabella Anne Prout.

FITZWILLIAM MUSEUM, CAMBRIDGE

MSS 167/175-1949. Letters to patrons and
publishers from Samuel Prout

CENTER FOR BRITISH ART, YALE

Bicknell Album of artists' letters etc.
B 1978.43.343-522

Letters from Samuel Prout to David
Roberts

EDINBURGH, NATIONAL LIBRARY OF
SCOTLAND

Journal of David Roberts, David Bicknell
Collection

Letters from David Roberts to Christine
Bicknell, David Bicknell Collection

PRIVATE COLLECTIONS, UK

Letters from Samuel Prout to David
Roberts

Letters from David Roberts to Christine
Bicknell

Album of 24 copies made in 1825 of tour
sketches made in Low Countries and
Germany, graphite drawings on wove
sheets 17 × 8 in

Select bibliography

ABBEY, J.R., *Life in England in Aquatint and Lithography 1770–1860*, 1953 and 1972. *Scenery of Great Britain and Ireland in Aquatint and Lithography*, 1952 and 1972. *Travel in Aquatint and Lithography*, 2 vols, 1956/7 and 1972.

ANON. 'Samuel Prout Esq., FSA', *Gentleman's Magazine*, CXC, 1852, 419 (obit.).

ART JOURNAL see Ruskin.

BARING-GOULD, S., *Devonshire Characters and Strange Events*, 1926, 160.

BOASE, T.S.R. *English Art 1800–1870*, Oxford, 1959.

BRADFORD, W. *Turner, Prout, Steer*, Courtauld Institute Coll., London, 1980.

BRITTON, J. *The Autobiography of John Britton*, 2 vols. 1849/50.

BUILDER, THE, 'The Late Samuel Prout', X, 1852, 339 (John Britton).

COLLINGWOOD, W., 'Reminiscences of an old Painter: Samuel Prout', *Magazine of Art*, 1898, 588.

COOK, E.T. and WEDDERBURN, A., *The Works of John Ruskin*, 39 vols, 1903–12.

DNB, *Dictionary of National Biography*, XVI, 1909, 424.

DUBUISSON, A. and HUGHES, C.E., *Richard Parkes Bonington*, 1924.

ESSEX REVIEW, 'Samuel Prout in Essex (1804)', XXXVII, 1928, 99.

GRANT, Col. M.H., *Old English Landscape Painters*, II; 1925, 273.

GRANT, Col. M.H., *A Dictionary of Landscape Painters*, 1952, 154.

GRUNDY, C.R. and ROE, F.G., *A Catalogue of Pictures and Drawings in the Collection of F.G. Nettlefold*, 1937.

HALL, S.C., *Retrospect of a Long Life*, 2. Vols. 1883.

HALTON, E.G., *Sketches by Samuel Prout in France, Belgium, Germany, Italy and Switzerland* (The Studio), 1915.

HARDIE, M. *Watercolour Painting in Britain: Vol. 2. The Romantic Period*, 1967; Vol. 3. *The Victorian Period*, 1969.

HINE, J. 'Samuel Prout, Artist', *Trans. of Plymouth Institution*, VII, 1878/81, 261.

HUGHES, C.E. 'Samuel Prout', *OWCS*, VI, 1929.

HUGHES, C.E. (ed. J. Mayne), *Early English Water-Colour*, 1950.

HOWGEGO, J., *Canaletto and English Draughtsmen*, British Museum, 1953.

HUNNISETT, B., *Steel Engraved Book Illustration in England*, 1980.

LAMBOURNE, L. and HAMILTON, J., *British Watercolours in the Victoria and Albert Museum*, 1980.

MUNBY, A.N.L., 'Letters of British Artists', II, *Connoisseur*, 118, 1946, 112.

PLYMOUTH MUS. AND ART GALL., *Samuel Prout*, 1851.

PLYMOUTH MUS. AND ART GALL., *Painters of Plymouth, 1650–1850*, 1971.

QUIGLEY, J., *Prout and Roberts*, 1926.

QUIGLEY, J., 'Samuel Prout', *Architectural Review*, 1926.

REDGRAVE, R. and S., *A Century of Painters of the English School*, 1866.

ROE, F.G., 'Some Letters of Samuel Prout', *OWCS*, XXVI, 1946, 41.

ROGET, J.I., *A History of the Old Water-Colour Society*, 2 vols., 1891.

RUSKIN, J., 'Samuel Prout', *Art Journal*, March 1849, 76. Reprinted 1870. *Notes on Samuel Prout and William Hunt*, Fine Art Society, London, 1879/80; 5th Edition, 1880, illus. with autotypes.

SCRASE, D., *Samuel Prout and David Cox*, Fitzwilliam Mus., Cambridge, 1983/4.

SOMERS COCKS, J.V., *Devon Topographical Prints 1660–1870*, Exeter 1977.

SWENSON, C., *Charles Hullmandel and James Duffield Harding*: A Study of the English Art of Drawing on Stone 1818–1850, Northampton, Mass., 1982.

TWYMAN, M., *Lithography 1800–1850*, 1970.

UWINS, Mrs, *A Memoir of T. Uwins, R.A.*, 2 vols. 1858 and 1978.

WEDMORE, F., *Studies in English Art*, 2nd series, 1880.

WORKS, see Cook and Wedderburn.

Index